THE SUPERHERO COSTUME

Dress, Body, Culture

Series Editor: Joanne B. Eicher, *Regents' Professor, University of Minnesota*

Advisory Board:
Djurdja Bartlett, *London College of Fashion, University of the Arts*
Pamela Church-Gibson, *London College of Fashion, University of the Arts*
James Hall, *University of Illinois at Chicago*
Vicki Karaminas, *University of Technology, Sydney*
Gwen O'Neal, *University of North Carolina at Greensboro*
Ted Polhemus, *Curator, "Street Style" Exhibition, Victoria and Albert Museum*
Valerie Steele, *The Museum at the Fashion Institute of Technology*
Lou Taylor, *University of Brighton*
Karen Tranberg Hansen, *Northwestern University*
Ruth Barnes, *Ashmolean Museum, University of Oxford*

Books in this provocative series seek to articulate the connections between culture and dress which is defined here in its broadest possible sense as any modification or supplement to the body. Interdisciplinary in approach, the series highlights the dialogue between identity and dress, cosmetics, coiffure and body alternations as manifested in practices as varied as plastic surgery, tattooing, and ritual scarification. The series aims, in particular, to analyze the meaning of dress in relation to popular culture and gender issues and will include works grounded in anthropology, sociology, history, art history, literature, and folklore.

ISSN: 1360-466X

Previously published in the Series

Helen Bradley Foster, *"New Raiments of Self": African American Clothing in the Antebellum South*
Claudine Griggs, *S/he: Changing Sex and Changing Clothes*
Michaele Thurgood Haynes, *Dressing Up Debutantes: Pageantry and Glitz in Texas*
Anne Brydon and Sandra Niessen, *Consuming Fashion: Adorning the Transnational Body*
Dani Cavallaro and Alexandra Warwick, *Fashioning the Frame: Boundaries, Dress and the Body*
Judith Perani and Norma H. Wolff, *Cloth, Dress and Art Patronage in Africa*
Linda B. Arthur, *Religion, Dress and the Body*
Paul Jobling, *Fashion Spreads: Word and Image in Fashion Photography*
Fadwa El Guindi, *Veil: Modesty, Privacy and Resistance*
Thomas S. Abler, *Hinterland Warriors and Military Dress: European Empires and Exotic Uniforms*
Linda Welters, *Folk Dress in Europe and Anatolia: Beliefs about Protection and Fertility*
Kim K.P. Johnson and Sharron J. Lennon, *Appearance and Power*
Barbara Burman, *The Culture of Sewing*
Annette Lynch, *Dress, Gender and Cultural Change*
Antonia Young, *Women Who Become Men*
David Muggleton, *Inside Subculture: The Postmodern Meaning of Style*
Nicola White, *Reconstructing Italian Fashion: America and the Development of the Italian Fashion Industry*
Brian J. McVeigh, *Wearing Ideology: The Uniformity of Self-Presentation in Japan*
Shaun Cole, *Don We Now Our Gay Apparel: Gay Men's Dress in the Twentieth Century*
Kate Ince, *Orlan: Millennial Female*
Ali Guy, **Eileen Green and Maura Banim**, *Through the Wardrobe: Women's Relationships with their Clothes*
Linda B. Arthur, *Undressing Religion: Commitment and Conversion from a Cross-Cultural Perspective*
William J.F. Keenan, *Dressed to Impress: Looking the Part*
Joanne Entwistle and Elizabeth Wilson, *Body Dressing*
Leigh Summers, *Bound to Please: A History of the Victorian Corset*
Paul Hodkinson, *Goth: Identity, Style and Subculture*
Leslie W. Rabine, *The Global Circulation of African Fashion*
Michael Carter, *Fashion Classics from Carlyle to Barthes*
Sandra Niessen, **Ann Marie Leshkowich and Carla Jones**, *Re-Orienting Fashion: The Globalization of Asian Dress*
Kim K. P. Johnson, **Susan J. Torntore and Joanne B. Eicher**, *Fashion Foundations: Early Writings on Fashion and Dress*
Helen Bradley Foster and Donald Clay Johnson, *Wedding Dress Across Cultures*
Eugenia Paulicelli, *Fashion under Fascism: Beyond the Black Shirt*
Charlotte Suthrell, *Unzipping Gender: Sex, Cross-Dressing and Culture*
Irene Guenther, *Nazi Chic? Fashioning Women in the Third Reich*
Yuniya Kawamura, *The Japanese Revolution in Paris Fashion*
Patricia Calefato, *The Clothed Body*
Ruth Barcan, *Nudity: A Cultural Anatomy*
Samantha Holland, *Alternative Femininities: Body, Age and Identity*
Alexandra Palmer and Hazel Clark, *Old Clothes, New Looks: Second Hand Fashion*
Yuniya Kawamura, *Fashion-ology: An Introduction to Fashion Studies*
Regina A. Root, *The Latin American Fashion Reader*

Linda Welters and Patricia A. Cunningham, *Twentieth-Century American Fashion*
Jennifer Craik, *Uniforms Exposed: From Conformity to Transgression*
Alison L. Goodrum, *The National Fabric: Fashion, Britishness, Globalization*
Annette Lynch and Mitchell D. Strauss, *Changing Fashion: A Critical Introduction to Trend Analysis and Meaning*
Catherine M. Roach, *Stripping, Sex and Popular Culture*
Marybeth C. Stalp, *Quilting: The Fabric of Everyday Life*
Jonathan S. Marion, *Ballroom: Culture and Costume in Competitive Dance*
Dunja Brill, *Goth Culture: Gender, Sexuality and Style*
Joanne Entwistle, *The Aesthetic Economy of Fashion: Markets and Value in Clothing and Modelling*
Juanjuan Wu, *Chinese Fashion: From Mao to Now*
Annette Lynch, *Porn Chic*
Brent Luvaas, *DIY Style: Fashion, Music and Global Cultures*
Jianhua Zhao, *The Chinese Fashion Industry*
Eric Silverman, *A Cultural History of Jewish Dress*
Karen Hansen and D. Soyini Madison, *African Dress: Fashion, Agency, Performance*
Maria Mellins, *Vampire Culture*
Lynne Hume, *The Religious Life of Dress*
Marie Riegels Melchior and Birgitta Svensson, *Fashion and Museums*
Masafumi Monden, *Japanese Fashion Cultures*
Alfonso McClendon, *Fashion and Jazz*
Phyllis G. Tortora, *Dress, Fashion and Technology*

THE SUPERHERO COSTUME

Identity and disguise in fact and fiction

BARBARA BROWNIE AND DANNY GRAYDON

Bloomsbury Academic
An imprint of Bloomsbury Publishing Plc

B L O O M S B U R Y
LONDON · NEW DELHI · NEW YORK · SYDNEY

Bloomsbury Academic

An imprint of Bloomsbury Publishing Plc

50 Bedford Square	1385 Broadway
London	New York
WC1B 3DP	NY 10018
UK	USA

www.bloomsbury.com

BLOOMSBURY and the Diana logo are trademarks of Bloomsbury Publishing Plc

First published 2016

British Library Cataloguing-in-Publication Data
A catalogue record for this book is available from the British Library.

ISBN:	HB:	978-1-4725-9591-1
	PB:	978-1-4725-9590-4
	ePDF:	978-1-4725-9593-5
	ePub:	978-1-4725-9592-8

Library of Congress Cataloging-in-Publication Data
A catalog record for this book is available from the Library of Congress.

Typeset by RefineCatch Limited, Bungay, Suffolk
Printed and bound in India

CONTENTS

PART TWO: IDENTITIES AND IDEALS 53

PART THREE: HARSH REALITIES 95

PART FOUR: CASE STUDIES 135

ILLUSTRATIONS

INTRODUCTION

Gaudy, theatrical, and athletically dynamic, the superhero costume remains one of the most singularly compelling signatures of a genre that is fast approaching its eightieth year of existence and one which has become a pervasive colossus of modern pop culture. Grant Morrison observes that the superhero's costume was "immediately intriguing" (Morrison, 2011, p. 15), emblazoned with emblems that, in the case of Superman, "would become one of the most widely recognized symbols of the twentieth century" (Weldon, 2013, p.13). Consequently, the flamboyant costume has become a key part of the superhero's essential appeal and, in countless transmedia incarnations since, continues to resonate vigorously.

One of the reasons that they continue to be so beguiling, aside from their brazen primary color schemes, is the way they are worn with such total confidence. Consider the hallowed archetype of the superhero genre, Superman, and his most iconic pose: fists-on-hips, legs apart, smiling, and with chest puffed out, boldly showcasing his S-shield. There is no trace of self-consciousness despite the inherent absurdity of his costume, only absolute moral certainty and unwavering commitment to heroism. The implication is clear: the kind of person who would wear such an outfit is someone who knows exactly who they are and what they stand for. The costume is an intoxicating demonstration of personal and ideological confidence that suffocates the potential for ridicule, especially when displayed in conjunction with awesome, superhuman feats.

Yet, a superhero's costume is one expression of a complex existence. The superhero lives his life as a masquerade.[1] Regardless of whether he is wearing his vibrant unitard or his civilian suit, he is projecting only part of his true self. The superhero genre is defined by dual-identity, and the costume is the most visible signifier of that duality. Costume, writes Reynolds (1992, p. 26) "functions as the crucial sign of super-heroism." The superhero costume is a mask dividing the spectacular mutant from the civilian alter-ego. All superheroes are "mutants" — Scott Bukatman (1994) describes them as "categorical mistakes" — and they mark their otherness with elaborate costume so distinct from everyday civilian wardrobe that no onlookers could ever suspect a connection between their two identities.

The substitution of one of these identities for the other is a deliberate act of construction. In clothing himself, the superhero constructs one of his two identities,

carefully layering and combining signifiers to ensure that his appearance is appropriate for his role. While we all partake in identity construction for our various roles, for superheroes the task involves a more extreme act of differentiation. His two costumes must differentiate between two vastly different personas: one ordinary, and one extraordinary. He frequently transforms his identity by switching wardrobes, substituting one identity for another. A flamboyant, theatrical design enables a dramatic performance of otherness, asserting difference from the mundane garments worn by the alter ego.

Wolf-Meyer (2006, p. 190) argues that the costume positions the superhero as a "liminal entity," existing "between states" so that he may achieve invisibility. This follows Fingeroth's (2004, p. 122) observation that the superhero was first conceived as a compromise between human and monster: an entity that is neither one thing nor another. This book takes the position that the costume marks the superhero as "Other." The costumed superhero is not, as Wolf-Meyer would have it, "invisible," but a vivid spectacle of otherness. He is not half-human, but superhuman, containing both the qualities of the human hero and the monster. In many cases, humanity is not compromised, but heightened.

The acquisition of the costume marks the pivotal moment in the emergence of a superhero. Although he may have acquired his powers previously, it is at the moment when he dons his costume for the first time, and hence adopts his super-identity, that the hero becomes a superhero (South, 2005, p. 95). This act of selecting a costume invites objectification. By electing to wear a costume, the superhero consciously constructs an identity. In this act, he is, like an actor, constantly aware of "his character, and his relationship with the audience" (Walter, 2011). His superhuman character, an artificial construction, is presented as a set of colors and shapes, in representation of a set of values. While in costume, he must perform according to those rules laid out by himself and by the superhero genre, represented in what he wears. This awareness of the representation of self leads the superhero to be as equally careful in the construction of his civilian alter-ego. When the superhero dresses down, he becomes an actor, performing the pretext of ordinariness. In his civilian wardrobe he becomes a mimic, building on past experiences to construct an imitation of normalcy.

By donning a costume, a superhero forces an artificial divide between the normal and extraordinary aspects of himself. The civilian wardrobe denies extraordinariness, while the superhero costume denies ordinariness. Audiences are forced to think of the superhero and his alter ego as polar opposites, as dissimilar as they can be. This polar division has long been a consequence of costume. Anthropologist A. David Napier (1986, p.1) observes that ritual masks enable paradoxes to exist, allowing "reconciliation of two things that . . . seem incompatible." In his study of eighteenth-century carnival and masquerade, Terry Castle (1986, pp. 4–5) proposes that costumes "ideally represent . . . an inversion of one's nature": an heiress can become a pauper; a saint can become a devil; a

man can become a woman. In the extravagant masquerades of eighteenth-century England and the USA, costume permitted an "experience of doubleness, the alienation of inner from outer . . . self and other together, the two-in-one" (or, as *Action Comics* would have it, "one and the same").

Indeed, practices of eighteenth-century masquerade have much to teach us about superhero costumes. This "age of disguise" with all its "exquisite duplicities" established ideals for real and theatrical "self-concealment" (Castle, 1986, p. 5). Amelia Rauser (2008, p. 101) records that "one particular tradition of [eighteenth-century] masquerade dress . . . was the 'two-in-one' costume . . . [which] traded on the grotesqueness or extremity of the fusion it represented." She describes, for example, a lawyer's costume which presented its wearer simultaneously as the figures of plaintiff and a defendant. Typically such costumes would be "split down the middle" and would sometimes represent the contrast between "opposing political" ideals or a more concrete representation of "the real, physical selves of . . . two enemies." While an explicit comparison could be made to Two-Face, a recurring character in DC's *Detective Comics* and *Batman* whose descent into villainy is literally etched into his face, the juxtaposition of two contrasting personalities, reflected in costume, could be more generally applied to the whole superhero genre. In any superhero comics, the reader sees both alter egos—civilian and supernatural—depicted on the pages as two halves of the same whole; divided but inseparable.

So inseparable are the costume and the superhero that without it he is reduced to the lesser title of hero. The prefix, "super," comes not from supernatural abilities,[2] but from the division, by costume, of the natural and the extraordinary into private and public personas. Costume is so inseparable from our notion of a superhero that in some cases the costume *becomes* the hero (as in Iron Man, when the costume provides the superhero with his powers), or carries with it the identity of the superhero (as with Batman's sidekick, Robin, whose title is passed, along with the costume, to younger generations). In the case of Iron Man, the costume is solely responsible for the character's superpowers, and hence his identity as a superhero. This idea that this relationship between the costume, the superhero's identity, and powers that make him unique, is so entrenched that it spills over into reality. Davies et al. (2007, p. 242) observe that superhero costumes encourage "risk-taking behaviour" in children who identify superheroes as role models.

Like any mask, the superhero costume transforms the wearer's identity by revealing a "powerful fearless other" (Tseëlon, 2001, p. 26) that must normally be concealed. It brings an "inner nature" to the fore, and in doing so plays to powerful fantasies about being recognized for who we really are. This inner nature is primal and powerful—a physical, not intellectual, being—dressed in skin-tight spandex to accentuate large muscles and thereby foreground masculinity (Weltzien, 2005, p. 231).

Reynolds (1992, p. 37) is quick to observe that male superheroes are presented differently to their female counterparts. He writes that the costumes of female superheroes function differently, inviting the male gaze. The overtly sexualized depiction of female superheroes has been widely debated elsewhere, most notably in Mike Madrid's *The Supergirls: Fashion, Feminism, Fantasy, and the History of Comic Book Heroines* (Madrid, 2009). The sexualization and fetishization of female superhero costumes has been so widely discussed that it would be unproductive to repeat the discussion in these pages. Needless to say, in a genre that thrives on depiction of hyper-masculine bodies, it would be remiss to suggest that gender is not key in the design of any superhero costume. Christian Pyle (1994, p. 5) counters Reynolds' and Madrid's arguments with the observation that male superheroes, with their skin-tight costumes, invite the homoerotic gaze. Pyle argues that the sexualization of the superhero through provocative costume is not gender-specific.

All of these implications of the superhero costume are as applicable in reality as they are within the pages of fantasy comics. Cosplayers and real-life "superheroes" can find themselves empowered by dressing as a superhero. Superhero motifs are adopted even by those who have had no direct contact with comic books, having become such a pervasive part of contemporary culture that the values expressed through superhero insignias are universally understood. As many commentators are quick to point out, these real-life appropriations try, but fail, to successfully duplicate the aesthetics of their source material (Chabon, 2008, p. 17), but nonetheless are effective at endowing the wearer with strength and confidence that they might not otherwise possess.

The costume's capacity to empower its wearer is not diminished by duplication. While the fictional superhero may use his costume to signify his uniqueness, the costume and its capacity to empower its wearers is multiplied. Multiplicity contributes to the ubiquity of understanding of the costume's meaning, and unites wearers and observers with a common sense of purpose. Matthew Ogen's documentary, *Confessions of a Superhero* (2007) follows four aspiring actors who make their living posing for photographs in the streets of Los Angeles in various superhero costumes, including Christopher Dennis, who poses as Superman and is noteworthy for the extreme contrast between his soft belly and the firm muscular torso of his fictional hero. Matt Yockey (2009) proposes that such images paradoxically "brings us closer" to Superman, and to the notion that "we can all be like him."

It has become increasingly difficult to make distinctions between the superhero costume in fantasy and its real-life imitations. Revisionist superhero comics present the superhero and his costume as if they were real, dealing with the same practical concerns as the real costume vigilantes who patrol the streets of cities including London and Seattle. This book will present the superhero costume in fiction and fact, exploring its function and meaning within the fictional

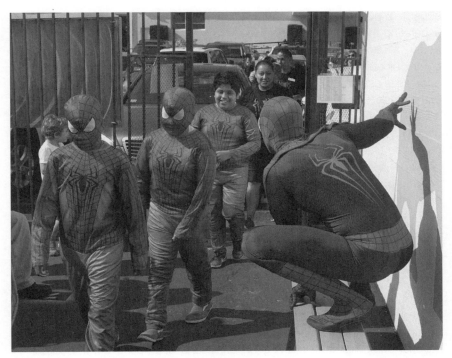

Figure 0.1 Cosplay creates multiplicity. The superhero's costume, which marks the hero's uniqueness in his fictional home, is infinitely duplicated in the real-world. At the "Be Amazing" Event at the Larchmont Charter School in Los Angeles (April 22, 2014), an authentic reproduction of the costume for the film adaptation, *The Amazing Spider-Man 2* (right), is contrasted with less-convincing duplicates (left).

© Spina USA/REX

narratives of comic book pages and film adaptations, and the realities of cosplay, political protest, and costumes vigilantes.

The first part of this volume, "Origins and Evolution," will identify issues that arise in the development and evolution of superhero costumes. Superheroes, and hence their costumes, undergo multiple incarnations and transformations. These chapters will address the origins of the superhero aesthetic, and trace its transformation through development and adaptation, as it takes on board external influences and adapts to account for different modes of representation. Chapter 1, "Superman: Codifying the superhero wardrobe" identifies *Action Comics* and Superman as the model that defined the superhero genre, establishing historical, athletic, and carnivalesque influences that have informed the design of the archetypal superhero costume. Chapter 2, "Identity, role and the mask" explores the superhero's two identities, which at first seem to be incompatible, that are divided and enabled by costume. The two roles that the

superhero plays appear contradictory: he is ordinary, and yet extraordinary. By separating these two roles into two different identities, the mask preserves the purity of each. This chapter explores the role of the mask in forming and communicating identity and establishing expectations of role and behavior. It addresses assumptions about the authenticity of the self, and the inauthenticity of the mask or costume. It also draws on anthropological studies of the mask, as a signifier of power and authority. Chapter 3, "Evolution and adaptation," observes how the desire for realism in cinema and fidelity to source material has prompted a shift in focus, from form to function, in the design of the superhero costume. It explores the methods employed to evolve and adapt the costume into a more credible object, finding that increasingly utilitarian costumes have been introduced in an effort to respond to audience demands for realism.

Part Two addresses "Identities and Ideals," beginning in Chapter 4 with "Wearing the flag," which identifies the importance of national identity in the design of the superhero costume and the values that it represents. Superheroes are often defined as patriots, and their patriotic values are reflected in the colors and shapes that adorn their costumes. Foreign adaptations of American superheroes often assert their local allegiance by incorporating elements of national dress into their costume, highlighting the often-inextricable link between a superhero's values and nationality. Captain America is presented as a national personification, drawing on depictions of Uncle Sam. The export of superhero identities is evidenced in *Spider-Man India* and *Batman Incorporated*, in which national identity trumps race, and exoticism is blended with primitivism. Chapter 5, "Dressing up, dressing down," addresses the superhero's alternative costume—the wardrobe of the civilian alter-ego. The "assumption of [this] false identity," the ordinary civilian, is "just as important as the concealment" of the hero's supernatural identity (Muecke, 1986, p. 218), and involves just as complex costume signifiers. This chapter demonstrates that the contrast between the ordinariness of the civilian alter-ego and the otherness of the superhero costume preserves the anonymity of the superhero, and proposes that neither is a disguise; rather that both costumes are authentic, yet incomplete, representations of the superhero hidden inside. Chapter 6, "Channeling the beast," looks specifically at anthrozoomorphic costumes, making comparisons to the masks and skins worn in shamanistic ritual, and in reference to theories of physiognomy. It proposes that, by incorporating animal symbolism into their costumes, superheroes are permitted to regress to a primal state, thereby justifying ferocity and strength that would not be permissible for those dressed in civilian clothing.

Part Three, "Harsh Realities," investigates superhero costumes within, and in relation to, real-life contexts. It addresses the audiences of superhero fiction, and the extent to which the ideals of superhero costumes are transferable to reality. It identifies how problematic the superhero costume can be when assessed according to the rules that govern real-life clothing and costume, including issues

of fashionability, manufacture, and functionality. Chapter 7 explores "Superheroes and the fashion of being unfashionable," the extent to which superhero costumes follow and diverge from fashion. It argues that, since superhero narratives are often ahistorical and defining visual features must be largely consistent from one incarnation to the next, costumes are resistant to change. This chapter positions the superhero as a fashion outsider, whose longevity necessitates a lack of engagement with collective taste. A gender divide is demonstrated, as female superheroes, including Wonder Woman and the Wasp, are identified as having direct engagement with the fashion industry. Chapter 8 explores cosplay and competitive costume-making as a form of participatory fandom. The chapter will present cosplay as a means of acquiring cultural capital, and identify how cosplayers pursue authenticity in efforts to distance their activities from other kinds of fancy dress. Chapter 9, "Real-life superheroes," discusses real-life activists and vigilantes who conduct their activities behind a mask, and under the guise of an alter ego. Examples will include costumed vigilante, Phoenix Jones, the fathers' rights organization Fathers 4 Justice, and Russian rock band and feminist activists, Pussy Riot. The chapter will explore these groups' motives for wearing a mask, and the physical and political protection offered by a costume.

The book concludes with three case studies, selected for the ways in which they challenge or complexify many of the arguments made earlier in the book. In Chapter 10, Alan Moore's *Watchmen* is presented as a deconstruction of the superhero genre, examining the real-world implications of superhero existence and activity. Moore's reframing of superhero stereotypes allows them to have different and specific relationships with their costumes. In Chapter 11, Iron Man is shown to exemplify how the identity of a superhero can be bound up in his costume. The Iron Man suit demonstrates how the requirement for functionality can be taken to extremes, as it is presented not simply as accessorized by functional tools, but as a utilitarian device in itself. The final chapter, a study of the X-Men, presents superhero costumes as uniforms, uniting heroes under a shared set of values, establishing professional bonds and the expectation of adherence to a shared code, and asserting their identities as minority outsiders.

PART ONE

ORIGINS AND EVOLUTION

PART ONE

ORIGINS AND
EVOLUTION

1

SUPERMAN: CODIFYING THE SUPERHERO WARDROBE

When readers first laid eyes upon Superman as depicted on the arresting front cover of *Action Comics* #1 in spring of 1938, they were faced with a new breed of adventure hero who was remarkable not only for his heroic feats, but also for his spectacular costume. This flamboyantly-clad figure, muscles accentuated by skintight blue spandex and with a red cape flowing dramatically behind him, made an immediate impression. The costume was, as veteran comic-book artist Jim Steranko (2013, p. 9) observes, "the crowning touch" that marked this new genre apart from the pulp heroes who came before.

Action Comics was "a first step towards a definition of the superhero" (Reynolds, 1992, p. 12) establishing concrete associations between "secret identities, distinctive garb and special abilities" (Chambliss and Svitavsky, 2008, p. 18). In the decades since, subsequent characters and storylines have relied upon, or in some cases subverted, Superman's archetype, to communicate similar messages to their own readership. Early visions of Superman have become so pervasive that all superheroes exist either to continue or to defy the rules established in that first superhero comic. Superman's creators, writer Jerry Siegel and artist Joe Shuster, along with the legions of creatives at DC Comics who have furthered their signature character, are responsible for establishing particular expectations about the superhero costume and the roles, responsibilities, and values that it represents.

It was in this founding of the genre that audiences began to develop the expectation that any character dressed in a skintight costume would have certain remarkable abilities, and certain moral obligations to use those powers benevolently for the good of mankind. Grant Morrison (2011, p. xvii) proposes that the superhero costume, as worn by Superman, aspires to "utopian[ism]," representing "something we all might become." After Superman established the costume as a visual signifier of this new genre, other costumed heroes swiftly sprang up. Batman, The Flash, The Crimson Avenger, Green Lantern, and Hawkman formed part of a new "mythic landscape" (Wolf-Meyer, 2006, p. 192).

The costume no longer simply marked the superhero as Other, but as a very specific Other: part of a wider pool of brilliantly colored action men.

In later years, the superhero costume came to be perceived as a kind of disguise (as evidenced by the fact that so many later heroes wore masks). Brad Ricca (2013, p. 128) writes that Superman's costume was not conceived of as a disguise, but rather "an announcement of who this character was." The identity and the costume are inseparable. Indeed, for many superheroes the design of the costume is directly motivated by their name (Coogan, 2006, p. 36). For many later superheroes, the name and costume took inspiration from the same source (see, for example, the many animal-inspired superheroes of Chapter 6); for Superman, the name and costume both contributed to the impression of him as "super"—a mighty Other.

Physical labor and the construction of masculinity

Superman's otherness is firmly established in a costume that is identical from day to day. Wearing only one costume, Superman reduces his core values to a single, consistent message which is not compromised by daily adjustments to his wardrobe. This kind of "distinctive persistent dress," finds Gregory Stone (1981, p. 144), is more commonly associated with professional responsibilities than with personal identity, and so through consistency of dress, Superman presents himself as acting in service of others. The costume is his workwear, distinct from his alter ego's more varied wardrobe.[1] As if it were the uniform of his profession, he expresses his willingness to serve. Moreover, the characteristics of the costume communicate that his work is primarily physical in nature.

Stone observes that, "to engage meaningfully in some transactions, it is enough to know merely 'what' the parties are" and not "who" they are (Stone, 1981, p. 145). When an individual's roles and responsibilities are established superficially through dress, a meaningful engagement may occur without the need to reveal any personal information. Superman is able to function as a superhero without revealing himself as Clark Kent largely because his labor requires no more than for him to perform superheroic feats. He does not need to express his mood or personality through everyday variation in dress, because in order to achieve his daily heroics he need only express his continued devotion to heroism, and his supernatural abilities.

With his skintight unitard that leaves so little to the imagination, Superman is costumed as a specimen of male strength and athleticism. Numerous authors have identified the connection between Superman and the circus strongman (Daniels, 1998, p. 18; Ricca, 2013, p. 128; Morrison, 2011, p. 14). In particular, it is likely that Siegel and Shuster were inspired by a strongman named Siegmund

Breitbart who performed in the 1920s in Siegel and Shuster's home towns, and who was billed in 1923 as "superman of the ages" (Andrae and Gordon, 2010, pp. 43–47). Much like mild-mannered reporter Clark Kent's transformation into Superman, Victorian strongmen, like Superman, similarly exploited the transition from ordinariness to otherness as spectacle. Indeed, John Kasson (as cited in Chambliss and Svitavsky, 2008, p. 2) relates that Eugene Sandow (see Figure 1.1), the "prototypical strongman of the 1890s," dramatized the transition from anonymous "man of the crowd" to "supreme" superhuman.

The unitard of the circus strongman is "designed to foreground the performer's work" (Monks, 2010, p. 21). The strongman makes a career of physical labor, and dresses accordingly. The costume is pulled tight over his muscles, so as to evidence his extraordinary size and tone, and is flexible, enabling the gymnastic stretches that he may perform for audiences. Like strongmen, superheroes are "super" primarily in their "physical superiority" (Chambliss and Svitavsky, 2008, p. 20), and so in order to highlight their "super-ness," their physical characteristics must be emphasized. Further, they express that the physical spectacle is a labor, performed for the benefit of others.

Certain aspects of Superman's costume go further than foregrounding his physical behavior, by directly influencing his physicality. This is particularly apparent in *Superman: The Movie* (Donner, 1978), in which Christopher Reeve handles the bulky fabric of the cape by incorporating a partial twirl when he turns his body. This gesture, being a side effect of wearing the cape, aids in distancing Superman from the meek Clark Kent, whose idiosyncratic gestures are affected by the freedoms and restrictions of a business suit. Later screen superheroes have had their movement more heavily restricted by their costumes, and in this way have constructed superhero identities who look different to their civilian alter-egos in their movements as well as their costumes.

The transformative power of costume gives the wearer the psychological advantage of feeling like a different person in their costume than in their civilian clothes. The "motors" of a costume have the power to dramatically alter the wearer's sense of physical and psychological identity (Cooper, 1999, p. 37). The motor effect of clothing in identity construction has been demonstrated throughout the history of dress, most notably in gender construction.[2] In theatrical costume, it can dictate the qualities of a physical performance, helping to transform the human performer into Other.[3] Tim Burton, director of *Batman* (1989) describes the impracticality of Batman's costume, observing that it restricts the wearer's motion and sight. The stiffness of Burton's costume limited the movement of the actors and stuntmen who wore it, to such an extent that it gave film incarnations of Batman a distinct style of movement. Unable to turn his head to the side, the character is shown performing a twisting gesture that has since become known as the "bat turn"—a turn of the head that requires the whole upper body to turn with it.

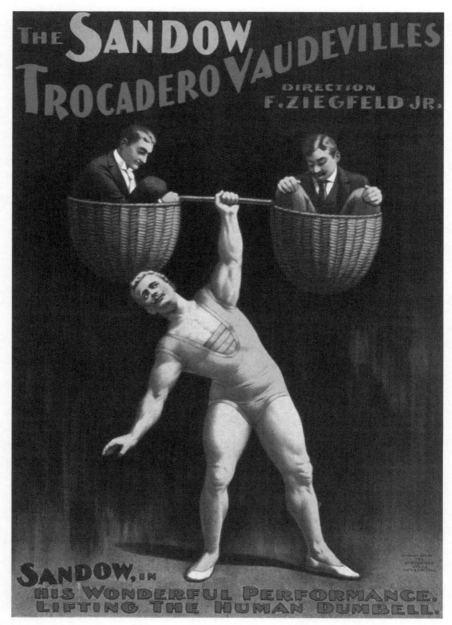

Figure 1.1 Eugene Sandow, one of several strongmen who is likely to have inspired Siegel and Shuster, 1894.

Image courtesy of the Library of Congress.

The cape's impracticality aside, Superman's costume offers him more freedom of movement than those of Burton's Batman or many other costumed heroes. This freedom of movement offers Superman, as it does the strongman, flexibility and agility for performing superhuman maneuvers in flight and combat. The practical benefits of a flexible costume may be less important, however, than the physiological impact. Walter (2011) proposes that a costume may help an actor to remain in-character, implying a connection between the novelty of the costume and the ease at which the actor remains in-character. The flexibility of Superman's unitard may act as a constant reminder that he is free to use his supernatural abilities, while in contrast, the stiff and bulky suit of Clark Kent provides a constant reminder that he must restrain himself. Both costumes help him stay "in-character": as Superman, to devote himself to good, to carry his body upright and proud, to be constantly alert to villainy and disaster; or as Clark Kent, to remain meek and mild-mannered, and to avoid conflict or detection.

By revealing the muscular body, the costume both enables and prompts masculine behavior. If we concede, as Friedrich Weltzien (2005, p. 229) does, that "masculinity [is] a masquerade," then this costume not only expresses the hero's masculinity, but constructs it. The hero's masculinity is bound up in the costume, as evidenced by the apparent contrast in the characteristics of his alter ego, who without the costume typically appears boyish and meek. Dressed as Clark Kent, Superman seems deprived of his hyper-masculinity (see Chapter 5). When they don their costumes, all superheroes (male and female) engage in gender construction. Superman, argues Weltzien, is responsible for the construction of a particular image of "manliness" which excludes the "love, family life and tenderness" that are important in defining his alter ego (p. 231).

The costume does not construct an isolated masculine identity, but rather frames him relative to all other men. Weltzien argues that the superhero's construction of masculinity prompts a "competitive relationship between men" (2005, p. 242). To present Superman as merely "masculine" would not do justice to his extraordinary nature. Instead, Superman must construct a vision of superior hyper-masculinity. Superman's toned physique, as emphasized by the costume, connotes physical superiority even to his own alter ego. By direct comparison with Clark Kent, Superman constructs masculinity not in contrast to femininity, but to the inferior masculinity of other males including the alternative version of himself.

Performance in combat

The superhero costume has been variously linked to historical armor or gladiatorial uniform (Fingeroth, 2004, p. 40; Ricca, 2013, p. 128; Weltzien, 2005, p. 238). Weltzien identifies influence from Roman, Medieval, and Renaissance dress,

specifically at the intersection of sports and paramilitary uniforms. Siegmund Breitbart, the strongman theorized to have influenced Siegel and Shuster, wore a Roman-inspired cape in promotional imagery (Andrae and Gordon, 2010, p. 47). This kind of military dress positions the wearer in reference to "historical models of the warrior, the classic domain of heroic manhood," and identifies him "as a person on a special mission" (Weltzien, 2005, pp. 240–241).

Superman's costume is not, however, conventional battle dress. Its bright colors and flowing cape more closely resemble dress uniform than combat camouflage. The costume makes a spectacle of combat, as if worn to attract attention to the wearer's heroic deeds (Weltzien, 2005, p. 241). Morrison (2011, p. 14) describes the costume as "showman-like," emphasizing the performative qualities of Superman's actions. While a villain may carry out his crimes in the shadows, Superman positions himself at the center of attention. Drawing attention, therefore, to his body and its actions, he challenges audiences to scrutinize his deeds, confident that they will share his values, thereby declaring that he has nothing to hide. Costume that foregrounds the body's physical expressions is often vibrant and decorative and, writes Aoife Monks (2010, p. 23), "extends to the display of the body itself as a source of visual pleasure, framing, emphasizing, and revealing it in ways that we can admire."

Much like the vibrant colors of early nineteenth-century British Army dress as described by military historian Scott Hughes Myerly (1996, p. 103), Superman's costume creates a "perpetual spectacle," clad in "the vibrant tokens of martial honor representing sublime values." For many years, brilliantly colored, and "often gaudy" uniform was synonymous with the army, and the colors on display were those of Superman: red, blue, and yellow (pp. 18–19). In the "theater of war," vibrant costumes intimidated enemies, while seducing the "hearts and minds of a nation" on the home front. The spectacle of Superman's costume has a similarly seductive power. Its use is primarily in combat or rescue but the visual spectacle is not for the benefit of combatants so much as it is for other observers. Superman's presence is reassuring to the citizens of Metropolis, to whom his "martial display" signifies protection.

The most attention-grabbing component of Superman's costume is the cape. In comic-book panels, the flowing red cape enhanced the spectacle of Superman's tremendous speed, creating the illusion of motion (Weldon, 2013, p. 13; Morrison, 2011, p. 15). As military garb, the cape may function as a call to arms. Julius Caesar wore a crimson cape into battle, the sight of which reassured his troops that he had joined them in combat while ensuring that he would not be reduced to the same status. The cloak transformed Caesar's actions in combat into a propaganda performance. Superman's own cape provokes similar admiration from both his human followers and superhuman peers, positioning him as a majestic general who aims to inspire others to act according to a same set of moral principles.

The cape is at its most symbolic in the death and return of Superman (*Superman Vol. 2* #75 January 1993, and #82, October 1993). The depiction of Superman's final battle with the monstrous Doomsday demonstrates the significance of the costume to those who witness him in combat. The costume is so integral to Superman's identity that even when separated from the body it speaks of Superman's state of well-being. In issue 75, a panel depicts Superman's shredded cape amid the debris of his last battle. The empty fabric speaks of the absence of Superman's body and he is assumed dead, as if separated from his cape he ceases to exist. After his death, *Daily Planet* photographer Jimmy Olsen remembers Superman not for his deeds but for the visual spectacle of his costume, recalling "that red cape of his really looked great whipping around in the wind." Olsen reviews his selection of photos of Superman's final battle, including several depicting the superhero in his final moments, and his broken body lying lifeless in the rubble. Olsen dismisses all of these images, and instead selects for publication a close-up of the torn cape.[4] It is this image of the cape, suggests Olsen, that most effectively symbolizes Superman's sacrifice.

Aside from the cape, the main components of the costume are little more than a second skin, but even in this capacity serves a purpose in combat as aggressively vibrant spectacle. Chambliss and Svitavsky (2008, p. 21) describe Superman's skintight costume in its early depictions as "an approximation of nudity." In *Action Comics* and later *Superman* comics, the costume appeared to have no structure of its own. As Michael Chabon (2008, p. 17) observes, artists drew Superman as an ostensibly nude figure, colored rather than clothed. Later comics and adaptations were forced to consider the costume as a real item of clothing (see Chapter 3). Dru Jeffries (2013, p. 33) notes that in these adaptations the naked "ideal" of superhero masculinity is "paradoxically, more easily attained with . . . thicker costume, upon which musculature can be inscribed." As red and blue color, inked directly onto the drawings of Superman's effectively naked body, the costume can be understood as a kind of "war paint" (Weltzien, 2005, p. 243). Similarities between war paint and the superhero costume are explored in more recent narratives that employ paint as a substitute for costume. In Frank Miller's *Batman: The Dark Knight Returns* (1986), a gang of vigilantes switches allegiance to support Batman, and, in tribute to their new leader, they paint blue bat symbols directly onto the skin of their faces. When they join Batman in combat, these vigilantes are depicted as marauding hordes, not dissimilar to the woad-covered warriors of ancient Britain.

The costume as biography

Chambliss and Svitavsky (2008, p. 21) write that "a superhero's costume externalizes his biography." For Superman, the costume acts as a record of his

alien origin by marking him as Other. Superman's abilities are a consequence of his Kryptonian identity, and he uses these abilities only when dressed as his Kryptonian self. In several ways, the cloth in which he drapes his body is an extension of this aspect of his biography: in *Superman: Secret Origin* #1 (November 2009), Martha Kent is shown constructing Superman's costume from the blankets that traveled with her adopted son in the craft that carried him from Krypton. In this origin story, the costume is an artifact of Superman's personal archaeology, telling of his alien birth, his intergalactic journey, and his adoption by human parents. It contains both alien and human elements, constructed by a human mother from Kryptonian cloth.

The otherness of Superman's costume is displayed in both appearance and functionality, as narratives describe the functional benefits of "extraterrestrial textiles" (Weltzien, 2005, p. 231). Kryptonian fabric is shown to be as strong as Superman's own skin (see *Action Comics Vol. 2* #7, May 2002, and *Superman: Secret Origin* #1, November 2009). Later superhero narratives expanded the notion of the alien costume by depicting ever-more-bizarre capabilities: Green Lantern's protective alien costume can be willed into existence by any worthy wearer of an alien "power ring" (*Green Lantern Vol. 4* #30 and #38) and the symbiotic black costume worn by Spider-Man in *The Amazing Spider-Man* #252 is an alien parasite which can adapt to resemble clothing, human or alien.

Alien identity is expressed centrally by the insignia that Superman wears on his chest. Images of Superman promote his identity primarily through explicit presentation of the crest—an "S" enclosed in a pentangular shield that co-creator Joe Shuster (as cited in De Haven, 2010, p. 64) intended as a "heraldic crest." In Superman paraphernalia, he is most commonly depicted either with his hands on hips, pushing his chest forward, or ripping open his shirt to reveal the costume underneath. Both of these poses draw attention to Superman's iconic insignia. If not read as an "S" monogram, the insignia is variously interpreted as the Kryptonian symbol for "hope" (*Man of Steel*, Snyder, 2013), or, more influentially, the family crest of the House of El (*Superman: The Movie*, Donner, 1978). In both of these interpretations the crest tells us something about Superman's Kryptonian lineage. Peter Coogan (2009, p. 79) proposes that it is the "S" that separates Superman and subsequent superheroes from previous costumes heroes of pulp comics, such as Flash Gordon. It is this insignia which transforms the costume from a simple disguise to a marker of an alternative identity. In displaying his Kryptonian heritage so overtly through this symbol, Superman chooses not to opt for the anonymity of a disguise, but instead to promote his alien identity. "Almost every superhero carries a bodily marking that is similarly expressive of his or her character" (Chabon, 2008, p. 25), whether human, alien, mutant or Other.

Elsewhere, dominant groups tend to impose the classification of "Other" on minorities (Staszak, 2009), however Superman takes ownership of his otherness,

choosing to project it through his costume. Staszak's definition of otherness presents the Other as "devalued," "susceptible to discrimination," and "defined by its faults." "Other," then, is a stigmatized and shameful label for most. It may be the case that the superhero, as a freak or outside, could be stigmatized in this way, but by taking control of his otherness through costume, he asserts pride in his difference. As will be shown in Chapter 12, this is particularly the case for the X-Men, who respond to societal intolerance by proudly displaying their mutant identities in their "X" insignias.

The insignia has become a shorthand for the whole costume, acting as an effective substitute in the real world where it would be inconvenient for fans to dress in the complete costume. The crest has become Superman's brand logo (Morrison, 2011, p. 15), and even in the fictional narrative of Superman comics is explicitly acknowledged as such. In *Superman: Earth One*, a 2010 retelling of the origin story, a flashback reveals a disagreement between Martha and Jonathan Kent regarding the purpose of the costume's S-shield. Martha declares that the "S" should evoke the word "son" in multiple contexts—"you're a son of whatever world sent you here, just as you are a son of Earth, and my son"—but this interpretation is dismissed as "too cute" by her husband. He recalls the words of his cousin, employed in advertising: "you pick a symbol to get across one clear idea. That's all the public has patience for." Instead, he says the symbol should express a singular fact: "you're unique in all the world. Extraordinary. Not just any man . . . and more than just a man . . . a super-man."

To this incarnation of Jonathan Kent, the costume is comparable to branded clothing which similarly project the wearer's values through an emblem or other visible sign of the designer's identity. With this interpretation in mind, *Action Comics* can be seen to have preempted the mid-twentieth-century trend for visibly branded clothing. Small designer emblems began to appear on the outside of sports attire in the first half of the twentieth century (see, for example, Lacoste, a sportswear brand founded in 1933 commonly associated with the prominent display of its crocodile logo in breast pockets), and in this environment a visibly branded shirt would mostly likely have been associated with physical activity (Giambarrase, 2010, pp. 260–261).

Superman the brand

Superman's values are depicted not only in the costume, but what it *omits*—a mask. Though many superheroes disguise their faces, Clark Kent makes a conscious decision to remain unmasked in order to reassure audiences of the integrity of his actions. *Superman: Birthright* #3 (November 2003) acknowledges the potential contradiction in creating two secret identities with the same face. Superman provides justification for refusing his mother's suggestion of a mask,

saying that onlookers will only trust him if they see his face (as will be explored in Chapter 2, the face connotes trustworthiness by revealing one's emotions and intentions, and in Superman's case, it is provides a reassuringly human contrast to his supernatural powers). The desire to keep his face uncovered leaves Superman with the conundrum of how to maintain the anonymity of his alter ego, Clark Kent. The problem is resolved by constructing an elaborate veneer of gestures and idiosyncrasies that acts, much like a mask, to distinguish Clark from Superman.

Even with his face uncovered, Superman is able to maintain the relative anonymity of his alter ego, Clark Kent (see Chapter 5), by dressing in a costume so vibrant that it creates a distraction. In her study of theatrical costume, Monks (2010, p. 23) writes that "self-expressive costume competes with that of the character's for prominence on the stage," and Martha Kent comes to the same conclusion. Despite the efficacy of Clark Kent's affected gestures of insecurity, the fact that his face remains identical to that of Superman is a concern for him and his mother. In *Superman: Earth One* (2010) Martha Kent stresses the importance of distracting onlookers from his face, suggesting that a brightly colored costume might achieve the desired result.

More often, the bright colors are not seen as a simple practical solution to a problem, but as signifying the same openness and honesty of his exposed face. To this extent, Superman's costume is a means of managing public perception. In Helen Walter's (2011) analysis of costume for theatrical performance, she suggests that costume is a means of controlling a relationship with the audience, being "both a barrier whereby the actor could hold himself apart from his character, and a means of facilitating the audience's engagement with the scene." Both the bright colors and the lack of mask invite close engagement, challenging onlookers to scrutinize his actions. For Superman, this transparency is vital in marking himself out as hero rather than villain.

Scott Hughes Myerly (1996, p. 267) observes that brightly colored uniform has connotations of trustworthiness in part because it makes the wearer accountable for his or her actions. A brightly colored costume is so noticeable that its wearer would be unable to commit criminal or dishonest acts without being identified by witnesses. Thus, the voluntary wearing of bright colors signifies honesty of intention. In this brightly colored costume, a set of core heroic values is consistently identified. The Superman brand signifies "respect and justice" (Chambliss and Svitavsky, 2008, p. 20), and "benevolence and altruism" (De Haven, 2010, p. 156). Superman established and continues to maintain these brand values "through seemingly selfless acts of heroism" (Wolf-Meyer, 2006, p.195). His actions came to define the whole superhero genre, and hence ensure the heroic connotations of any similar costume.

These values do shift over time to reflect the evolving values of the society in which he operates (Fingeroth, 2004, p. 160). The shift is expressed in changes

in the costume, most notably in film adaptations. The bright colors that are the hallmark of Superman's costume in the comics are vital in maintaining his status as hero, but the darkening of the costume in recent film adaptations suggests a shift in how the brand is interpreted. As the costume has become darker, as in Zack Snyder's *Man of Steel* (2013), so too has the hero. Superman no longer represents the battle of good versus evil, as he and audiences are increasingly aware that distinctions between good and evil are not clear-cut.

Building on the work of Scott McCloud, Peter Coogan (2009, p. 79) observes that the superhero's costume achieves expression through reduction. Particularly in early depictions, Superman's costume is depicted minimalistically, not to eliminate detail, but to strip the costume down to its most "essential meaning" (McCloud, 1993, p. 30). While other wardrobes may communicate complex and ambiguous messages, Superman's unitard and cape clearly and unambiguously express one set of values.

In the red and blue color scheme, these values are subtly framed as patriotic (Morrison, 2011, p. 15), appropriating universally held ideals for Siegel and Shuster's American audience. Fingeroth (2004, p. 73) argues that, over time, Superman's values have converged with those of the American Dream, even more so than for Captain America (see Chapter 2)—"hard work, fair play, the opportunity to maximize your potential." It is this set of all-American values that made the Superman costume an appropriate choice for pro-Obama imagery leading up to his 2008 election to the presidency. Obama was repeatedly depicted as a superhero in official and unofficial images during his campaign. Most notably, he was featured in a portrait by comic-book artist Alex Ross, entitled *Time for Change* (2008). Ross's Obama is shown striking a Superman pose with his shirt ripped open to reveal an "O" insignia emblazoned on his chest (Nama, 2011, p. 149).

By alignment with Superman, Obama was positioned as a hero-in-waiting: a man who had the potential to save America. This perception was dependent on a near-universal familiarity with Superman's brand values in the American populace, in combination with a willingness to accept Obama as a hero figure. Public knowledge of a brand's values and a willingness to accept them are vital in ensuring the success of any brand. In fashion, there is a two-way relationship between the brand and a consumer, whereby the brand helps to define the consumer, and the consumer helps to define the brand (Pavitt, 2000, 156). When a person wears branded goods, those brand values are transferred, so that he or she appears to project values that are in fact appropriated from elsewhere. These messages are affected by other signals. When many people are seen acting in apparent contradiction to the values of the brand that they wear, a cultural shift may occur whereby the brand values appear to change. A high-fashion brand may appear to lose its exclusivity if it is too frequently seen worn by consumers of low socio-economic status or those who engage in antisocial

behavior, as demonstrated by the unfortunate connotations of drunkenness and hooliganism that the Burberry brand acquired during the 1990s.

Similarly, a superhero's brand values can be rewritten by the consumer or the media, and public perception of the superhero's values can differ from those that he initially intended to convey with his costume. The superhero's mythology is not written solely by the superhero himself, but by those who observe him, particularly when those observers are as influential as psychiatrist Fredric Wertham. Wertham's notoriously influential treatise against comic books, *Seduction of the Innocent* (1954), painted Superman as un-American and a potentially dangerous role model for child readers. Some of the most troubling readings of Superman compare his actions and costume to those of the Ku Klux Klan. Chris Gavaler (2012, p. 192) argues that the "generic formula" of the superhero—"the vigilante hero who assumes a costume and alias"—is borrowed from the behavior of clansman Ben Cameron, whose tale is recorded in Thomas Dixon Jr.'s *The Clansman: An Historical Romance of the Ku Klux Klan* (1905). Cameron is recorded as having a masked alter-ego named the Grand Dragon, who, like Superman, was presented as a "costumed hero with overt, physical and always recognisable presence" (Gavaler, 2012, p. 196). Superman, proposes Gavaler, more closely resembles Grand Dragon, with his consistent and identifiable alter-ego, than previous pulp heroes that are more commonly cited as Siegel and Shuster's main influences, and who tended to be masters of "multiple disguises with no single, representative costumed persona." Moreover he argues that, though many years have passed since the publication of *Action Comics* #1, Superman retains the same principle qualities, and so the remnants of Klan mythology remain embedded in the character. For some audiences, it is difficult to overcome these connotations of white supremacy and vigilante violence. Superman continues to be perceived as representative of violence and aggression. Evidence in support of this interpretation will no doubt continue to appear as children engaged in costumed superhero play are prone to "extreme risk-taking behaviour" that sometimes results in injury (Davies et al., 2007, p. 242).

Resistant to this external pressure, the Superman brand continues to express the core values intended by the character's original creators, and it is these core values or heroism and strength (both physical and moral), that audiences recognize when they don their own Superman branded clothing. The Superman costume is able to transfer heroic values to settings as diverse as children's play, political graphics and even striptease.[5] Wenger (2007) argues for the use of superhero costumes in child therapy, observing that "the superhero's costume functions much like the mother's face . . . associated with positive feelings as well as the promise of hope, rescue, safety and trust." A study by Karen Pine (2014) into the "transitional power of clothing" has found that subjects experienced increased social confidence when wearing a Superman T-shirt. The

same T-shirts made participants believe that they were capable of lifting heavier objects (incidentally, it is this unrealistic belief in their own physical abilities that makes children in superhero costumes more inclined toward risk-taking; Davies et al., 2007).

Several authors assert the benefits of superhero costumes in childhood play, as a source of courage and for the extent to which it promotes moral values. Heather Barnes (2008, p. 18) describes the potential for superhero play to offer children, who would otherwise have very little control over their environment, a sense of being "in charge of their world." Vivian Gussin Paley (2014, p. 13) observes that, for children at play, a Superman costume is a "call to action." An individual wearing this costume cannot stand idly. He or she must act. For some, therefore, the costume is an activating tool.

Figure 1.2 depicts a small boy amidst the military coup d'état that took place in Thailand in 2006. The image bears resemblance to Jeff Widener's celebrated photograph of a protestor who "stood fearless in the face of the creeping war machines" during student protests in Tiananmen Square in 1989 (Smith, 2014). In Widener's photograph, the unnamed protestor's "defiance in the face of aggression" (Pickert, 2014) seemed to tell a David-and-Goliath tale of "the power of ordinary people against oppressive regimes" (Smith, 2014). Widener (2014) describes being moved by the strength exhibited in the unknown man's passive defiance. Here too, a boy's vulnerability contrasts with the military might of the tanks that patrol the streets behind him, and yet he seems unperturbed, as if the Superman costume has imbued him with the strength of a superhero.

The archetype and his imitators

As the prototypical superhero, Superman is responsible for a set of generic costume elements and associated values, and hence for spawning an industry in unbranded, nonspecific superhero imitations. Marvel's postmodern critique on the superhero genre, *Generic Comic Book* (April 1984), features a character known only as "Generic Super-Hero" whose costume bears similarity to that of Superman (Cronin, 2009). The character wears a cape, skintight unitard, and belted trunks on the outside, which he purchases from a tailor who specializes in clothing superheroes.

Mark Leigh and Mike Lepine's *How to be a Superhero* (1990, p. 45), a light-hearted guide to developing a new superhero identity, is not affiliated with any particular superhero or comics publisher, and yet it describes features of costume that can be traced back to Superman. It recommends that costumes are sewn from "muscle . . . enhancing skintight spandex." *The Superhero Starter Kit* (Klutz, 2006), which also makes no explicit reference to any particular superhero, is sold boxed with a crimson cape. Such examples provide evidence

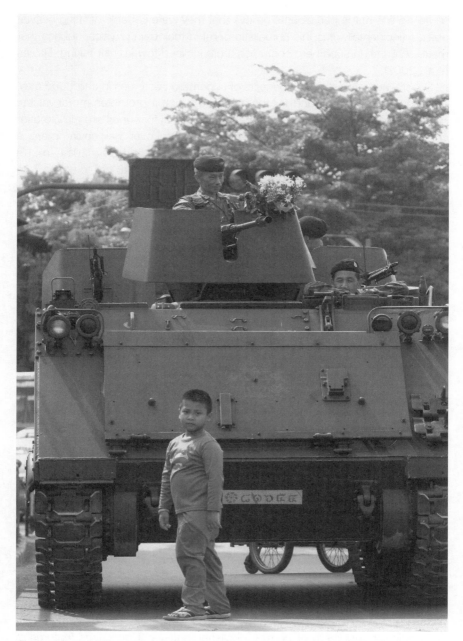

Figure 1.2 A child is seen playing on the street, in spite of the military patrolling the streets of Bangkok, 2006. The young boy's vulnerability, in contrast to the size and might of the tank behind him, is offset by his Superman costume.

© Jimmie Wing/Rex

of Superman's status as codifier of the superhero genre. Those characteristics that define Superman have come to represent the whole genre, and certain costume elements—the unitard and insignia—have become synonymous with the superhero wardrobe. So universally recognized is Superman's costume that the superheroic connotations have supplanted those that came before. Audiences who view a man wearing a unitard and cape no longer read the costume as that of a strongman, but instead assume that it belongs to a superhero.

This codifying status of the costume is very dependent on the success of the Superman brand and its ability to visually and emotionally stimulate its audience. Superman's costumes succeed at inspiring audiences by striking a balance between familiarity and spectacular otherness. As Walter (2011) observes, costumes separate the character from the audience, but must also meet audience expectations. Characters cannot appear too "Other" as their strangeness would render their meaning inaccessible. In order to successfully communicate a set of values, the costume must be reassuringly familiar. Superman achieves this balance of ordinariness and otherness in his two alter egos. The character is represented as strange (a colorful alien) and yet familiar (in the dull-gray suit of his Clark Kent alter ego). This difference between the wardrobes of the superhero and his alter ego is another vital component of the superhero code (and will be explored in more detail in Chapter 5). By adhering, however loosely, to the costuming conventions laid down in *Action Comics* and other early depictions of Superman, further superhero comics were able to express, through costume, the distinction between the superhero and his civilian alter-ego, and the direct relationship between costume and heroic values. These meanings extend beyond fictional representations of superheroes to real-life appropriations of the superhero archetype.

2
IDENTITY, ROLE AND THE MASK

Regardless of whether it covers his face, the superhero costume is a kind of mask, allowing him to masquerade within a constructed identity. Masks enable paradox (Napier, 1986, p. 1). The superhero's two identities, seemingly incompatible, are divided and enabled by costume. The two roles the superhero plays appear contradictory: he is ordinary, and yet extraordinary. By separating these two roles into two different identities, the mask preserves the purity of each.

Jonathan Turner (2013, pp. 331–332) observes that the notion of identity is distinct from the notion of self, as "self is now viewed as a . . . series of identities that can be invoked individually." These are visibly expressed through costume, so as to direct others to verify each identity. In particular, one identity can act as a "filter . . . of selective perception" so that one identity can mask another.

Batman #457 (December 1990) tells its readers that "a masked person is not simply a man or woman whose real identity is hidden, but he is an enigmatic entity standing outside the sphere of ordinary conduct . . . enjoying a freedom of movement and conduct denied to ordinary men." Under the mask, or swathed in costume, the superhero distances himself from his civilian alter-ego, and in so doing establishes expectations that he will behave according to the expectations of the superhero genre. Dress establishes expectations of certain behavior: when an actor is in costume, audiences expect him to play the role to which he has been assigned. When that costume is fantastical, audiences will suspend their disbelief and expect the unexpected. The superhero costume, being so clearly different from everyday dress, prompts the expectation that its wearer will partake in unusual, even paranormal acts. The costume and mask also have more sinister connotations, introducing expectations of immoral behavior. The superhero costume must straddle the fine line between these two poles.

The mask and issues of identity

The function of a costume or mask is to "disguise, protect or transform" (Wilsher, 2007, p. 12). For superheroes, the mask serves all three of these functions. It

transforms the wearer from ordinary civilian to superhero, disguising him in order to protect the identity of his alter ego, and those he cares about. The duality of the superhero's identity is bound up in his costume. His public face, the mask, conceals his private face, hidden underneath.

The origins of the mask lie in religious ritual and theatrical performance. These two uses of masks, sacred and secular, are responsible for transformation of identity in two separate ways. In religious ritual, the person who dons the mask feels himself transformed into a supernatural being—a spirit or deity, whereas in secular performance the transformation occurs in "the imagination of the audience" (Wilsher, 2007, p. 13). The superhero costume holds power because it achieves both transformations. First, it transforms the hero into something beyond human, allowing him to behave instinctively, unrestrained by human weakness or social convention, fully occupying his supernatural identity. Second, in front of an audience, the mask permits superhuman behavior.

Batman comics are overt in their acknowledgment of the power of transformation given by the mask. On the rear cover of the collected *Robin: A Hero Reborn* (1991) appears a quote from the *Encyclopedia of Magic and Superstition*: "The donning of a mask is believed to change a man's identity and faculties, for the assumed appearance is held to affect the wearer's inner nature and to assimilate it to that of the being represented in the mask." The man becomes the mask. Bruce Wayne, in his costume, ceases to be Bruce, and becomes the Bat.

Anthropological studies suggest that the mask may represent two different approaches to identity. The first "assumes the authenticity of the self" (Tseëlon, 2001, p. 25). In such cases, the mask is a lie, concealing the wearer's true identity. In the superhero genre, such an approach would suggest that it is the civilian alter-ego that is the authentic identity. Peter Parker, Bruce Wayne, and Tony Stark are genuine, complete people, and they merely play at being superheroes in their alternative identities.[1] The second approach proposes that the mask presents an aspect of the self. To some extent, "the mask reveals the identity" (South, 2005, p. 95). Identity is complex, and the mask is an "authentic manifestation" of a part of that complex whole (Tseëlon, 2001, p. 25). The mask, therefore, either enables anonymity or clarifies an aspect of self. Parker is both Peter and the Spider; Wayne is both Bruce and the Bat: a hybrid identity, and at any one time they perform only a part of their complex selves (Langley, 2012, p. 19).

Peter Brook (1987, p. 231, as cited in Tseëlon, 2001) argues that these two motivations for wearing a mask may be connected. By providing anonymity, the mask "provides a hiding space," and this, in turn, "makes it unnecessary for [the superhero] to hide." In costume, he is safe to reveal parts of his identity that must otherwise be repressed. "Because there is greater security, [he or she] can take greater risks." These risks reflect the inner desires of the superhero to preserve his or her particular set of values, and so enable a hidden part of him or herself

to appear. The parts of the hybrid identity that are revealed in the superhero are those that are unconventional, and so need to be concealed in everyday environments. In the mask, the superhero can release his repressed anxieties and desires, and act as his uninhibited instincts dictate.

For any individual, "there is a continuous construction of self" (Schöpflin, 2010, p.1). All humans present a public face: acts of identity construction occur in every choice of garment, as wearers select their clothes to reflect the way they hope to be received by others. Much of this identity construction occurs subconsciously, but for superheroes, the public persona is a deliberately and carefully constructed alternative identity. The superhero's wearing of a costume is a consequence of the extreme duality of his or her identity. While most of us must only differentiate between different roles (personal and professional), superheroes grapple with two entirely distinct identities which must never be seen to coincide. The superhero costume must be far removed from the civilian clothing of the alter ego, and both must be carefully designed to ensure that there is no risk of overlap.

The identity of the mask

Many masks may present a likeness of a real person, and so represent a complete identity. Masks modeled on celebrities or politicians worn in mockery or protest, theatrical costumes representing real or fictional characters, or animal costumes worn by children at play, all represent a subject who is distinct from the wearer of the mask. That subject exists independently of the mask. He leads a complete life (real or fictional), and the mask is merely a copy or representation. Even in such cases when the mask is abstract, or the image of the subject poorly reproduced, the identity that it imitates is itself whole.

In contrast, superhero masks do not represent something beyond the superheroes who wear them. Daredevil's costume may connote "devil," but he does not wear it so that people will believe he is a real demon any more than the Flash expects people to confuse him with a flash of lightning. Spider-Man's costume creates associations with spiders, but does not represent the spider identity, just as Batman's costume resembles a bat, but Batman does not attempt to carry himself off as a real, giant bat. The superhero identity does not exist independently of the costume. In many ways, the costume *is* the superhero. This is evidenced in particular with costumes that change hands, leading to a superhero identity that is shared between several wearers of the costume. Batgirl had several alter egos: Betty Kane, Barbara Gordon, Stephanie Brown, Helena Bertinelli, and Cassandra Cain. Each of these women has a legitimate claim to the Batgirl identity, but it exists independently of any of them. It may be true that Tony Stark is the public face of Iron Man, and that he feels no need to hide his alternative

identity, but Iron Man's powers do not belong to Stark. It is the suit that is capable of super-powers, and that enables the character's acts of super-heroism.

If the superhero identity does not exist beyond the costume, it would seem reasonable to design the costume as a complete identity. Surely the most effective way to conceal the secret identity of the wearer would be to design a costume that gives the impression of something whole; to appear to leave no unanswered questions. However, superhero costumes and masks are intentionally reductionist. Like ritual masks, they are without emotion. Moreover, they are designed to be plain; often a single color with few, if any, markings. Even if a superhero's mask is connected to a constructed identity (Batman, Spider-Man, Daredevil) it is expressly an incomplete identity. As such, it is overtly a disguise.

Napier (1986, p. 9) observes that it is this sense of an incomplete identity that drives audiences to seek out the secret alternative identity hidden underneath. The mask is "known to have no inside" and this "invit[es] the audience to peer behind the mask" (Jones, 1971, as cited in ibid.). The observer knows that the mask is only surface decoration; superficial, and not representative of a complete identity. This inevitably creates the impression that there is more to be discovered, and encourages the urge to solve that mystery. Unlike the everyday civilian clothes of the alter ego, that appears to represent a complete identity, the pointedly reductionist superhero costume provokes questions. It is actively and overtly a disguise, implying that there is something significant and interesting to discover underneath.

It is the fact that it is incomplete that makes superheroes vulnerable to discovery. While no one questions or challenges the identities of Peter Parker or Bruce Wayne, they do go to great lengths to try to unmask Spider-Man and Batman, as when, for example, Professor Smythe sets hidden cameras, with the aim of capturing video of Spider-Man without his mask (*Amazing Spider-Man* #105, February 1972).

As if in acknowledgment that a superhero's mask never represents a complete identity, Steve Ditko (co-creator of Spider-Man), developed first Mr. A (1967) and then, The Question (1967), two superheroes whose costumes were intentionally without identity. Mr. A and The Question were efforts to present a superhero as objective, able to fight crime without the errors and limitations that result from the subjectivity of a single identity. Mr. A is depicted wearing a blank, expressionless face, while The Question is entirely without a face. The Question's mask is a skin-like material glued directly to his face, covering his features but offering no replacement. In the mask, The Question has no eyes with which to express his emotions, and no other identifying facial features. These empty masks are worn to erase the identity of the alter ego without transformation into someone or something else.

Even when there is initially separation of the two identities of the superhero, there is, over time, erosion of the distinction between the two. "Every mask

leaves an impression on the person who wears it" (Morris, 2005, p. 420). For some, this may happen as soon as the superhero identity is introduced. Steve Rogers is permanently transformed into Captain America. He retains the name, Rogers, and rarely makes an effort to conceal his true identity, but his "costume all but eliminates any other identity he might have" (Moser, 2009, p. 29). Where the secrecy of the alternative identity remains intact, the identity crisis will inevitably form a vital part of the superhero narrative. The civilian alter-ego must resist the urge to behave like the superhero, and must constantly remind himself of the separation of his two identities.

Power, authority and the privileged few

In religious and ritual use, masks provide "recognition of power and authority" (Bedeian, 2008, p. 6). Only a privileged few are permitted to wear certain masks, and so they come to signify special status in a society. In historical societies, and in some African societies still, masks are among the objects that play "an integral part of the way in which leaders project their authority . . . The respected elder who advises the community, the revered chief or the divine king with his host of gods and ancestors, all make use of [masks] to represent their power and authority." For superheroes too, the costume asserts power. It declares the dominance of the wearer over others, and declares status at the top, or even above, human social hierarchy.

This dominance is asserted not only through the act of wearing the mask, but also through the physical features of the costume. The costume often makes the superhero appear larger—physically dominant. If male, the costume emphasizes or accentuates his muscles, and thereby, his masculinity. It adds bulk, increases height, and reinforces the physical power of the superhero. Grant Morrison and Mark Millar's *Aztek: The Ultimate Man* (1996–1997) wears a magical suit that is not only responsible for his super-powers, but also makes the character look much larger than the average man. His crown-like helmet and heavy armor extend his physical presence so that his physical strength is immediately evident. In *Kingdom Come* #2 (August 1996) Bruce Wayne has become so old and frail that he is unable to adopt the Batman identity without relying on the suit for physical support. It is only with the bulk of his armored costume that is able to continue to appear physically imposing, and to retain the strength of his superhero alter-ego. In both these cases, the costume is responsible for enabling and expressing the abilities of the superhero. As with other aspects of identity construction, this is not unique to the superhero costume. "Power dressing" in real human society involves choosing garments that make the wearer appear dominant, and therefore more successful. Shoulder pads, for example, add bulk and assert masculinity as well as physical dominance, which, in the boardroom, can connote professional dominance.

The mask, and hence the power that it brings, may be wielded by only a privileged few. "As is often the case mask wearers and mask makers belong to secret societies where only the initiates are privy to their mystery and magic. They are kept hidden from view so as not to lessen their dramatic impact during the ritual performances" (Bedeian, 2008, p. 2). Those who are permitted to retain their dominance, do so in part by retaining exclusive rights to wearing the mask. Superheroes are themselves secretive, exclusive. They will not share their powers, their knowledge, or their identities with the masses. They are either solitary or operate within a small, select group. The mask enables them to remain secretive, and hence preserves and enhances their power. In the Silver Age, members of the Justice League keep the identities of their alter egos secret even from one another. So vital is the privacy of their alternative lives, that at first they address one another only by their superhero names, and meet only in costume (see, for example, *Justice League of America* #41, December 1965).

Those who are entitled to wear the mask must prove their worth. They must demonstrate "accumulated wisdom" or special abilities that separate them from the rest of society (Bedeian, 2008, p. 2). The donning of the mask is a rite of passage (Napier, 1986, p. xxiii) that signifies the transition from ordinary to extraordinary, as a civilian becomes a superhero. In superhero origin stories, the introduction of the costume marks the superhero's adoption of a new role: the moment that he becomes a superhero. Often, this occurs as a consequence of (or in preparation for) a defining event in his story so far. The first time that he steps into the costume marks initiation into an exclusive role, and completes the hero's transition from one of the ordinary masses, to one of the extraordinary few.

Those villains who frequently clamor to reveal a superhero's true identity do so because they understand the power provided by the mask. By removing it, they seek to reduce this power. The *Batman* television series (1966–1968) is littered with examples of colorful villains whose ultimate aim is to unmask the titular hero. In "The Contaminated Cowl" (season 2, episode 35), the Mad Hatter makes an attempt to steal Batman's cowl, not only to expand his collection of unique headwear, but also because he believes that it will remove Batman as a threat to his ongoing criminal enterprises.

The ability of the mask to preserve the mythical power of the superhero is a concern for Batman's nemesis, the Joker. In "The Laughing Fish" (*Detective Comics* #476, March 1978), Joker confronts Rupert Thorne, a corrupt Gotham politician. "I know you bid for the Batman's identity . . . I don't want that secret penetrated—ever." Thorne is taken aback by the Joker's apparent desire to protect his sworn enemy, not understanding the thrill that the Joker takes from his continuing obsession with the Bat. To reveal the identity of the masked hero would bring an end to the Joker's *raison d'étre*. The Joker views himself as "the greatest criminal ever known." The Batman, he believes, is his only worthy

nemesis. To unmask Batman would be to reduce him to the status of "mere policeman," making him an unworthy opponent.

More recent interactions between Batman and the Joker continue in the same vein. *Arkham Asylum* (1989) depicts Batman entering Gotham's notorious asylum to confront the Joker. The Joker's fellow inmates call for Batman's costume to be ripped from his body:

> "I say take off the mask," "I want to see his *real* face."
> The Joker retorts, "That *is* his real face."

The Joker understands that when Wayne dons the mask, he ceases to be Bruce and adopts the identity of the Bat. In his view, it would be pointless to reveal Wayne's face, as to confront him would not be the same as confronting Batman. Joker seeks to understand Batman, to explore the deepest recesses of his mind. He wants to subject him to the same prying enquiry that he has suffered at the hands of psychiatrists in the asylum. The Joker can only learn about Batman, and communicate with him on what he believes to be equal footing, when he is costumed.

The Joker appreciates something vital about Batman's mask: firstly, that it is the mask that gives Batman his power, and raises him above other civilian crime-fighters; secondly, that to remove the mask would be to humble Batman. Without the mask, he would be real, ordinary, and his mythical status would be lost.

Face-ism

Numerous cultural practices reveal that "humans predominantly recognize and differentiate others by the face" (Kövecses and Koller, 2006, p. 10). Passport photographs, portraits, and other images related to personal identity, tend to feature the face. An individual's identity is bound up in his or her face more so than any other body part (Napier, 1986, p. 3). With many superheroes, this is not the case. The face is covered by a mask, preserving the anonymity of the superhero's everyday identity, while the costume that covers the rest of the body bears most of the signifying characteristics of the particular superhero. In many cases, the superhero brand is emblazoned on the chest. In donning the costume, the superhero transfers his or her identity from the face to the body.

Marvel's Daredevil wears a simple red mask with few defining features other than the red color and two small protrusions to suggest horns. This mask affords anonymity to Daredevil's alter ego, Matt Murdock. But rather than opt for total anonymity, Daredevil displays the initials "DD" as a monogram on his chest. Initials, like the face, are frequently used to signify an individual's identity. This monogram therefore replaces the face in providing Murdock/Daredevil with an

identity. Daredevil has a particular motivation for wanting his identity to be communicated via his body rather than his face, as Murdock's weakness, his blindness, is a flaw that is entirely contained within his head. In his case, this transference of identity from face to body has the added advantage of detracting attention from the weakness of his eyes to the strength of his body.

When identity favors the body over the face, there is a tendency for audiences to perceive physical characteristics over emotional and intellectual aspects of identity (Butler et al., 2003, p.72). When, as in a passport photo, the face occupies most of the image, the viewer is drawn to consider the subject's personality. Images with a lower face-ism ratio, in which the body occupies a larger part of the image, tend to focus the viewer's attention on physical aspects of the subject. A superhero costume which communicates identity through the body more than the face therefore prompts audiences to perceive a being of physical power rather than of intellect. In this respect, the superhero in costume seems more suited to acts of physical prowess, and the everyday identity of the alter ego is more commonly associated with acts of emotion or intelligence.

The Batman, like Daredevil, wears a plain mask, but displays a distinct insignia on his chest. When he dons the costume, Bruce Wayne ceases to be "a face"—a celebrity billionaire whose face appears on the covers of magazines—and becomes a body—the Bat. In costume, the Batman undertakes acts of violence and heroism. He is a physical force to be reckoned with. Out of costume, Bruce Wayne yields another kind of power—an intellectual power—in his role as a captain of industry. When his identity is transferred from face to body so too is his power, from the intellectual to the physical. Even Peter Parker, whose mask has a distinct identity, is a more physical being when dressed in his costume. As Peter, his concerns are emotional and intellectual (family, friends, relationships), but as Spider-Man he is devoted to his physicality.

How dress defines role

In constructing their identities, superheroes "call forth in themselves expectations about how they are to behave" (Turner, 2013, p. 332). Any costume, as it is associated with a particular role, is accompanied by a set of unwritten rules dictating how the wearer must act. Through clothing, all humans communicate expectations about their actions and abilities (Stone, 1981, p. 142). "Dress is part of the expectations for behaviour that define a person's role within the social structure. Thus, dress . . . helps to define an individual's role within society" (Miller et al., 1991, p. 807). The relationship between dress and behavior is so commonly understood that people will modify their behavior to suit their clothes.

All humans play a number of different roles in their lifetime, and the transition from one role to another is marked by costume. A worker will change into casual

clothing in the evening or at the weekend to signify that he or she no longer expects to engage in work. The two roles that this individual plays, marking home life apart from professional role, are distinct, and the clothes that signify each role can never be exchanged without unwanted connotations. For superheroes, the difference between the two roles is more marked. The appearance of a costumed character immediately prompts the expectation of spectacular action, and anything less would be a disappointment. Conversely, civilian clothing establishes the expectation of civilian behavior. Out of costume, the superhero's alter-ego is rarely, if ever, expected to engage in acts of super-heroism.

"The characteristic of a costume that differentiates it from all other forms of apparel is its open proclamation of departures in behaviour . . . costume announces that the wearer is stepping out of character and into a new constellation of imagery or unusual social relationships" (Joseph, 1986, p. 184). Mere mortals may communicate adherence to a social contract through their clothes, or, if the clothes are rebellious, departure from those norms. Superheroes take this departure to the extreme. Their clothes are so unlike anything that ordinary people wear that the costume comes with the expectation of behavior that is equally extraordinary. Everything about him is different: his costume, and therefore his abilities, responsibilities, and identity.

In *The Amazing Spider-Man* (Marc Webb, 2012), Spider-Man is shown rescuing a boy from a car that is about to be engulfed in flames and fall into the Hudson River. Spider-Man is forced to use all his strength to prevent the car from falling, and is therefore unable to reach the boy trapped inside. Instead, he commands the boy to put on his mask, saying "it will make you strong." Having put on the Spider-Man mask, the boy finds enough strength to clamber out of the car, and is rescued. Spider-Man and the young boy share an understanding that the mask creates an expectation of certain powers and responsibility. This expectation is so powerful that the mask appears to enable acts that might otherwise seem impossible.

The precise details of every superhero costume establish expectations on two levels. First, they mark the wearer out as a superhero, and so establish the expectation of supernatural and heroic behavior. Secondly, they set one superhero apart from another, hinting at how his actions will differ from those of other superheroes. In this way, the qualities of the costume also generate expectations about the tone of the wider narrative. "Batman's dark, bat-like costume . . . suggests Batman's mode of operation: stealth, concealment, surprise" (Reynolds, 1992, p. 26). It tells audiences that Batman's story will be much more somber than that of the bright and colorful Superman.

The superhero costume does more than simply establish role; it establishes responsibility. In costume, the superhero has no choice but to engage in acts of heroism. A costumed hero can never stand idly by as a disaster or crime occurs. In donning the costume, he tells onlookers and audiences that he is extraordinary,

and so anything less than extraordinary action would seem out-of-character. To this extent, the superhero costume acts like a uniform. Any human in uniform takes on the responsibilities associated with a role. A doctor, in his white coat, *must* come to the aid of a wounded man; a soldier in his military greens *must* run to the rescue of his injured ally. In both these cases, any man in civilian clothing would not be subject to such expectations.

Simultaneously, the costume permits behavior that may otherwise be unacceptable, providing merit or justification for the wearer's actions. A man carrying a gun on the street may be assumed to be dangerous, unless he is dressed in military or police uniform, in which case the weapon is excused. Two men engaged in a brawl on the street may both be assumed to be hooligans unless one wears the uniform of a security guard, in which case we assume that the uniformed man is on the right side of the law. Likewise, the superhero's costume excuses behavior that might otherwise seem suspect. It is a license to act outside the law, to resort to violence instead of compromise. Thanks to the apparently inextricable link between the superhero costume and positive values that was established in early Superman comics, the superhero costume marks the wearer out as on the side of good, regardless of whether his actions might otherwise be suspect. A mask, tights, and cape tell audiences that, however violent the acts of the superhero may be, they are for the preservation of a set of values in which we all believe. These ideals are virtuous, even if the reinforcing behavior is not. For playwright W. B. Yeats (1972, p. 151, as cited in Tseëlon, 2001, p. 25), the mask permits "active virtue," as opposed to the "passive" virtue of others. The costume allows superheroes to actively enforce their values while others rarely do more than passively accept a moral code.

There are many cases in which the superhero costume narrows the range of acceptable behaviors. The costume simplifies responsibilities by discarding ordinary expectations. In costume, the superhero is not expected to go about everyday life. The everyday responsibilities of ordinary civilians are removed, freeing the super*human* to act only as a super*hero*. The costume thereby "provides an avenue for selective personification" (Napier, 1986, p. xxiii).

Selective presentation of few, but not all, aspects of self, allows the superhero to select only those parts of himself that he deems suitable for the super alter-ego, and those that suit the role he wishes to play. If, for his public persona, he wishes to cast off the perceived flaws of his civilian alter-ego, he may do so. The costume can thereby enable "an explicit denial of personality" (Napier, 1986, p. 16). The weaknesses of the everyday alter-ego appear to disappear with the donning of the costume. They are set-aside, or at the very least, repressed, in order to prioritize the strength of the superhero alter-ego.

The superhero is responsible for selecting a series of restrictions or rules that govern the actions of his costumed self. To this extent, it is similar to the experiences of individuals who dress-up for play. Fron et al. (2004) argue that

costumed play is, to some extent, "ludic"—restricted by rules. Each identity the superhero inhabits, as expressed through costume, has a different set of rules according to which the superhero must act. The pleasure of dressing up comes partly in the pleasure of acting according to a different set of rules. For example, a child may enjoy dressing up as a robot because it changes the rules that govern his patterns of speech and movement. Consequently, "dressing-up" may be seen as both liberating and restricting. It liberates the wearer from the ordinary rules by which he lives, but imposes another set in their place. This offers the wearer difference, and escape, but within restricted boundaries.

This set of rules is defined within the narrative by the fictional superhero, and externally by the superhero genre and its audiences. Over time, the rules work to establish a connection between values and costume. In the fictional world of the superhero narrative, "the meaning of the garment may be said to be a product of the wearer's intentions" (Barnard, 1996, p. 72). The superhero and the costume designer are often one and the same, it is the superhero who is responsible for establishing the meaning of his costume. He designs the costume to create certain connotations, and then, by his first acts in costume, establishes expectations about future behavior.

All too often, however, the superhero's intentions backfire, and audiences begin to develop their own interpretation of the superhero's role, and of what his costume represents. Designers are never entirely responsible for the messages communicated through their designs. "Alternative meanings" emerge, which costume "designers had not intended" (Barnard, 1996, p. 73). In *Tales of Suspense* #40 (April 1963), Tony Stark is informed that his "terrifying [Iron Man] costume . . . frightens people," and he is prompted to recolor the suit to more accurately express his heroic values (see Chapter 11). Spider-Man frequently finds himself branded by the media as a menace (*Amazing Spider-Man* #1, March 1963), and his costume adopts connotations that do not align with Peter Parker's heroic intentions. In *Ultimate Spider-Man* #7 (May 2001), Spider-Man grapples with the monstrous Green Goblin, attracting the attention of a police helicopter. Faced with the apparent otherness of both combatants, the NYPD fail to distinguish between the heroic deeds of Spider-Man, and the wanton destruction carried out by the Green Goblin, whose appearance is equally flamboyant. They open fire on both parties.

The deceit of the masquerade

By donning a costume, the superhero exposes himself to possible misinterpretation. Costumes and masks so frequently indicate criminal or deceptive behavior that the superhero risks being associated with unsavory acts. Commonly, people who wear a mask to protect their identity are usually people

who are undertaking villainous or morally questionable acts. For example, bank robbers wear masks, as do the Klu Klux Klan. In the revisionist *Superman: Earth One* (2010), Martha Kent highlights this issue. In conversation with Clark, Martha explains why she would never include a mask as part of her son's Superman costume:

> Martha: You can't ever wear a mask.
> Clark: Why not?
> Martha: When people see what you can do, when they see how powerful you are, they're going to be terrified. A mask would only add to that . . . They'll need to see your face to see there's no evil in it.

Martha Kent recognizes the associations between moral ambiguity and the mask. Even those who are on the right side of the law are usually partaking in violent or questionable acts when they wear a mask. The SAS wear balaclavas to conceal their identity. Although they work for the government, the public know that they have been called in for unsavory activities. Their job usually involves violence, and occasionally involves killing. These characters, although they can be on the right side of the law, are often above it, utilizing questionable methods that would commonly land ordinary citizens in jail.

Costume overtly conceals part of an identity, appearing to place a real and complete identity with one that is false or incomplete (Miller et al., 1991, p. 808). The mask provides a "shield from one's own morality," as well as from expectations that he will adhere to a social contract. It becomes a vital tool in deindividuation, by "removing personal identification" and consequently also removing "personal responsibility" (Tseëlon, 2001, p. 31). In the notorious masquerade balls of the eighteenth century, the mask enabled escape from moral integrity (Castle, 1986, p. 2). For children in Halloween costume, it absolves them of responsibility for their acts of vandalism. For superheroes, it allows them to cast aside doubts about the morality of their behavior, and behave as they would never dare in their civilian clothes. In *Daredevil Vol. 2* #2 (1998) Daredevil attacks a mugger in his civilian suit, and is himself mistaken for a mugger by a trio of onlookers. When he realizes his mistake, he is forced to flee. Without his costume, he is incapable of defending his violent actions. The immorality of his violence is recognized, by himself and his onlookers, when they are not shrouded in the unquestionable decency implied by the costume.

The mere act of wearing a mask may itself be considered morally questionable, as it is a deception of sorts. The "mask has come to connote something disingenuous, something false" (Napier, 1986, p. xxiii). The mask is, ultimately, a lie. The word "mask" "suggest[s] concealment or deceit, either of the face or person, or of emotions or intentions" (Wilsher, 2007, p. 12). As a disguise, worn with the aim of providing anonymity to the wearer, the mask suggests a "sinister

dimension" (Morris, 2005, p. 255). "From medieval times onward, the prevalent interpretation of the mask focuses on its role as an evil disguise" (Napier, 1986, p. 9). It has historically been believed that, in masquerade, individuals "risk identification with the devil" (ibid., p. 15). With his name and the design of his costume, Daredevil overtly exploits this connotation. His costume is entirely red, with a horned mask and demonic red lenses, taking inspiration from the costume once worn by his father, an aging boxer nicknamed The Devil (*Daredevil: The Man Without Fear* #4, January 1994).

Daredevil wears his demon disguise despite acting on the side of good, not evil. The title page of *Daredevil Vol. 2* #1 (December 1998) depicts the character surrounded by doves, a traditional symbol of goodwill, symbolizing affiliation with justice and virtue. Issue 5 of the same series shows him aiding an injured nun. His costume therefore appears, at first glance, to present a contradiction. It seems to establish the expectation that Daredevil will resort to evil acts. However, it is the case in ritual, including common festival practise such as Halloween, that demon masks are used to ward off evil rather than invoke it; "to provide protection from unseen evil" (Bedeian, 2008, p. 2).

Despite the numerous negative connotations of the mask, superheroes are able to "justify the deceptions . . . necessary to create and preserve their secret identities" (Morris, 2005, p. 255). "The deceptions that superheroes have to engage in to create and preserve their secret identities are . . . typically morally justified . . . in so far as they are reasonably judged necessary to protect innocent people from harm" (ibid., p. 256). True, the costume permits morally questionable acts of violence and deception, but it also protects innocent civilians. Those civilians closest to the superhero or his alter ego do not share his strengths and are unable to defend themselves as he does. The superhero's most reliable method of protection for those civilians is to keep his attachment to them a secret. Arguably, it is by necessity, not choice, that the superhero resorts to wearing a mask. He may be aware of its negative connotations, but is willing to risk misinterpretation in order to preserve the safety of the people he loves.

3
EVOLUTION AND ADAPTATION: FORM VERSUS FUNCTION

We have entered a "post-truth era" in which "believability" outranks genuine truth, and in which realism is more desirable than reality (Keyes, 2004; Boorstin, 1962, p. 226). Credibility is important, even in the fantastical. As superheroes are reincarnated time and again, in the comic-book medium as well as in film and television adaptations, various methods have been employed to evolve and adapt the costume into a more credible object. The desire for realism in cinema adaptations has transformed the costume from a collection of graphical forms to a wearable garment, Golden Age comics presented the costume as form— whose only function was to visually signify super-heroism. As the genre has developed, and audience's tastes have transformed, costumes have evolved to prioritize function over form.

Attempts to render superhero costumes more believable can directly conflict with demands for fidelity to source material, and so a number of opposing strategies have developed to satisfy the contradictory desires of different audiences. Some artifacts aim to justify the costume in its original form by offering feasible explanations for its absurdity, others have pursued believability by presenting costumes motivated by necessity. Revisionist origin stories and film adaptations have re-presented the superhero costume as technologically motivated assemblages. Meanwhile, in efforts to inject realism into even the most lurid costume, hyperreal textures have begun to appear on the pages of comics.

"Sucked into silliness"

Superheroes are immediately identified as extraordinary by their costumes. These costumes are, in contrast to the civilian clothing of their alter ego, colorful, bold, figure-hugging, and often seemingly impractical. At first glance, they may

appear ludicrous, but their origins reveal aspects of these costumes to be both necessary and plausible.

The superhero costume emphasizes otherness, and cannot resemble everyday dress. The most immediate impression of a person's identity is conveyed through his appearance, and so a superhero's costume cannot express the mundane. The superhero is, after all, "super." He is capable of extraordinary feats, and so his costume must be equally extraordinary. It is, therefore, the responsibility of the comic-book creator to assert the unique abilities of a superhero by dressing him in a costume which may be, by some accounts, bizarre, "fanciful," "surreal," or "ludicrous" (Donovan, 2012, p. 115; Bullock, 2006; Singer, 2012, p. 28). Michael Chabon observes that alongside Bruce Wayne's tuxedo, or Clark Kent's workwear, the skintight Lycra of their costumes is "preposterous" (Chabon, 2008, p. 18). The outrageous design of many superhero costumes, he argues, particularly in television adaptations, is evidence that they have been "sucked into silliness" (ibid.). Colorful, skintight costumes have no doubt contributed to the impression of the superhero genre as "puerile" (Julian, 2012).

Chabon notes that superhero costumes are not only ridiculous in their fictional settings, but also never successfully translate to reality. Any attempt to accurately replicate a superhero costume, for adaptation to film or television, or for cosplay, inevitably result in failure. "If transposed into the real world, the iconography would simply buckle under the weight of its own absurdity" (Wolf-Meyer, 2006, p. 187). Indeed, "even the most splendid of these [costume adaptations] is at best a disappointment. Every seam, every cobweb strand of duct-tape gum, every laddered fishnet or visible ridge of underpants elastic . . . acts to spoil . . . an illusion." These harsh realities draw attention to the fact that the costumes are as fantastical as the superheroes who wear them. The fabric displays properties that are impossible to emulate with real materials. "Like the being who wears it, the superhero costume is, by definition, an impossible object" (Chabon, 2008, p. 17).

So impractical, and so far removed from reality, are these superhero costumes, that Chabon suggests it would be a mistake to view the superhero costumes depicted in comics as blueprints for real garments. The panels of a comic are not comparable to a fashion illustration. These illustrations are not intended to provide guidelines for the manufacture of these designs using real methods and materials. They are, Chabon observes, colors and lines on a page, not "fabric, foam rubber or adamantium" (Chabon, 2008, p. 17). They are, ultimately, only graphical.

When we consider superhero costumes as graphics, not as fashion designs, they become more appropriate. In the paradigm of graphical signs, their bright colors and bold contours are not striking. If anything, these features are commonplace. As necessitated by printing methods of the 1930s and 1940s, at the time of the origin of Superman and his peers, the comic-book medium is one

of block colors and black outlines. When presented alongside other graphical forms, including the typography that emblazons the covers of *Action* and *Detective Comics*, the collection of block colors and outlines that form superhero costumes do not seem so out-of-place.

Real-life references: The historical and the sporting

Superheroes are only impressive if they are presented in contrast to reality. They appear alongside ordinary human characters so as to emphasize their difference. Difference to the human parents, girlfriend, or employer, and the ordinariness of his alter ego, serve to reinforce how spectacular the superhero is. It is only by grounding the superhero in reality that audiences can relate to his alter ego, while being simultaneously stunned by his awesome powers. Although it may appear as unusual as the superhero himself, the costume actually contributes to this impression of reality through reference to real-life costume.

For superheroes, "hyperbolic myths of origin have . . . served to lend a paradoxical plausibility to the biographies of heroes" (Chabon, 2008, p. 14). The role of the origin story is often to "naturalize unnatural abilities," thereby bringing the superhero character "closer to the actual world the reader lives in [sic]" (Fehrle, 2011, pp. 218–219). The costume plays an important role in this naturalization process, connecting the supernatural to the everyday, and thereby establishing a kind of plausibility. Numerous superhero costumes have historical origins, including, for example, the ancient accessories plundered by Hawkman in the guise of his archaeologist alter-ego, Carter Hall. By incorporating elements of historical or theatrical costume, or otherwise explaining the costume, it is possible to introduce some plausibility to characters that are otherwise too fantastical for suspension of disbelief.

The story of Marvel Comics' Thor is a direct reimagining of a Norse myth. Although even in its pre-comic-book form, Thor is a mythical rather than historical figure, this ancient mythology has become so engrained in cultural history that reference to the myth lends credence to every aspect of the comic-book character and his story. Elements of Thor's costume resemble parts of ancient Norse armor. His cape, winged helmet, and protective wristbands have been frequently depicted in romantic interpretations of Viking armor (Richards, 2005, p. 120). Thor's costume suggests a real-life heritage, grounded in an ancient world and, notably, a time in which myth and reality were intertwined. In tales from the ancient world—China, Scandinavia, and Greece in particular—there is often no clear distinction between myth and legend. Fact, fiction and fantasy exist on a continuum and it is only in historical hindsight that we try to distinguish

one from another. Tales of Greek and Norse gods are told as if they were as real as the tales of kings and queens of the time, and demigods are recorded as having played roles in historical events (Achilles at the siege of Troy, for example). Any reference to these particular histories helps to justify the blend of fantasy and reality that is encountered in comic books.

There are also contemporary visual references that contribute to the plausibility of the superhero costume. The circus strongman inspired elements of Superman's costume (see Chapter 1); Robin's skimpy costume is excused by Dick Grayson's origin story, in which readers are told the tale of his late family, a troupe of trapeze artists (*Detective Comics* #38, April 1940); Spider-Man's suit was initially developed in imitation of wrestling costumes (*Amazing Fantasy* #15, August 1962). Connotations of athleticism and physical performance have been reinforced, perhaps even strengthened, as sportswear has come to resemble superhero costumes increasingly over the past few decades. The invention of artificial fabrics including Lycra (or "spandex") have enabled clothing that "cut[s] down resistance and drag through air and water" (Karaminas, 2009, p. 184), enhancing human athletic performance and causing the appearance of sportswear to converge with that of superhero costumes. Some twentieth-century innovations in fabric were so advanced that they have enabled ordinary people to behave as superhumans; to withstand the extreme temperatures and conditions that exist in some of the most severe locations on earth and in space.

The Olympic Games have exposed an audience of billions to uniforms that are startlingly similar to superhero costumes. Contemporary Olympians' clothes are skintight, to aid performance, and brightly colored, usually presenting colors from the flag of a contender's home nation. Cyclists and triathlon competitors wear unitards, many divided into large areas of primary colors, reminiscent of the areas of block color in Golden Era comic books. Though not superheroes, these athletes are extraordinary. Many are world-record holders, and all display awesome strength and stamina that are way beyond what people would encounter in their everyday lives. Indeed, promotional materials for the 2012 London Paralympics explicitly branded competitors as "superhumans" (Channel 4, 2012). Exposure to the sight of colorful and skintight costume serves to reinforce the believability of similar costumes in fictional settings. The continuing manufacture of activewear in this style helps to reaffirm audiences' appreciation of superhero costumes as practical rather than fantastical; "suitable for high-level action" and feats of spectacular strength or agility (Karaminas, 2009, p. 184).

Technology and utility

Conscious that audiences may struggle to immerse themselves in a fantasy that is not grounded in reality, writers of comic books and their adaptations have

sought to explain superhero costumes. They have employed origin stories, tales of technological discoveries, and functional necessity, to justify elements of the costume. Oliver Queen, stranded on an island in Jack Kirby's *Adventure Comics* #256 (January 1959) provides a utilitarian explanation for his Green Arrow costume, telling readers that "to camouflage myself [sic] while hunting small game, I covered myself with a green leaf suit." Revisions of this hero's origin story are similarly explicit in justifying Green Arrow's attire. *Green Arrow Year One* #2 (September 2007), retells the tale of Oliver Queen's island adventures, in which he develops the central components of his Green Arrow identity. On this occasion, his hood is a "hunk of sail canvas," refashioned as a makeshift shroud, "just to keep the sun off." Presenting Green Arrow's green hood and costume as a functional necessity, its extraordinary design can be presented as incidental rather than intentional.

Visual and verbal explanations increase the apparent feasibility of a costume by locating them in the context of scientific and technological discovery. Panels in *Tales to Astonish* #35 (September 1962) devote space to explanatory notes when the dialog or narrative mentions aspects of Ant Man's costume. The "closely woven steel" of his costume is explained in scientific terms, as "consisting of unstable molecules which stretch and contract." These fictional explanations are interspersed with facts, denying the reader any visible distinction between fantasy and reality. That the costume's creator is a scientist, Dr. Henry "Hank" Pym, adds weight to the apparent feasibility of his achievements. Such explanations do not permit magical or alien readings of extraordinary costumes; rather, they ground the incredible aspects of its design in scientific reality.

Means of connoting "measured accuracy" (Male, 2007, p. 105), including diagrams and notes, and conventions appropriated from factual presentation, provide feasible explanations of the costume and its features. When images of a character in costume are presented in the form of technical illustration, "to elucidate structure, function and mechanics," they are read as a technically accurate "visual exposition" of the manufactured or constructed component parts (ibid., p. 114).

The final page of *Robin: A Hero Reborn* (1991) presents the character's costume diagrammatically, connoting "pictorial truth" (Male, 2007, p. 62). The page features a schematic diagram, with cutaway segments and a combination of solid and dashed lines to differentiate between body and costume. The lines are blue, as if to suggest that the image is a blueprint or carbon copy, and text labels provide utilitarian explanations for the costume's key features. A label at the top of the page describes the diagram as representing "suit-devices," as opposed to "costume." Recent film adaptations of the Batman costume have also been "pseudo-utilitarian" (Chabon, 2008, p. 18). Every contour of Batman's costume is explained as armor, and even the cape has been rationalized by demonstrations of an innovative new fabric, capable of stiffening into the form of

a kind of wing. Lucius Fox, Batman's equivalent to Bond's "Q," is employed in technical development. His role as innovator and curator of Wayne Enterprises' vast collection of military technologies ensures the feasibility of an endless supply of new gadgets.

Iron Man's origins are grounded in a technological breakthrough, and his super-powers are entirely bound up in his costume. Like any real-life technology, his costume has undergone numerous reinventions. New, improved versions incorporate additional features that keep the costume one step ahead of real-life technology as Iron Man comics develop through the decades, ensuring that, despite Iron Man's fifty-year run, it remains futuristic (see Chapter 11). Frequent references to the functionality of the costume provide justification both for Iron Man's abilities, and for his extraordinary visual appearance.

The most common justification for recent adaptations of superhero costumes have involved presenting them as armor. Particularly in revisionist incarnations, superheroes express concern for their own physical well-being by donning a costume that is visibly protective. Armor is justifiably different from everyday dress, and it is feasible that a character whose *raison d'être* is to engage in combat would wear battle-dress. Armor can be employed for historical reference (as in Thor, The Americommando, and Black Knight), or for military connotations. Captain America's costume is a hybrid of military and historical references; "musketeer boots and gauntlets . . . King Arthur's chain mail . . . and a Praetorian shield" (Knowles, 2007, p. 132). At the time of Captain America's creation, shields were no longer part of a warrior's standard-issue armor, but connotations of valor and the pseudo-historical hero are so bound up in the image of the shield that it seems a feasible and appropriate addition to the costume.

There is a trend toward armor displayed in the reimagining of superhero costumes for recent incarnations and adaptations. Costumes that were once interpreted as skintight spandex, such as the Batsuit, have been redesigned to incorporate the stiff contours of armor. Batman adaptations reveal the extent to which the apparent functionality of a costume can change without compromising its superhero signifiers. Early television and film adaptations, including a fifteen-part serial in 1943 and later a television series starring Adam West (1966–1968), featured the heroes Batman and Robin clothed in thin cloth. Adam West's costume featured delicate satin cloak and gloves, and other than the utility belt his costume was far from functional (see Figure 3.1). When the character was revived for the screen in Tim Burton's *Batman* (1989) and later *Batman Begins* (Christopher Nolan, 2005), the costume was more rigid, as if machine-molded rather than sewn, giving the impression of state-of-the-art armor. Perhaps the most notable live-action portrayal of Batman and Robin, for its capacity to both adhere and diverge from the comic-book costumes, is *Batman Live* (2011–), a touring stage show that was first staged in Manchester in 2011. The show hybridizes previous film and comic-book costumes, taking inspiration for its

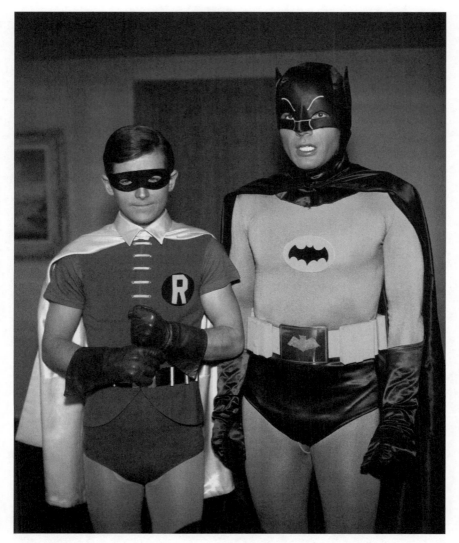

Figure 3.1 Burt Ward and Adam West in costume for their roles as Batman and Robin in *Batman: The Movie* (Leslie H. Martinson, 1966).

armored costumes from Nolan and Burton's Batmen, but adhering to the color scheme of Robin's comic-book costume (see Figure 3.2). Robin's costume features an unlikely combination of delicate yellow cape and heavy segmented boots. His previously bare legs are concealed beneath a knitted green body stocking, knitted with thick yarn to give the appearance of chain mail (though in later productions these are masked by green moulded panels).

Figure 3.2 Promotional image for *Batman Live* World Arena Tour, 2011. As in recent film adaptations, these costumes are armored, and segmented as if to suggest modular construction.

© Jonathan Hordle/REX

Even Superman is not immune to this militarization of the costume. In *Action Comics Vol. 2* #7 (May 2002) Superman steals the "indestructible armor" of his Kryptonian ancestors. The costume has advanced technological properties, with the flexibility of fabric and the indestructability of Superman's own skin. Scott Johnson (2012) proposes that the presentation of Superman's costume as armor must logically imply that Superman himself is no longer invulnerable. Johnson therefore views this revision of the costume also as a rewriting of the rules that govern his story. This reading locates Superman as a cyborg, in a similar category to The Great Machine (*Ex Machina*, 2004–2010), whose own natural powers are supplemented artificially through costume. However, an alternative reading of the series suggests that this armor's purpose is not to protect Superman, but rather to protect itself. A torn costume is a frequent signifier of a weakened or dying hero (see, for example, the death of Superman in *Superman Vol. 2* #75, and ripped costumes appearing throughout *Justice Society of America: The Next Age*, 2007). Bloody skin, exposed through tears in the fabric of a costume, appears to present the superhero as vulnerable, and, since the effectiveness of many superheroes is dependent on visible projection of strength, it is in a superhero's interest to keep his costume intact.[1]

The pursuit of credibility: Hyperrealism and assemblage

Perhaps the most ridiculous feature of the typical superhero costume is the unitard at its center. Although we may attempt to justify this in historical terms, or by drawing parallels with activewear, it remains the case that most people do not dress in an "all-in-one." Playsuits and leotards are not everyday attire, and so this feature of the superhero costume reduces its believability. It was Tim Burton's (1989) assertion that "a leotard is ridiculous," which led to its elimination in film adaptations of the Batman costume. Christopher Nolan's Batman "pulled apart" the costume, with parts ordered "through different companies" (Brooker, 2012, p. 92). For Batman, this enabled the manufacture of the costume to remain a secret and, for the film's audience, it provided reasonable justification for Batman's appearance.

When a costume is a collection of separately sourced parts, dressing in it becomes an act of appropriation, not design—an altogether more everyday, and therefore believable, method of dressing. Although the costume as a whole may seem extraordinary, if its individual parts are everyday, feasibility is achieved through demonstration of its construction.

Ghost Rider and his alter ego, Johnny Blaze, wear ostensibly the same clothes so as to naturalize the costume. When Blaze undergoes transformation his body changes, but his clothes do not. He retains his assembled combination of

motorcycle jacket, leather trousers, and T-shirt. The two identities are differentiated predominantly by the transformation of Blaze's body—into a flaming skeleton—and only minor adjustments to costume, including accessorization in the form of draped chains.

Similarly, if the audience is offered detailed insight into the development of costume, and able to trace its development from everyday clothing to something spectacular, this transition may appear more organic. *Action Comics Vol. 2* depicts Superman in denim jeans, work boots, a T-shirt, and cape. The ordinariness of his costume presents this incarnation of Superman as more human than alien. The T-shirt, emblazoned with his "S" insignia, is identical to those worn by real-life fans, strengthening their affinity with their fictional hero. The cape, however, is alien (see #2, December 2011), and the first piece of the fantastical costume which is developed over the course of five issues of the comic. The discovery that the cape is Kryptonian, and impervious to bullets, foreshadows the acquisition of the remainder of the costume. Through flashbacks to Kal-El's alien origins, alien and human elements of Superman's personal biography converge, until he steals an ancient Kryptonian costume in issue 7 (May 2012). Both versions of the costume are appropriated—initially from familiar human fashion, and then from unfamiliar alien fashion. Both acts of appropriation deny Superman's direct involvement in the design of his costume, presenting it as a found object.

Alongside these revisions of the costume and its origins, there have been efforts to increase the believability of the unitard. Artists including Alex Ross have elected to retain existing costumes, but to render them more credible as real objects through hyperreal textures. Ross's images of Superman's unitard depict folds of fabric at the seams and elbow joints, and a cape which appears to come alive as it twists in the wind. Hyperrealism renders the costume, if not believable conceptually, then at least "visually credible" (Male, 2007, p. 63).

While *Superman: Peace on Earth* (January 1999) and *Batman: War on Crime* (November 1999) both present fantasy characters and abilities, Alex Ross's images demonstrate what Alan Male (2007, p. 63) describes as a "concern for accuracy regarding elements of perspective space and scale" that characterizes hyperrealism. Even in fictions that are "fantastical and magical," hyperreal illustrations "conform [to certain rules of literal pictorial representation] . . . with all components physically working properly and all interacting in a convincing manner." Credibility is achieved through "intense detail . . . realistic gestures and simulation of movement," all of which, for Alex Ross as for other hyperreal illustrators, are "borne out of painstaking observation" (Male, 2007, p. 64). Supplementary material accompanying *The World's Greatest Superheroes* (Dini, 2010) describes Alex Ross's process as involving studies of live models. His illustrations originate in reality, from specially commissioned costumes. When illustrating Superman for *Peace on Earth*, he commissioned the creation of a

real spandex costume, to be worn by his life model; images for *War on Crime* began with a the creation of an expressive Batman cowl, sculpted on a plaster cast of the life model's head, which was in turn used as a model for a final latex cowl and mask.

Ross's method derives from a desire to uncover "what reality would do" to the fiction of the superhero costume. Ross views comic-book panels as the minimalist foundations for real costumes, "made of fabric and thread." It is this desire to understand the costume in reality that has driven him to develop a method that blurs fact and fiction: that draws the costume into the real world before inserting it back into fiction, degraded with real-world imperfections. He seeks to combine "bend and push" the imperfections of reality into a model of perfection. The result, he identifies as an "exaggeration of the source" as opposed to an honest depiction (Alex Ross, interviewed in Borrelli, 2010)

The decline of the costume

Superheroes are no longer restricted to the medium of comics. The largest audience of a superhero narrative is now a cinema audience. The audience of any superhero film is considerably larger than that of the equivalent comic, and that audience largely consists of people who have never read the source comics. These audiences assess the superhero costume not by their familiarity with the images in comic books, but according to their previous experience with the medium of film. Reality is the model by which they judge any photographic medium, and so, to the cinema audience, realism is key.

Will Brooker (2012, p. 113) stresses that fidelity to reality is different to fidelity to the source material. The small proportion of the cinema audience who are primarily comic books fans, and secondarily film fans, may view realism and plausibility as an issue of fidelity. An accurate representation of the costume as it has been depicted on paper, may to them be more faithful to the idea of the superhero. But to a more typical cinema audience, faithfulness to reality is the ultimate goal. A plausible costume is one that is not so much a spectacle as it is justifiable, even mundane.

The issue of plausibility is one that increasingly affects superhero narratives. Recent adaptations, much more than those of previous decades, have devoted considerable effort to explanation. Contemporary audiences will not accept the fantasy of the superhero unless it can be somehow justified, and are quick to criticize when those justifications are flawed or absurd. Early comics and adaptations made little or no effort to explain the costume, whereas in more recent narratives, explanation, and grounding in reality, has been key (see, for example, Mark Millar's *Kick-Ass*, 2008–2014, or Brian Vaughan's *Ex Machina*, 2004–2010).

M. Night Shyamalan's *Unbreakable* (2000) indirectly positioned its hero as a superhero without a costume, "in order to achieve a more realistic vision" of the genre (Wolf-Meyer, 2006, p. 188). Even films that unashamedly position themselves within the superhero genre have responded to the perception that the costume compromises the realism sought by contemporary audiences. Tim Shone has observed that, in recent film adaptations, the time that the superhero spends in costume is increasingly diminishing. The less time the superhero spends in his costume, Shone (2012) argues, the more we are able to relate to the character concealed beneath it. He cites as his example Nolan's Batman trilogy, in which the bat costume is used sparingly. More time is devoted to justifying the Bat—providing Bruce Wayne with motive, explaining his physical strength and stamina, and quantifying the various elements of his costume and associated gadgetry—than to displaying the spectacle of the superhero in all his costumed glory.

PART TWO

IDENTITIES AND IDEALS

4

WEARING THE FLAG: PATRIOTISM AND GLOBALIZATION

The connection between superheroes and nationality is inescapable. The superhero was born not only in the midst of The Great Depression, but also under the encroaching shadow of the Second World War. Superman was, and continues to be, an upholder of American values, and his story represents the successful integration of an immigrant outsider (Fingeroth, 2004, p. 53). Indeed, as A. David Lewis (2013, p. 2) argues, the whole superhero genre is a response to the immigrant experience, and the struggle to adapt to a new national identity. Just as the first American superhero is associated with the American Dream (Eagan, 1987), other superheroes have, through costume, asserted an inextricable link to their nations.

Amir Siddiqi (1965, as cited in Lewis, 2013, p. 2) defines a hero as one who shapes his or her community for the better. He considers birthplace to be a vital attribute in the making of any hero, as it is allegiance to that place or society that will shape his values and determine the fate of his people. Superheroes in particular, whose influence is so extraordinary that they may change the destiny of their nation, have the power to shape the global status of any nation to which they are allied. This potential is considered in a two-page spread for *Look* magazine (February 1940), entitled "How Superman Would End the War," which speculates that Superman could single-handedly bring down the Axis Powers, and in *Superman: Red Son* (2003), which imagines Superman as a hero of Soviet Russia, and whose influence is such that the Soviet Union thrives while the USA is on the verge of collapse.

Superheroes including Captain America, Captain Britain, and others identified in this chapter are positioned as national personifications. Their costumes incorporate elements of a flag (as in Captains America, Britain, and Canuck), or of national dress (Spider-Man India). These superheroes' costumes "render the individual's identity as national member highly salient" to both the wearer and the audience, further, because the flags or national dress are "tangible

representation[s] of the [nation]," they offer the wearer a "manifested object of identification" (Schatz and Lavine, 2007, p. 332). These costumes have the additional advantage of vilifying the superhero's enemies, who are presented as causing damage not just to the individual, but to the "abstract ideals" of the nation (Wanzo, 2009, p. 340).

While superhero costumes are typically symbols of otherness, these costumes express the otherness employed in the service of a nation, emphasizing the superhero's solidarity with nonsuper-powered citizens of the same society. The DC Universe is littered with such superheroes. Iran's Sirocco, who encounters Superman in *Superman* #662: *The Weight of the World,* combines a skintight unitard with a Keffiyeh headscarf and camel-toed boots. This and similarly exoticized costumes appear to pay respect to an individual superhero's cultural heritage, yet as *Batman Incorporated* demonstrates, culturally specific costume can both exoticize and primitivize its wearer. Any costume which visibly expresses allegiance to a culture or nation can tread a fine line between patriotism and nationalism, or between exoticism and primitivism.

Stars and stripes . . . and spandex

Captain America was created as a defender of the values of the United States of America. His appearance resembles those of Olympians, for whom national allegiance becomes the defining factor in the design of their uniforms. When they inject Steve Rogers with a serum to give him super-powers, the American secret service intend that his supernatural athleticism will be used in combat, on behalf of the US Army. He is dressed in a flag-like costume, and introduced to the world as an embodiment of American pride and superiority.

National personification of the United States had previously appeared in the forms of the female figure, Columbia, and later, Uncle Sam. Both of these figures were commonly depicted draped in the flag, or clothed in garments which took inspiration from the flag's core elements, stars and stripes. First World War propaganda made use of these figures to inspire patriotism, most famously in J. M. Flagg's recruitment poster, in which Uncle Sam points an accusatory finger at young men who had not yet enlisted. The poster, notorious in part because of the many parodies that have appeared since, presents Uncle Sam in red, white, and blue, with a white star emblazoned on his top hat.

From his first appearance in *Captain America Comics* #1 (March 1941) Captain America was presented as an Uncle Sam for the modern age. His costume bore the same elements of the flag: a single white star on his chest, on a blue background, and red and white stripes beneath. References to Uncle Sam continue in contemporary incarnations: the cover of *Captain America Vol. 4* #3 (August 2002) depicts a close-up of his gloves, with forefinger pointing deliberately at the reader, making explicit reference to Flagg's 1917 poster.

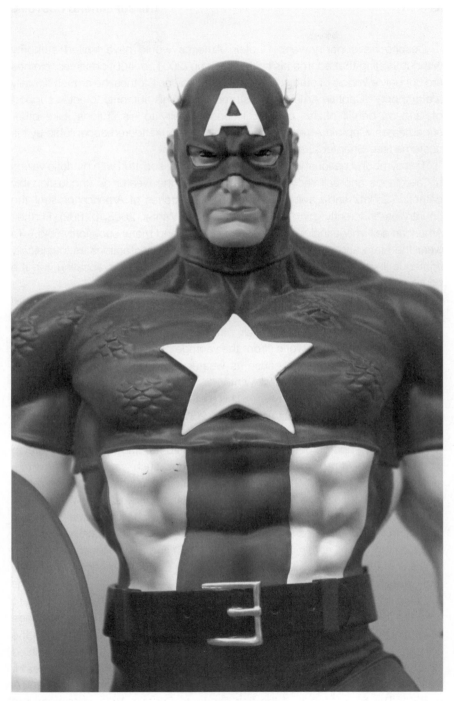

Figure 4.1 The stars and stripes of Captain America's costume express national allegiance. From his first appearance in 1941 Captain America was presented as an Uncle Sam for the modern age.

Despite his super-powers, Captain America would have limited authority without the flag that adorns his body. As Cohn (2001, p. 406) observes, clothes are not only symbols of status, but also create power. Clothes, he argues "literally *are* authority." Captain America's costume asserts his authority to act in support of, and on behalf of, his country. It lends validity to his actions. Like other superheroes, Captain America engages in violence, rendered acceptable by his costume (see Chapter 2) and his status as a soldier.

This symbol of national identification is so firmly associated with patriotic values of "allegiance and self-sacrifice" that it presents the wearer as unquestionably patriotic (Schatz and Lavine, 2007, p. 330). Histories of America present the country as "inherently good" (Kemmelmeier and Winter, 2008, p. 862). Further, American self-image includes a sense of political and moral superiority (ibid.). To wear the stars and stripes is, therefore, to present ones actions as intrinsically righteous (ibid., p. 872). The flag legitimizes his aggression by locating it in the context of an ongoing defense of American liberty.

Meanwhile, the flag costume may be a strategy to prevent rebellion. Exposure to the flag can provoke individuals to "behave in ways that are consistent with the worldviews and values" of their nation, to the extent that it causes an individual to perceive the world "from the vantage point of [his] national identity." A flag costume can thereby cause its wearer to undergo a process of "self-stereotyping" (Kemmelmeier and Winter, 2008, p. 861). In this way, Captain America's costume is means by which his military creators can ensure continued "unconditional loyalty" (Schatz and Lavine, 2007, p. 331), and maintain control over their creation.

While many superheroes create their own costume, and maintain ownership of their own identity, for national personifications such as Captain America, identity is appropriated. This act of appropriation is planned and regulated, usually by authorities who speak on behalf of other citizens, and who are in a position to select candidates worthy of representing their nation. Captain Canuck, for example, operates as an agent of the "Canadian International Security Organization" (see *Captain Canuck* #1, July 1975) and Steve Rogers is selected to serve the U.S. Army as Captain America (see *Captain America Comics* #1, and *Captain America Vol. 1* #255, March 1981).

Selected by representatives of a nation, these superheroes are permitted to wear the flag as a badge of honor. Historically, honorific robes suggest a lineage or continuity (Cohn, 2001, p. 406). The identity and authority expressed in the costume extends beyond any individual wearer, to a set of values that has existed long before the birth of the wearer, and will continue to exist long after his death. National symbols represent the nation "across time" (Schatz and Lavine, 2007, p. 333). The timelessness of the flag connects Captain America to past and future, to the shared history of the American people, and to their shared ambitions for the future. It gives his actions "larger meaning and purpose," as if his American

identity supersedes Steve Roger's "personal existence and inevitable mortality." As Captain America, he is gifted not only super-strength, but also the perceived invulnerability of his nation, expressed through the motifs and colors of his costume. The star and stripes appear to endow him with additional strength by aligning him with a larger set of values that cannot be eroded or destroyed in combat.

In signifying a society and set of values greater than any one wearer of the costume, a robe of honor can never be the property of its wearer. Although Captain America is permitted to wear it, he is only a custodian of the flag. Superheroes including Captains America, Britain, and Canuck have no more ownership of their costumed identity than they do of any other symbol of their nation. The flag, and therefore the flag-inspired costume, remains the property of the nation and its people. In return for this gift, there is an expectation that the national superhero will place the needs of his countrymen before himself.[1]

Having an identity bestowed upon him by his nation, Captain America has responsibility for, but not ownership of, his own actions. The nation is "a collective subject" and there is a sense of shared responsibility for any achievements carried out on the nation's behalf (Foster, 1991, p. 241). Actions of an individual are perceived as actions of the community, on small and large scales: "*we* won the football"; "*we* won the war." This sense is reinforced by the knowledge that Steve Rogers' super-powers were artificially provided by agents of the state. So long as he wears the flag, the American public can take collective pride in Captain America's achievements.

The problematic consequences of shared accountability are addressed in the post-9/11 *Captain America Vol. 4* #1–6 (published collectively as *The New Deal*, 2003) in which Captain America attempts to distance himself from the American people, in order to protect them from suffering the consequences of his mistakes. After many decades of American imperialism, and reprisal in the form of the September 11 attacks on the World Trade Center, Captain America makes a televised appeal for viewers not "to hold a nation accountable for the actions of a man." As he speaks, he removes his mask, and in doing so, sheds the "A" insignia that aligns his identity with his nation. Without the mask, he speaks as his civilian alter-ego, and declares "I'm Steve Rogers. I'm a citizen of the United States of America, but I'm not America. My country's not to blame for what I've done."

This is not the only occasion on which Steve Rogers has abandoned his costume in order to distance himself from his American identity. Jonathan Turner (2013, p. 334) observes that "external events can . . . erode commitments to an identity." "When this occurs," he writes, "people are more likely to . . . seek new identities." In *Captain America* #180 (December 1974) Steve Rogers becomes so disillusioned with the American presidency that he creates a new superhero identity, free from affiliation with any one nation. As the Nomad, he wears a black

costume that is free from any national signifiers. As Björn Hochschild (2014, p. 7) identifies a panel in #180 in which "Nomad's own forsaking of all former ideals becomes his weak spot." Nomad's struggle is contrasted with Captain America's triumph. The background of this frame features a poster of Captain America victoriously holding an American flag aloft while in the foreground Nomad battles with a snake as it swallows its own tail. Nomad struggles against this "symbol of meaninglessness," and "a moment later his failure becomes evident: he stumbles over his own cloak" (ibid.). The cloak, which is in other comics a mark of superhero supremacy, is shown here as a point of weakness. Without a set of values to represent, the costume becomes a hindrance.

These arguments assume the existence of a fixed set of American values, embodied in the flag. Since his first appearance, Captain America's costume has changed very little. While other costumes, including those of Batman and the X-Men, have significantly evolved over the years (see Chapter 3), Captain America's, like Superman's, has remained relatively consistent, suggesting a continuity of values. It is important to note that Captain America first appeared at a time of international crisis, when American values were under threat, and a new era of American political and military dominance was beginning to emerge. At this time of uncertainty and change, American values needed to be reinforced, and to an extent, rewritten for a new age. Robert J. Foster (1991, p. 237) observes that cultures, and national values, are continually in flux. Nations forge, but do not fix, their values. A static symbol, such as a flag, creates the impression of stability when in fact the values for which it stands continually evolve. Foster writes that a set of national values appears innate, or "taken for granted," perhaps creating the impression that the flag, and hence Captain America's costume, reinforces an apparently innate set of American values. Far from being innate, these values are constructed, and Captain America is a tool employed in this construction.

Increased awareness of the outside world, such as that experienced during the Second World War, causes a nation to reassert its identity, and modernize the values represented in its flag. Alliances and conflicts with other nations prompt the shifting of values, to emphasize similarity or contrast with those foreign nations; nations emerge from a war having altered their world-standing and impression of self. Hence, the meaning of the flag is subject to change. By emphasizing a relationship between the nation (his flag costume) and aspects of his character (pride, strength, allegiance), depictions of Captain America contributed to the construction of a new set of American values, and helped to forge a new, modern identity for his nation. As the character has developed during the twentieth and twenty-first centuries, while also continuing to wear the flag, he continues to affect change in perceptions of the meaning of the flag, and of the American values that it represents.

Recent cinema adaptations have explicitly acknowledged the values expressed in the character's costume as outdated. In *The Avengers* (Joss

Whedon, 2012), Captain America himself questions the overt patriotism of his Second World War costume following his twenty-first-century revival, asking "aren't the Stars and Stripes a little old-fashioned?" While the costume of the *Captain America* comics has gone largely unchanged since his inception, movie incarnations see the character's outfit far more consciously military in presentation. In *Captain America: The First Avenger* (Joe Johnston, 2011), the comic-book inspired costume is reserved only for public relations activities. When Rogers abandons his promotional tour for front-line battle, the costume is adapted to incorporate elements of army fatigues.

Conflicted identities: Nation versus race

Though national identity may be influential in defining a superhero's values, a hero's identity may be equally defined by his ethnicity. Ethnicity and nationality go hand-in-hand in the many portrayals of national stereotypes that litter comics born during the Golden Age (not least the numerous examples in Batman comics that are discussed below). In the past few decades, however, the ethnicity and nationality of a superhero have not necessarily been entwined, or in some cases, efforts have been made to actively challenge stereotypes.

Spider-Man has had several identities of different ethnicities. *Spider-Man 2099* (1992) features Miguel O'Hara as a Latino Spider-Man, and *Ultimate Comics: Spider-Man* (2011–2013) tells the tale of Miles Morales, an African American who adopts the Spider-Man identity after Peter Parker's death. Commentators' surprise at the decision to create an African American Spider-Man, in the form of Miles Morales, provides evidence that the superhero genre has previously equated American national identity to whiteness. Morales and O'Hara's difference from Peter Parker stems primarily from their ethnicity. Nonetheless, they are distinctly American, and their narratives present them as examples of American diversity, not as outsiders. Morales' first appearance occurred soon after the election of Barack Obama, whose inauguration as President was confirmation that African American values had come into alignment with American values, thus a black Spider-Man could now express American identity.

Although there are several American incarnations of Spider-Man who do, as the example of Miles Morales shows, represent an aspect of American identity, the Spider-Man identity is not itself innately American. Peter Parker, Miles Morales, and other of Spider-Man's alter-egos share a distinctly American experience (particularly in high school), but they are not patriotic upholders of American values as Captain America and Superman are. Spider-Man represents the plight of an individual within a nation that sometimes seems to act against him, not the plight of an individual in service to his state. The lack of nationalism that distinguishes Spider-Man from Superman or Captain America makes his

story transferable to other cultural settings, in a way that the other superhero narratives are not.

Superman's heroism derives from his American identity—a product of his Kansas upbringing. As a result, any relocation of Superman also necessarily requires redefinition of his core values. *Red Son* (2003), for example, depicts Superman as a socialist hero, raised in Soviet Ukraine, with a chest insignia that feature a hammer and sickle instead of an "S". While he maintains his innate goodness in this alternative universe, he employs his abilities in support and defense of socialist ideals.

Red Son is one of many revisionist comics that typically represent difference to the source material in changes to the hero's core values, reflected visibly in his or her costume. One-off tales, set outside of regular continuity, such as Marvel's *What if . . .?* (1977–) and DC's *Elseworlds* series (1989–) place familiar superheroes in unfamiliar settings and partnerships, or imagines them with different identities. Shilpa Davé (2013, p. 127) locates Spider-Man India in this tradition of revisionist superhero tales. The adaptation was created in 2004 by Gotham Entertainment group, intended primarily for an Indian audience, and relocates the familiar origin story of Spider-Man to Mumbai, with schoolboy Pavitr Prabhakar substituted for Peter Parker. Though Spider-Man India does reassign Spider-Man's national identity, his experiences and ideals remain largely the same. He does adopt visual signifiers of his Indian identity, but his struggle remains the same as those of Peter Parker. His story survives this relocation because he is defined by his personal identity more than his national identity.

Nonetheless, in order to mark Spider-Man India apart from his American cousin, it was necessary to depict visual signifiers of his Indian nationality. Spider-Man India wears a costume that combines the skintight red and blue of the American Spider-Man with an Indian dhoti, a loose cloth draped around the waist. To wearers, the dhoti symbolizes both Indian identity and the values of honestly and simplicity (O'Rourke and Rodriguez, 2007, p. 123). The incorporation of the dhoti was not solely a matter of communicating a specific set of values, but also for the purposes of expressing the nationality and race of the wearer. Davé (2013, p. 130) remarks that, since the Spider-Man costume entirely conceals the wearer's face and body, simply placing an Indian inside the same costume would not visibly differentiate the American and Indian Spider-Man from one another. Pavitr Prabhakar's entire body is covered, and so too is his race. Spider-Man India's costume signifies Indian-ness beyond race, even to the extent that it eliminates race, presenting nationality as a set of traditions and values, not of ethnicity.[2]

Davé's observation has wider ranging consequences for discussions of other superhero costumes, particularly those that were, like Spider-Man's, inspired by Mexican wrestlers, or "luchadors." In "lucha libre" (free fighting), as in superhero narratives, the identity of a wrestler in inseparable from his mask. There is even a

sense that the wrestler's powers are bound up in the mask. If his mask is removed during a fight, he is "disempowered" and cannot continue to fight until it is returned or replaced (Levi, 2005, p. 108). "An etiquette developed around protecting the honor and anonymity" (ibid., p. 101) of the masked wrestler. This set of semi-formal rules requires that the wrestler must never expose his unmasked face. The removal of an opponent's mask is grounds for disqualification, and a wrestler only removes his own mask in extraordinary circumstances, by prearrangement with the event organizers. An unmasking may be a symbolic gesture at the end of a career, to signify the death of the identity contained within the costume.

Heather Levi (2008, p. 134) writes that the luchador's mask transcends the division between pre-Hispanic indigenous civilizations and post-Colombian Hispanic communities by reinforcing a "continuity between indigenous Mexico . . . and the urban present." The mask itself represents Mexican identity, being derived from "indigenous ritual practices" (Barberena, 2009, p. 165). By concealing his face, the wrestler avoids the issue of ethnicity, associating himself with a nation, a cultural history, and family lineage, rather than a race.

Such precise expressions of national identity are simultaneously inclusive and exclusive (Hogan, 2003, p. 100). The mask is worn in part to transcend class boundaries, rendering wrestlers socially equal to the audiences who seek to emulate them (Barberena, 2009, p. 167), and to connect to a heritage that is specific to that local audience, meanwhile excluding non-Mexican Hispanics.

Spider-Man India's dhoti functions in much the same way as a luchador's mask. It bridges the divide between a traditional Indian past and a Westernized present. It marks the character as culturally Indian without explicitly exposing him as ethnically different from the American Spider-Man. Davé (2013, p. 134) views this as a separation of character and costume, proposing that in Spider-Man, it is the costumed identity that is a product of American values rather than the boy underneath, and likewise "to make the hero Indian is not necessarily to make the man underneath racially Indian but instead to change the costume so that it represents India."

The way in which Spider-Man India adopts his costume suggests that these two characteristics—nationality and ethnicity—are, at least for Pavitr Prabhakar, mutually exclusive. O'Rourke and Rodrigues (2007, p. 124) present Prabhakar's adoption of the Spider-Man identity as a process of separation from his former self. Building on Joseph Campbell's (1949) description of the process of becoming a hero, they note that the individual must depart from his common world, and separate himself from his former identity, and that this transformation requires the adoption of a costume or other adornment. Through adoption of the Spider-Man India costume, Prabhakar is separated from his former self, from his ethnic identity, so that he may adopt a distinct national identity in its place.

Exoticism and primitivism in *Batman Incorporated*

Through the years, mainstream American superhero comics have struggled to distinguish ethnicity from otherness, insofar as characters of nonwhite ethnicity are often costumed to appear either exotic or primitive. This is perhaps most apparent in DC's *Batman* comics. Since his first appearance in 1939, Batman has built a global network of friends and allies. In contrast to the all-American Superman, Batman is positioned as a man of many nations, having trained and operated across the globe. *The Man Who Falls* (1989) recounts Batman's origins, including martial arts training on a Korean mountaintop, his French education in the art of deception, and his rescue by a masked Indian shaman. During his international excursions, Batman encounters other characters whose wardrobes combine the conventions of superhero costume with signifiers of national identity and cultural heritage.

Batman: Hong Kong (2003) narrates the meeting of Batman and the Hong Kong superhero, Night Dragon. Night Dragon's costume provides Western audiences with a generalized impression of pre-communist China's beauty and strength, with striking but vague visual references. It draws inspiration from historical Chinese battle-dress, featuring a jewel-encrusted helmet, with horns and reptilian scales worthy of the dragon references in Song Dynasty ornamented armor. The overcoat has the rigid silhouette and overlapping plates of Qin Dynasty lamellar. Perhaps macabrely, the green scales of his chest plate resemble a jade burial suit. This bricolage of historical references combines to express a nonspecific Chinese heritage. It is an elaborate and yet ambiguous expression of the exotic, which provides the character with apparent cultural authenticity.

Batman's status as man-of-the-world is exposed by these exotic superheroes as inauthentic. His training has made him international, but not multicultural. He is no stranger to transgressing national identities, having donned a kilt to battle a mechanical Loch Ness monster (*Detective Comics* #198, August 1953), but on the whole fails to integrate. He does not adapt to foreign cultures, but rather relies on local allies to build bridges. These allies are necessary in part because Batman's powers are limited. As a human, he is not equipped to defend himself or others against all foreign threats, and so he finds strength in numbers.

Batman is set apart from other superheroes in his lack of super-powers. Though a skilled and well-equipped crime fighter, he does not possess superhuman abilities that mark other superheroes apart from ordinary man. His skillset is not exclusive to one man, and therefore "anybody could be Batman" (Williams, 2011). With the right training and resources, Batman's actions could be duplicated. It is this that underpins the central themes of *Batman Incorporated* (2011–2012).

The *Batman Incorporated* series envisions a world in which Batman is the leader of an international franchise, and sets about recruiting agents to act on his behalf across the globe.[3] In his hunt for protégés, Batman visits Japan, Russia, France, Britain, Argentina, and the Democratic Republic of Congo. He recruits an army of agents, each of whom adopt the bat identity to varying degrees, multiplying Batman's identity. With these recruits in place, Batman is not one, but many. "Batman," Wayne tells reporters, "is everywhere" (*Batman Incorporated Vol. 1* #6).

Williams (2014) observes parallels with Bruce Wayne's legitimate business activities, specifically, the globalization of Waynetech. Indeed, he approaches his plans for expansion as any legitimate businessman would, by pitching his ideas to a panel of shareholders. *Batman Incorporated Vol. 2* #0 (November 2012), depicts Wayne in a penthouse boardroom, in front of a map of the world dotted with Batman insignias, laying out his plans for an "international crime-fighting franchise" to potential investors. His plan begins with the introduction of an army of Bat-branded robots, and proceeds with the recruitment of "real soldiers." These men and women are established crime-fighters, located throughout the globe, each of whom has their own superhero identity, and many of whom were directly inspired by Batman.

As in any act of global franchise, a consistent visual identity is key in asserting relationships between Batman and his agents. As "extensions" of the Batman brand, the agents' costumes "represent the moral codes of their [leader]" and act as a guarantee that the wearers will behave in accordance with a prescribed set of values (Williams, 2014). Many of Batman's recruits wear costumes that are direct adaptations of Batman's. Wingman's costume differs from Batman's in only a few key features—the texture of the cape, and the angular contours of the hood (see *Batman Incorporated Vol. 2* #4)—and Batwing dresses as a more mechanized version of his hero (Vol. 1 #6). These privileged few are permitted to brand themselves primarily as bats. The remaining recruits maintain their own costumes, sometimes featuring a hint of a bat, but keeping their own identity dominant.

In order to assert the uniqueness and otherness of each of Batman's agents, there is required an "objectification of culture" (Conklin, 1997, p. 713)—an externalization of each agent's national and cultural biography, which is expressed primarily through their costume. Though their home nations are largely Westernized, the presence of Batman, an American, gives his agents cause to assert their difference. Just as indigenous people find meaning in their history and culture when presented to foreign visitors, as soon as outsiders are present, it becomes essential to visibly assert cultural identity (Conklin, 1997, p. 712).

Though these features of costume appear to be markers of cultural authenticity, they are for Western audiences. "Western visual codes" required for these costumes to communicate the intended messages (Conklin, 1997, p. 712).

A sense of authenticity is therefore often dependent on imagery that is appropriated from Western media, and from Western constructs of exoticism. For these Westernized societies, native dress is as exotic to natives as to outsiders. As René Ménil (1996, p. 177) observes, this is not a kind of exoticism that contrasts self with other, but that constructs self as other. A pure kind of exoticism, in which the outsider is as exotic to the native as the outsider is to the native, has been eroded by colonial exoticism, in which "people have an exotic vision of themselves." This vision of self as other is expressed through these agents' decision to dress, neither in the Westernized style of their countrymen, nor the style of their leader, Batman, but in consciously exotisized costumes of their own design.

Their independent identities, as manifested in their costumes, seem to assert individual agency of Batman's recruits. However, the narratives ensure that the agents remain subservient. Each is required to prove himself in a probationary period (see *Vol. 2* #0), and if successful, to pledge allegiance to Batman and his values (as depicted in a minor panel in *Vol. 1* #6). Moreover, their costumes are visibly less advanced than Batman's. The exoticism displayed by Night Dragon (see Figure 4.2) is evidently not permitted here, as agents of Batman Incorporated are presented not as exotics, but as primitives.

Two of Batman's first recruits are Little Raven and Man-of-Bats, a father and son duo whose makeshift HQ is a ramshackle shed in South Dakota (see *Batman Incorporated Vol. 1* #7). The pair are depicted as Native American. Man-of-Bats wears a feather headdress and his trousers are ornamented with fringes, while Little Raven, more Westernized than his father, wears a sporting hoodie and matching mask. The contents of their shed reveal that they are avid fans of Batman. The room is a shrine to their hero, stocked with Batman paraphernalia in illuminated display cabinets. Their own collection of weapons and gadgets is limited (their truck, a poor substitute for the Batmobile, breaks down just before Batman arrives). As if to reiterate the notion that anyone could be Batman, he tells Little Raven: "It doesn't have to take millions . . . Batman on a budget."

The depiction of Man-of-Bats and Little Raven exoticizes small-town America, depicting it as if it were a world away from Gotham City, more comparable to desert towns of Mexico than the urban sprawl of the USA. The heroes are exoticized too, with costumes that are more ornamental than functional, decorated with fringes and feathers. However, this exotic vision is also markedly primitive. The cover of *Vol. 1* #7 depicts Little Raven riding bareback through the desert, his father on the back of a buffalo, and Batman leaving both of them behind as his Batcycle speeds ahead. If not for the presence of Batman and his technologically advanced motorcycle, the scene could belong in a tale of the Old West frontier. Other recruits also seem plucked from history, representing historical expression of their home countries: The Knight represents a romanticized vision of medieval England, dressed in fairy-tale armor; Australian

Figure 4.2 A panel from *Batman: Hong Kong* (2003) features Night Dragon, a Hong Kong superhero who allies himself with Batman. His costume makes reference to historical Chinese military dress, with the aim of asserting the character's cultural authenticity.

Aboriginal, Dark Ranger, eschews Batman's high-tech weapons in favor of a primitive boomerang (see *Batman Incorporated Vol. 2* #0). These costumes, all primitive or even historical, in contrast to Batman's high-tech arsenal, seem to position Batman as the only civilized power in a world of underdeveloped nations.

Batman's previous allies, including Night Dragon, are presented as exotic equals. Night Dragon's costume "mythologises and reifies" aspects of Chinese cultural tradition (Khoo, 2007, p. 3). The gilded mask has an alluring strangeness. By contrast, the agents of Batman Incorporated are costumed as if in "an antithetical relation to modernity" (Thomas, 1994, p. 173, as cited in ibid.). Their costumes and weapons are rudimentary, often improvised. El Gaucho, for example, wears a cloth tied around his head instead of a purpose-built mask (see *Vol. 1* #3). This primitiveness is a legacy of 1950s *Detective Comics*, in which many of Batman's agents first appeared,[4] but persists despite the many updates and modification that their leader's costume has undergone in intermediate years.

As a powerful international agent, Batman must tread a fine line between guiding influence and "corrupting force" (Conklin, 1997, p. 711). Primitivism "constructs its objects as . . . the oppressed classes" (Khoo, 2007, p. 3), and Batman could be seen to exploit his recruits' subaltern status to keep them in line. His decision to allow them to keep their own costumes, rather than brand all agents in identikit uniforms, suggests a certain respect for their individual cultural heritage. He recognizes that he must be seen not to erode the identities of any of his agents, positioning himself as a guiding influence whose leadership is respectful of cultural difference. However, this decision also reinforces his own superiority.

5

DRESSING UP, DRESSING DOWN: A SPECTACLE OF OTHERNESS, AND THE ORDINARINESS OF THE CIVILIAN ALTER-EGO

Superman: *Peace on Earth* depicts Superman slumped in his armchair (see Figure 5.1). His shirt has fallen open to reveal his bold insignia, but the glasses of Clark Kent remain on his face. He wears the weary expression of a man who is tired of the struggle to maintain his public persona. So much of this image is ordinary: the framed photograph of his father and crooked table lamp that sit beside him are extracts from normalcy. Superman, with his extraordinary powers signified by the vibrant colors of the costume, is framed by dull and average surroundings. Although Superman is an extraordinary being, he lives his civilian life in ordinary surroundings: an "identity tourist," "passing" as an average human man (Nakamura, 2002, p. 13).

Duality, and the struggle to negotiate the relationship between two different identities, defines the superhero as much as his super powers. To balance the carnival of the super identity, the superhero shelters in the guise of a civilian. This civilian identity expresses social solidarity, allowing "the reader the fantasy of being extraordinary on the outside while continuing to seem ordinary on the outside" (Smith, 2009, p. 126). Having a dual identity necessitates having two alternative costumes: one for the superhero, and another for his or her alter ego. The superhero costume gives him special status, the wardrobe of his alter ego must do the opposite: it must remove that status, and reduce the superhero to the level of the ordinary civilian.

Much like an actor in costume, the dress of the civilian alter-ego allows the hero to "hold himself apart from his character," the superhero (Walter, 2011). While in costume, a superhero "inhabit[s] a self that is not his own." A superhero acts for the people, and so his superhero identity exists for that audience. The

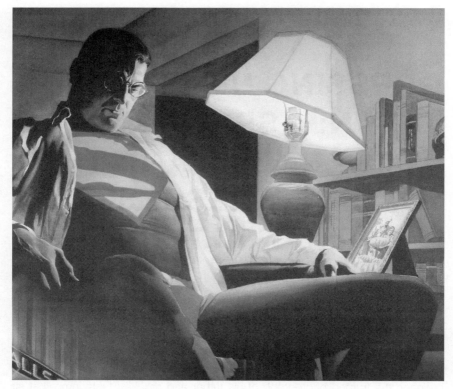

Figure 5.1 A frame from *Superman: Peace on Earth* (1999), illustrated by Alex Ross, depicts Superman/Clark Kent slumped in his armchair, with his office shirt falling open to reveal the "S" insignia of his Superman costume.

™ and © DC Comics

civilian alter-ego is an opportunity for the hero to take back ownership of himself. The civilian wardrobe enables ownership of his actions, his relationships, and his life.

His civilian wardrobe is not, however, genuine civilian dress. When Superman steps out of red, yellow, and blue, and into black or gray, or when Spider-Man exchanges spandex for cotton and denim, he is not removing his disguise, he is substituting one costume for another. The presentation of the superhero as "ordinary" in his civilian alter-ego is a deliberate act of construction. Like all disguise, the superhero's everyday wear merely "represents dress" when it in fact "acts as costume" (Muecke, 1986, p. 217). It imitates the wardrobe of an ordinary civilian, but it masks a body that is far from ordinary. It is another masquerade, and in that respect is akin to the superhero costume. It is "both a veil and a performance" (Collins, 2011), concealing the superhero identity while constructing an artificially ordinary alternative.

Performing ordinariness

In theatrical disguise, it is common for the false character to be a stereotype. He adopts "stock roles, with stereotyped . . . characteristics and accoutrements" (Muecke, 1986, p. 219). This achieves a portrait of normalcy untainted by character quirks or micro-adjustments to uniform that mark the rest of us as expressive individuals (see Chapter 7). The superhero's civilian disguise must be stereotypical to the extent that it is bland. It must be so unremarkable that those who meet him can never suspect any connection to the superhero that is concealed under his disguise. The civilian wardrobe represents conformity, normality—an embodiment of the ordinary.

All fashion relies on negotiation between the conflicting desires for competition and conformity (Barnard, 1996, p. 11). When we dress, we do so to conform to a social contract, while simultaneously expressing our individuality (Simmel, 1904, p. 295). For most of us, this is a balancing act that must be performed with every garment or outfit. Our clothes must communicate our willingness to adhere to society's laws and conventions while also demonstrating that we have a particular place within that society that makes us individuals. For superheroes, this opposition is embodied in the two separate costumes. The superhero costume constructs uniqueness, while the civilian wardrobe constructs normality by adhering to convention.

The superhero mythology relies as much on the civilian alter-ego as it does the costumed and super-powered hero. It is essential to the typical superhero narrative that "the extraordinary nature of the superhero [is] contrasted with the ordinariness of his surroundings" and "with the mundane nature of his alter-ego" (Reynolds, 1992, p. 16)—both for the believability of the narrative and for the overall satisfaction of the reader. The civilian disguise must be so commonplace that the superhero can convincingly blend in to normal society. He must be able to walk down the street without anyone taking a second glance; his clothes so run-of-the-mill that they counteract the appearance of the character's impressive physique.

In many ways, the civilian costume is, or must be, more effective a disguise than the superhero equivalent. "The most cunning mask is no mask at all," as it does not invite questions (Reynolds, 1992, p. 26). While the superhero costume invites curiosity, and promotes the urge to seek out the identity of the man behind the mask (see Chapter 2), the civilian costume must present such a convincing replica of normality that no one questions its authenticity.

"Legitimating one's identity in the eyes of others is always a driving force of human behavior" (Turner, 2013, p. 337), and it seems this is also true of superheroes. Superhero narratives describe the lengths to which a superhero goes to present the illusion of normalcy. In Richard Lester's *Superman II* (1981) Lois Lane, suspecting Clark Kent's secret identity, jumps into a raging river with

the expectation that Superman will save her. Instead, Clark feigns helplessness, stumbling along the riverbank, and only takes action to save her when he spots an opportunity to do so without compromising himself. Similarly, Spider-Man allows himself to be subjected to ritual humiliation in order to preserve his secret. In *Ultimate Spider-Man* #14 (December 2001), Peter Parker's classmate begins to suspect the truth of his transformation into Spider-Man. The student plans to kick Parker in the rear end in full view of his classmates, hoping for an exposing superhuman evasion. Via Parker's inner monologue, we are told that Parker is able to anticipate the attack: "My Spider-Sense is going off here at school . . . that can only mean one thing. And the Academy Award for best performance by an amateur superhero trying desperately to hold on to his secret identity goes to . . ." As Parker takes the kick, he howls in simulated pain, tears stream down his face—but the masquerade is preserved. These efforts to appear normal in public continually reinforce the separation of the superhero and his alter ego. "When the expectations of others are . . . consistent, revealing few conflicts and disagreements" they begin to "speak with the same voice" as an individual's constructed identity (Turner, 2013, p. 334). An audience of onlookers can become so convinced by a disguise that they will vouch for its authenticity, so that over time the superhero may rely on a "network" of others to become unwittingly complicit in its reinforcement. Thus the alter ego becomes, in Gregory Stone's (1981, p. 143) terms, "a social object."

The dullness of the civilian alter-ego highlights the contrast to his superhero self, making the fact of his duality as much a spectacle as the character's super powers. That Clark Kent and Superman are "one and the same," and that none of his co-workers at *The Daily Planet* have come to learn the truth despite the fact that Superman wears no mask, attests to the effectiveness of the contrast between his two costumes. When a character appears so ordinary and human as Clark Kent does in his work suit and glasses, his colleagues will go so far as to overlook the remarkable similarity between his face and that of the Last Son of Krypton.

V for Vendetta's (Alan Moore, 1982–1989) V demonstrates the jarring effect of seeing superheroes perform ordinariness without first changing into a civilian guise. In the film adaptation (McTeigue, 2006), V is depicted engaged in domestic chores, including cooking and cleaning, while wearing the mask. Croci (2014) proposes that this is necessary as V has no real alternative self; that the Guy Fawkes mask contains the character's only identity. Having been deprived of his "domestic identity" (Koch, 2014) through disfigurement, he adopts the mask to regain a sense of identity and self. The domestic space is usually the domain of the civilian alter-ego, but here, as V has no civilian identity, he performs ordinariness in his superhero wardrobe.

Implicit in his decision to create an alter ego is the superhero's acknowledgment that he is a kind of monster or freak. He adopts a mask of ordinariness because

he knows that he is anything but ordinary. In performing a masquerade, he concedes that his superhero identity does not align with dominant ideologies. He aims to symbolize common social values, and in silent protest at the possibility of being perceived as an outsider. Following Sheldon Stryker, Jonathan Turner (2013, p. 333) notes that when "an identity is established by reference to the norms . . . of the broader society," an individual's self-esteem becomes associated with that identity. There are explicit references in superhero narratives to the private concerns that he may be perceived as a "freak." In both Superman and Spider-Man's case, their powers manifest themselves during adolescence, elevating the isolation and social unease of that period to a vastly heightened degree. Peter Parker's powers initially manifest themselves in spasms that cause his classmates to label him "spazoid." His acquisition of superpowers is a frightening experience, prompting concerns for his physical health and his sanity. In *Ultimate Spider-Man* #2 (December 2000), Parker asks "what the hell is wrong with me? . . . Gotta be someone I can talk to without being locked away in a freak farm . . . maybe I'm dying." The civilian wardrobe still allows the adolescent Spider-Man and Superman to ostensibly remain like everyone else, until they make the conscious decision to adopt an overt otherness. By dressing as a civilian, and doing so convincingly, the superhero is able to set his own mind at rest. He can reassure others, as well as himself, that despite his unusual powers he is still essentially human.

Playing to the reader

So often in real-life, clothes are aspirational. They reflect the ambition to be more attractive, more wealthy, or more sophisticated than we really are. Indeed, the whole fashion cycle relies on consumers' desires to achieve or emulate a higher socioeconomic status than we really have (Crane, 2000, p. 6). Superheroes have a special status to which many aspire, but, like an haute couture dress, the special status of a superhero is out of reach to ordinary civilians. The average reader of a comic book does not have the power or influence of a superhero. His status is limited, and he cannot relate to the experience of saving the world, or even saving the day.

The civilian alter-ego exists so that comic-book readers may see a glimmer of themselves in their favorite hero. It is the alter ego that makes the superhero relatable. While all-too-human heroes such as Sherlock Holmes and Indiana Jones have achieved popularity, Danny Fingeroth (2004, p. 32) has observed that these heroes have the potential to make ordinary readers feel inadequate by contrast. Likewise, it is difficult to sympathize with tales of monsters with supernatural powers, but no human conscience (ibid., p. 123). The civilian alter-ego represents the reader in ways that neither of the superhero genre's

predecessors have. He is typically human: he is adequate. Like the average reader, he has no expectations of greatness and no entitlement to glory. The civilian costume expresses a particular kind of ordinariness to which the reader can relate. Jerry Siegel famously depicted Clark Kent with glasses because he wore them himself. His decision to use himself as a model turned Kent into a reflection of the mundane.

Wendy Parkins' study of celebrities' performance of ordinariness offers insights into why audiences need their heroes to reflect elements of their own lives. She identifies a trend for celebrities "associating themselves with the values of the ordinary . . . as a means of contesting other dominant connotations of celebrity" (Parkins, 2004, p. 248). Celebrity has connotations of elitism which can be countered through signs of the mundane. Superheroes too risk negative press. Although they have been given a human face, superheroes can be, and sometimes are, perceived as dangerous freaks and vigilantes. The solution is to integrate the freak with ordinariness, and in so doing to highlight that, to varying degrees, we *all* harbor personal demons under our "skin of normalcy" (Fhlainn, 2009, p. 4).

"A trace of the ordinary in the extraordinary . . . connects even the most worldly celebrity to the mundane" (Wark, 1999, pp. 48–49, as cited in Parkins, 2004, p. 427). Through this performance, a figure "who is not ordinary seeks a new kind of authenticity" (Tolson, 2001, p. 452, as cited in ibid.). The civilian alter-ego makes the superhero real, tangible, and more so because it is so close to the reader's own vision of himself. On the first page of their superhero pastiche, *Kick-Ass,* Mark Miller and John Romita Jr. (2010) acknowledge that comic-book audiences fantasize about one day becoming a superhero themselves. In order to sustain this fantasy, comic-book artists must permit the audience to see glimpses of themselves on the page. The civilian alter-ego permits the reader to imagine himself in the superhero role. Indeed, in Spider-Man's first appearance (in *Amazing Fantasy* #15, 1962), Peter Parker's decision to don a disguise is motivated by fears that are likely familiar to many readers. Not yet confident in his newfound abilities, Parker is afraid of failure and public humiliation: that he will "be a laughing stock." Far from the concerns of more fully-fledged superheroes—severe and noble concerns for the safety of their loved-ones— Parker's fear of embarrassment is markedly ordinary. In his civilian wardrobe, he is just like the rest of us.

For the reader, who knows all of the superhero's secrets, the civilian disguise must be transparent. The reader must be able to see through the disguise in order to appreciate the complexities of sustaining a false identity, and the narratives that rely on it. It is a long-established convention in theatrical performance that a disguise must be transparent to the audience for the narrative to function as intended. Peter Hyland observes that, in the long tradition of theatrical disguise, "the audience does not need to be fooled by something that

it sees on stage in order to believe that the people on the stage have been fooled by it." Indeed, audiences do "not expect to be fooled by stage disguise." They need to be aware that "an actor who has just entered [is] playing a disguised version of the same character he had played before rather than a different character" (Hyland, 2002, pp. 78–79). When readers see Clark Kent or Bruce Wayne partake in everyday errands or activities, they need to know that he is capable of so much more. With this knowledge, the alter ego's apparently normal actions take on extra significance. In Christopher Nolan's *The Dark Knight* (2008), Bruce Wayne neglects to intervene as a cocktail party is raided by the Joker and his henchmen. He escapes into a space that guests assume to be his panic room, and closes the door behind him. His actions appear selfish. The host appears to have deserted his guests, leaving them helpless in the hands of a gang of criminals. The viewer, however, knows of Wayne's superhero alter-ego, and understands his true motives. They know that he cannot intervene while dressed in a tuxedo. He must first change into the Bat costume, then reenter the party as Batman, as if with the impeccable timing of someone who is everywhere at once.

Transparency of the disguise may be enabled through plot. "A character intending to take on a disguise usually announces either in soliloquy or to a confidant that he or she is going to do so" (Hyland, 2002, p. 79). Equivalent exposition occurs in superhero narratives, as a panel explicitly reveals that Superman and Clark Kent are "one and the same" (in *Action Comics* #1 Superman is shown pulling his shirt over his costume), or that Bruce Wayne explicitly announces that he will "become a bat" (*Detective Comics* #33, November 1939). The iconic image of Superman, so frequently parodied as it has been in Alex Ross's *Time for Change* (see Chapter 1), depicts Kal-El in transition between his two identities, ripping the shirt of his civilian suit open to reveal the Superman costume hidden beneath. The readers are shown both costumes—both identities—simultaneously, so that there can be no doubt that the two identities belong to the same man. "If we do not lose sight of the identity of the impersonator . . . we observe . . . his skill in playing his new role" (Muecke, 1986, p. 218). Without this insight, appreciation of the superhero's struggle with identity would not be possible, and there would be no opportunity for the dramatic irony that is staple in numerous narratives.

Unmasking Clark Kent

Superman is different from the average superhero with respect to this secret identity issue . . . In other cases, the superhero identity is secondary, artificially constructed identity, while the original, ordinary civilian identity is the real one, but that for Superman, it's the other way around . . . The Clark Kent persona

is the disguise . . . The mild-mannered reporter guise is just that, a sustained ruse.

<div align="right">MORRIS, 2005, pp. 256–257</div>

For Superman, the clothes of his civilian alter-ego are not merely "ordinary"; they are a very specific interpretation of "ordinary." This is "ordinary" from the perspective of the superhero; "ordinary" viewed through the eyes of the extraordinary. Clark Kent is "Superman's opinion of the rest of us" and his everyday workwear is Superman's interpretation of how the normal, human population dress. Clark Kent is "a pointed caricature" of what Superman sees as an average human male (Feiffer, as cited in De Haven, 2010, p. 38). Kent's civilian clothing therefore offer insight into how he views humanity—at least in its most typical, American form—as dull, gray, and stiff.

Kent's glasses are the cornerstone of his disguise. They are a kind of "costume shorthand" (Hyland, 2002, p. 81) that provide the pivotal event in the transition from one alter ego to the other, regardless of what else he is wearing, the glasses are enough to mark Kent apart from Superman. In *Superman: The Movie* (Richard Donner, 1978) the transformative power of the glasses are shown as Clark, for a moment, considers revealing his identity to Lois. While Lois fetches her coat, Clark Kent waits in her hallway. He lowers his glasses, and as he does so, his posture changes. His shoulders straighten, his chin rises, and he adopts the heroic air of Superman. He begins to speak in the deep baritone of his super alter-ego, and despite his dinner suit, he is Superman. Within moments of Lois' return, he changes his mind about the confession, and lifts the glasses back up to his face. Suddenly, he is Clark again.

Superman does not naturally fall into this mold of ordinariness. It has been tirelessly constructed. *Superman*: *Earth One (Vol. 2,* 2012*)* tells of how the young Clark Kent, an intellectually brilliant student, capable of outshining all his classmates, purposefully maintained a "C" grade for all his subjects. Lois Lane observes that Kent's academic performance was not only average, but consistently so. There was no subject at which he excelled, nor one at which he struggled. He maintained a precisely average level of interest and academic achievement. Young Clark had repressed his extraordinary abilities, and constructed a persona that was modeled on the norm, continuing his performance of ordinariness into adulthood. Matt Wagner's *Trinity* (2004, pp. 8–9) tells of how Clark's commute to *The Daily Planet* is frequently delayed as he misses three trains a week. Aboard the train, the regulars all chuckle at the guy they have dubbed "terminally late." His inner monologue reveals this to be a purposeful imitation of the unreliability of human commuters, as Kal-El sees them.

While Superman learns from observation, Batman and Spider-Man learn from recollection. Superheroes who have acquired their powers later in life have a previous self as a model for their civilian persona. Spider-Man did not have to

invent his civilian wardrobe the way he did his Spider-Man costume; he only has to maintain it. Likewise, Bruce Wayne had wardrobes full of expensive suits before he concocted his Batman costumes. But even in these cases, as soon as they don the superhero suit, the civilian wardrobe becomes part of a disguise, and the hero must be conscious of the persona that it communicates. They must try to dress and behave as they did before they acquired their superhero identity, preserving the image of their former selves.

Comparisons can be made to the methods used by undercover researchers. There are "Strict codes of cultural boundaries which are vigorously enforced" which necessitate the invention of false identities (Fhlainn, 2009, p. 4). Secret identities are constructed in order to "gain research access to otherwise closed research settings." This may occur when the subject of a study is "closed or inaccessible" to outsiders, just as normal human society is likely unwilling to accept a super-powered semi-human as one of their own. Humanity is a closed society; we do not treat nonhumans (or those with nonhuman powers) as equals, and so it would be difficult for a superhero to lead any semblance of a normal life, or to integrate into society, were he not disguised as ordinary. Likewise, a journalist who intends to write an article on the Mafia, a spy who investigates a terrorist cell, or an anthropologist who analyses aspects of subculture, must present themselves with an identity that is "indigenous to that setting." Covert participant observation, when it is employed in journalistic, anthropological or other social studies, falls into several categories. Martin Blumer identifies two of the roles these covert researchers play as "covert outsider" and "retrospective participant observer" (Blumer, 1982). The "covert outsider" is one who originates from outside the subject of his study, and disguises himself in order to infiltrate the group. He learns their costumes and customs, and then positions himself as "one of them." His real identity remains secret. Superman falls into this category. As Kal-El, he is Kryptonian—an outsider to human society. He uses his childhood experiences to construct a believable pastiche of an ordinary human, and adopts that identity in passing himself off as the human Clark Kent. Other superheroes, who have acquired their powers later in life (Batman, Spider-Man, etc.), are "retrospective participant observers," having participated in ordinary human society before they became super-powered. Throughout this learning process, they were genuine participants in civilian society. They are able to reflect on their past experiences, and use them to create a model on which they construct their civilian disguise.

But no matter how effective the costume, an "actor unavoidably remains just outside the character he is playing" (Walter, 2011). Despite the apparently ordinary identity expressed by his civilian wardrobe, it cannot remove the superhero's powers.[1] Once a hero has gained his powers, he can never go back. For better or for worse, he is a changed man. He may remember what it was like to be ordinary, but even dressed as his former self, his civilian wardrobe is only a mask. The superhero is concealed, never eliminated, when he reclothes himself,

and so "there is always the ghost of a self in his performance" (ibid.). Clark Kent will always be Superman, whether at home shaving with his heat vision reflecting from a shard of the spaceship that brought him to Earth, aiding his adoptive father on the Kansas farm homestead by shifting dozens of heavy bags of grain in the blink of an eye, or at the offices of *The Daily Planet*, where typing at super-speed allows him to file a story before deadline (see *Superman: Birthright*, 2004).

Self-objectification

Anyone who must inhabit different identities—actors, con-men, superheroes—must have "an undeniably complex relationship with self." The act of dressing in costume makes an individual acutely aware of "the presentation of self" (Goffman, 1959), "giv[ing] him a heightened awareness of the methods by which we create and recreate selves [through] the act of clothing and re-clothing" (Walter, 2011). The design and wearing of the superhero costume must make the superhero aware that his civilian clothing is also a kind of costume, and that the two alternative costumes are equally as important in expression of identity. The job of a superhero involves not only "clothing," but also "re-clothing" (ibid.); dressing up as a hero, or dressing down as a civilian. In both guises, aspects of his identity "are expressively accentuated and other aspects, which might discredit the fostered impression [of the alter ego], are suppressed" (Goffman, 1959, p. 111). In *Superman: Earth One* (2010), Clark presents himself in front of the mirror in glasses, tie and cardigan, and informs the reader that *this* wardrobe, as much as his superhero suit, is his mask.

By differentiating his two alter egos through costume, the superhero acknowledges the power that clothes have in expressing identity, and so embraces the idea that he can be judged according to his wardrobe. As Lucy Collins (2011) observes, the act of dress in identity construction is an acknowledgment of objectification. The superhero makes the conscious choice to have two different wardrobes because he understands that audiences will assess him according to his appearance. Audiences will readily objectify him and his alter ego, and this is something that the superhero is able to exploit. Indeed, it is in the superhero's interest to invite objectification—to be judged according to his appearance—as the secret of his true identity does not lie far from the costumed surface.

Dressing down, and inviting objectification, is key to "trans-status disguise" (Hyland, 2002, pp. 77–83), a practise that flourished in the late nineteenth century social experiments, and is still vital in more recent journalistic practices such as those employed by Polly Toynbee (2003). In 1890, Jacob Riis published *How The Other Half Lives*, a taxonomy of class structure which included notes on "bodily signifiers" of class, most notably, costume. In his text, Riis invited readers

to covertly "be with and among [the] people [of lower socioeconomic status] until you understand their ways" with the aim of encouraging greater trans-status empathy (Schocket, 1998, pp. 112; 118). There then began a trend for articles in British and American periodicals that featured the observations of "middle-class [reporters] who briefly lived 'working-class' lives." The accounts of these writers reveal dress as core in the construction of a trans-status disguise. In 1903, Jack London expressed surprise at how remarkably attitudes toward him changed when he donned a frayed jacket. The jacket, he noted, became a "badge and advertisement of [his perceived] class." By "vesting [him]self in class-specific apparel" he invited observers to make assumptions about his socioeconomic status, and in so doing created opportunities to "move freely" among social groups that had formerly viewed him as an outsider (London, 1903, as cited in ibid., p. 119).

These journalists and sociologists cloaked themselves in a signifying cloth, granting liberation and opportunity (Schocket, 1998). The clothes reduced their status, masking anything remarkable about their profession or prestige, and they found themselves empowered. The disguises gave them a peculiar power of normalcy and anonymity, which allowed them to partake in relationships and activity that were previously out of their reach. The superhero experiences this same liberation. In his civilian clothes he is able to walk down the street, sleep in an ordinary bed, shop for groceries, and form relationships. Perhaps most importantly, he is able to drop his guard. The civilian clothing provides relief from the constant pressure to save the day, and to live up to his own remarkable reputation.

Method in the masquerade

The transition from superhero to civilian identity, and vice versa, is necessarily a private act. In order to preserve the secrecy of the civilian identity, it is vital that there are no audiences for the transformation that occurs when the superhero dons his costume. Batman's transformation occurs in a secret location, the Batcave, as hidden as the Bat's real identity. With his super-speed, Superman is able to change in relatively public spaces, most famously, a phone booth. The speed at which he changes into his costume makes the act invisible to the human eye. Other superheroes find the preservation of their secret identity more difficult. The costume must be kept somewhere secure, as its discovery could potentially reveal the superhero's identity, but also close-at-hand, so that it may be accessed quickly. Peter Parker keeps his costume in his backpack, so that his two identities are never far apart. This makes him vulnerable to discovery, as the costume, and so Parker's secret identity, could so easily be revealed.

It is during transition that the superhero is most vulnerable. He has not yet fully adopted the superhero identity, and so lacks the power of the disguise. His duality—the thing that he most closely guards, and at all costs—is exposed at that moment of change. He has neither the anonymity of his civilian alter-ego, nor the strength of his superhero identity to protect him. The privacy of this moment is important in any wearing of the mask. In theatrical performance, even though audiences know that the mask identity is fictional, a glance at the actor as he steps into his costume ruins the audience's experience. There are performances in which costume changes take place on stage, but actors always go to great lengths to conceal the transformation, to the extent that "quick change" is a sought-after skill (Sobchack, 2000). In Sichuan opera, performers of "bian lian" ("face changing") change their masks in full view of their audience, using sleight-of-hand so that the transformation is invisible. Great skill is involved in achieving change as quickly and smoothly as possible (Scott, 2008). The performer may wear several layers of thin masks, peeling them off a layer at a time throughout the performance (the "pulling mask" technique) or, in the "blowing mask" technique, colored powder is blown onto the performer's oiled skin (Yu, 1996, p. 13; Ho, 2006). These performers have felt the need to hone their "face changing" skills over many years out of appreciation for the importance of keeping transformation a secret. Like superheroes, they know that the mask is only powerful if audiences cannot comprehend the connection between one identity and the other. The two wardrobes of the superhero exist primarily in order to eliminate one another.

Though the costume plays a vital role in this deception, it is only part of the disguise. To truly fool his audience, the superhero's civilian alter-ego must act the part. Anthony Dawson equates disguise to a kind of theatrical illusion (Dawson, 1978, as cited in Hyland, 2002, p. 77). In stage magic, the illusionist's tools are disguised as everyday objects (Tognazzini, 1993, p. 356). As long as the objects on stage are perceived as common objects, the audience will assume that they have properties commonly associated with those objects and are not capable of anything extraordinary. In this disguise, "naturalness" and "consistency [are] key to conviction" (ibid., p. 355). In this instance, naturalness is akin to ordinariness. In his civilian wardrobe, a superhero's behavior and mannerisms must compliment his garb. The civilian wardrobe must eliminate every trace of the superhero, and his performance must appear authentic.

The two performed roles of the superhero align with Percy Fitzgerald's definitions of the two most common methods of acting: "self-exhibition" and "real acting" (Fitzgerald, 1870, p. 259, as cited in Walter, 2011). In his superhero costume, the superhero is an exhibitionist. He is colorful, larger-than-life, and moreover so unique that he conforms to few expectations.[2] He is *supposed* to stand out from the crowd. The civilian alter-ego, however, must conform to very strict expectations, existing in a world of normal people, who understand

normality because they inhabit it. These ordinary people are quick to spot anything that is not quite right and so the superhero's civilian wardrobe must arguably be more effective a disguise than his superhero costume. To ensure authenticity, he must do all that he can to embody the civilian role; a kind of Method acting.

The superhero must learn to inhabit his two distinct roles with such ease that both performances become second nature. The temporal medium of film is ideally suited to communicate how quickly the superhero must slip from one identity to another. On screen, audiences have seen Clark Kent enter a revolving doorway, utility closet or phone booth, and then emerge mere moments later as Superman. Over time, the civilian alter-ego becomes a way-of-life; so much so that the superpowers become apparently connected to the costumed role. Any superhero who readily uses his powers without his suit seems to contradict the rules of the genre. The conventions of superhero comics forbid the superhero from using his powers while dressed in his civilian wardrobe, and any attempt to do so is likely to go awry. In *Superman* #652 (July 2006, aka *Up, Up and Away,* part 5), Superman has been without his powers for a year when he suddenly regains them. In his civilian wardrobe, he tries to regain control of his powers, and thereby return to his former self. He attempts to leap over a tall building, but loses control, slips and lands with a "*whaaam*" on the concrete. Throughout this failed experiment, Superman remains dressed as Clark Kent. With powers that are limited or poorly functioning, the character is not fit to wear his Superman costume. Unless he can embody Superman, and do justice to the costume, he must remain trapped in the wardrobe of his alter ego.

6

CHANNELING THE BEAST

There is a breed of superheroes who take their powers or their identities from animals, most notably Spider-Man and Batman. The costumes addressed in this book so far are largely inanimate and abstract. Clothing and costume generally has no identity of its own, rather it helps the wearer to project his own identity through association with particular social groups or lifestyles. Animal costumes are an exception to this rule. An animal costume aspires to be something else, and so allows the wearer to play at being something other than himself, specifically, that animal. The costume itself has an identity, and aspects of that animal identity are transferred to the wearer when he dons the costume.

Superheroes are experts in biomimicry. There are those that are supernaturally animalistic (Mandrill, Tigra) and those who choose to construct themselves as animal through costume (Batman, Wildcat, American Eagle, Nite Owl). Even those costume elements which may not initially appear animalistic may function similarly to things found in the animal kingdom. Batman's chest insignia is shown to function similarly to defensive eyespots on butterflies. In *The Dark Knight Returns* #2 (May 1986) and again in *Batman: Dark Victory* #5 (April 2000), Batman survives bullet shots to the chest thanks to a reinforced chest plate beneath his large bat insignia. To the observer or combatant, the insignia appears to be a "bullseye motif over the heart" (Leigh and Lepine, 1990, p. 45). Batman's inner monologue reveals the reason for displaying such a visible "target" in the center of his chest is to attract fire to the part of his body that is most heavily armored. In this respect, the insignia functions like an animal's eyespot, deflecting attack from more vulnerable parts of the body (Olofsson et al., 2010).

In adopting an animal costume, superheroes channel a beast. Though they are still human, they adopt the ferocity and strength of an animal. In doing so, they cast off the restraints imposed by civilized human society. In costume, the superhero may resort to primal behavior, reflecting instincts that have been repressed by millennia of social and academic advancement. So, argues Peter Brook (1987, cited in Tseëlon, 2001, p. 26), a mask "is actually not a mask. It is an image of an essential nature. In other words . . . a portrait of a man without a mask." The man behind the mask is an artificial construction, but the mask

allows him to be who he really is; to revert to a primal, unsocialized, and arguably "pure," animal version of himself.

Parallels can be drawn with shamanistic skin-walking rituals, and animal role-players and cosplayers who develop "anthrozoomorphic" identities which draw upon "the spiritual and supernatural associations of the animal kingdom" (Robertson, 2013b, p. 7). These adopted identities are not wholly animal, but hybrid "animal-human beings," which enable an individual to separate his civilized human and primitive animalistic alter-egos, and thus more fully understand his own humanity (Turner, 2008, p. 33; Carlson, 2011, p. 199).

Physiognomy and anthrozoomorphism

Images depicting animals with human characteristics, and hybrid animal-human beasts, were a staple of ancient religion and mythology. Sometimes, they were deities, like Bastet, the feline goddess of Ancient Egypt, and at other times they were the monstrous product of animal/human coupling, like ancient Crete's Minotaur. These historical animal-human hybrids had a special power and allure. The duality of this fusion of "human and the non-human" can be frightening, or at least unsettling, drawing attention to humans' desire to perceive themselves as distinct from the animal kingdom, and discomfort at anything that spans that divide (Bahun-Radunović, 2011, p. 69). This awkward mix of fear, unease, and respect remained throughout the ages, as societies continued to produce tales of were-creatures: humans cursed with transformation into a beast.

Charles LeBrun (1619–1690) was the first illustrator to depict animal-human hybrids for physiognomy. The seventeenth-century fashion of physiognomy, to judge character according to the features of the face, prompted caricaturists to seek associations between facial features and particular personality types, and in LeBrun's case, this involved establishing associations between the features of animals and their perceived personalities. LeBrun depicted the god Jupiter with facial features approaching those of a lion to convey "serenity, courage, and ferocity," a man with the extended snout of a hog to suggest gluttony, and another with the protruding forehead of a monkey, which to LeBrun represented intelligence (Morel d'Arleux, 1806). Although the connotations of these hybrids may have changed (to contemporary caricaturists, the monkey represents *un*intelligence), techniques of anthropomorphism are now mainstays of editorial cartoons and caricatures. Comic-book creators are equally keen to depict humans or superhumans whose appearance and behavior approaches that of an animal. The Penguin, introduced as a villain in *Detective Comics* #58 (December 1941), is stout with a beak-like nose, and in many depictions bears a remarkable resemblance to LeBrun's illustrations of physiognomic eagle heads. Theories of physiognomy are also taken for granted in costume design, as

superheroes are perceived as taking on properties of the animal that their costume represents. These animal costumes seem to signify something about the wearer that is extracted from what we know about their chosen animal.

Animals selected for use in ritual masks tend to be those that are deadly to man. "The dominion of man over animal" extends only to livestock and domesticated creatures (Carlson 2011, p. 207). Wild animals, particularly predators, remain a source of fear for humans who visit or inhabit wild spaces. "The capacity of the animals to kill represents great warrior like power" and it is that power that the wearers' of masks are most eager to invoke (Bedeian, 2008, p. 11). Though superheroes' chosen animals are not always deadly, they do tend to take inspiration from fierce and predatory creatures. For comic-book creators, what seems more important than the real physical threats posed by animals is the fears that they inspire. Superheroes including Batman "enrobe themselves in nightmares" (Langley, 2012, p. 119), identifying with animals that pose little or no threat in reality, but yet have the capacity to provoke irrational fear. A superhero's decision to take inspiration from a fearsome animal demonstrates an understanding of audiences' subconscious, albeit irrational, tendency to judge an individual's capacity for aggression according to his physical attributes. Batman knows that, despite physiognomy having been thoroughly discredited, his appearance as a bat will strike fear into the hearts of Gotham City's criminal underworld. Bruce Wayne's choice of a bat is prompted by his perception of the bat as "a creature of the night, black, terrible" (*Batman* #1, 1940).

"The Batman Nobody Knows" (*Batman* #250, 1973) illustrates the potential for a nightmarish symbol to be transformed into an individual's worst fears through rumor and speculation. The comic follows a group of underprivileged children on a camping trip led by Bruce Wayne. The boys speculate about Batman's abilities and appearance. One paints him as a monstrous human/bat hybrid with wings so large that they blanket the whole of Gotham. Another describes a man ten feet tall with real bat ears that give him super-hearing. When Bruce decides to surprise the boys by appearing as Batman, they are so unimpressed by his costume that they refuse to believe that he is the real Batman.

The fear-provoking properties of bat costumes have made them popular Halloween and fancy-dress costumes, even before Batman's inception. Photos and illustrations from the late Victorian era depict bat costumes that bear a striking resemblance to Batman's suit. A late-nineteenth-century French fashion illustration published in *La Mode Illustrée* depicts a woman's costume with bat wings (see Figure 6.1). The cape extends over the shoulders and terminates at the tips of the wearer's fingers, where it is stitched to the gloves so that it can be dramatically spread when the wearer outstretches her arms. In this illustration, the small bat on the chest appears three-dimensional, as if a model of a life-sized bat. In photographs from the time, this model bat has been reduced to a flat bat insignia. The ensemble is capped with an oversized bat head, as if the wearer

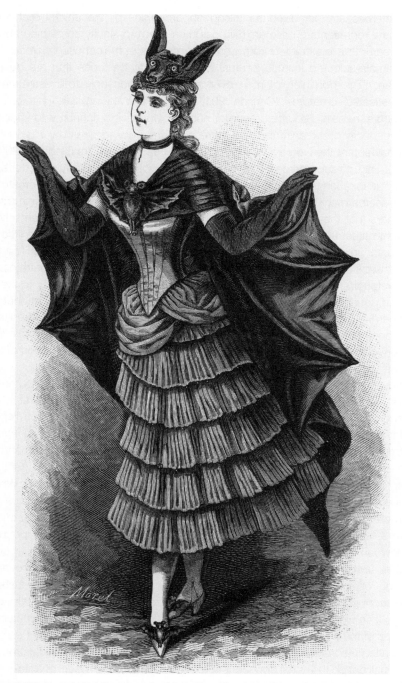

Figure 6.1 French fashion plate, *La Mode Illustrée: Journal de la famille,* 1887, depicting a bat-themed fancy-dress costume. The costume includes a bat insignia on the chest.

has slain a giant bat and is proudly exhibiting the spoils of her hunt. Though there is no evidence to suggest that Bob Kane imitated this costume, its existence many years before the first *Detective Comics* suggests that perhaps there is something intuitive about this kind of human-bat transformation.

In Grant Morrison's *Batman: The Return of Bruce Wayne* (Part 1: "Shadow on Stone," 2010), Batman is depicted with reference to the animal sins used in shamanistic rituals. Having traveled through time, Bruce Wayne finds himself battling cavemen. He drapes the carcass of a giant bat over his shoulders, transforming himself into the "Man of Bats." With a real bat's head as a hood, and wings as a cape, this incarnation of Batman directly inhabits the body of the bat. The costume seems to take inspiration from "skin-walking," a mythical practice of some Native Americans, who purportedly had the ability to transform into any animal by wearing its pelt. Batman's adventure through time takes him back to an era of "humankind's earliest attempts to relate to their origins" (Cooper, 1999, p. 26), when animal masks were worn to liberate the wearer from inhibitions by returning to "a pre-civilized and pre-inhibited 'deeper strata of existence'" (Bihalji-Merin, 1971, cited in ibid.).

The difference between this man-in-batskin and the twentieth- and twenty-first-century Batman draws attention to the more symbolic, reductionist design of Batman's costume. The costumes of anthrozoomorphic superheroes take only key elements from their animal source. Batman, for example, has a minimalistic approach to the bat's form. In costume, he casts the shadow of a bat, but many of the core features of a real bat, such as fur, have been omitted. Animal costumes in ritual may include elements appropriated directly from the animal, such as the skin or bones which cloak the "man of bats," but the mask is more commonly a designed artifact. It is a stylized, abstract interpretation of the animal. Features are simplified or accentuated, patterns are made more geometric, and overall the face becomes less a direct replica of nature than a human interpretation.

An equivalent process occurs in the creation of animal superhero costumes. One commonly recognized practice in comic books and caricature is reductionism; a practice of eliminating those characteristics that are not meaningful or expressive, so that they do not distract from those elements that are considered vital in the identification of character or expression of personality and emotion. As Stuart Medley (2010, p. 53) observes, "all comic artists employ at least some level of . . . abstraction, some removal of realistic detail." In caricature in particular, images "amplify perceptually significant information while reducing less relevant detail." What this achieves is emphasis on the "unique" features of the subject (ibid., p. 65). When few features of the animal must be chosen for use in a costume, this process must be highly selective. They must be the features that are most expressive of the animal traits that the superhero hopes to invoke. No two interpretations of an animal are the same, as each selects different features in signification of a specific set of values. Catwoman's costume, for example,

takes inspiration from the cat as predator, not as a cute and fluffy companion. Her costume, therefore, omits the feature of a cat that is most associated with domestic cats, namely, the fur, but retains features that allow her to appear sleek and lithe.

By concealing human expression, an animal mask communicates minimalistically. Reductionism masks facial expressions, and thereby conceals the "hesitancy," "sensitivities," or other human weaknesses of the wearer (Cooper, 1999, p. 25). The ambiguity of animal expression makes the masked superhero's intentions impossible to gage, giving him the advantage of surprise. Wendy Woodward (2009) draws parallels between animals and "faceless others." To Woodward, the human face, which can be read as communicative and subjective, expresses the individuality that marks humans from animals. The face is our most expressive body part, transmitting a human language of social signals. By rendering humans faceless, as with a mask, they are reduced to the status of animals. Man's inability to read an animal's intentions in its facial expression causes animals to be unpredictable and therefore potentially dangerous.

Where superheroes have been depicted as family-friendly, efforts have been made to make the mask less ambiguous, and therefore less menacing. Injecting human emotion back into the mask reduces the perceived threat imposed by the wearer. The eyebrows painted on Adam West's Batman mask have this effect, presenting Batman as a nonthreatening character for the show's family audience. These painted brows arch quizzically upwards, humanizing (and perhaps feminizing) the hero.

In conjunction with this reductionism, remaining features must be exaggerated, as they are in caricature. The visual simplicity of some comic-book images requires a superhero to be instantly recognizable from the color and shape of his costume. The superhero must be recognizable in his most simplified form, by a pose or silhouette. For this reason, those features that form part of the silhouette are often those that are retained in interpretation of an animal. The bat's ears, though not the most striking feature of a bat in reality, form a crucial part of Batman's costume because they differentiate the shape of his head from others in the dimly lit alleyways of Gotham City. Likewise, the bat cape, which has the added benefit of being (sometimes) functional, allows Batman to mimic the silhouette of a giant bat, and to adopt a bat-like pose, with the cape wrapped around his body as if they were closed wings. The distinct silhouette, and a design that "disregard[s] most of the interior detail" allows Batman to be "depict[ed] accurately . . . in outline" (Medley, 2010, p. 57). In film and television incarnations, Batman is often in motion as well as in shadow, increasing the need for an instantly recognizable silhouette. Simplified shapes allow messages to be communicated more quickly, and more clearly (McCloud, 1993, pp. 37; 41). It is useful to provide "only as much visual information as is needed to convey the basic facts. Anything more elaborate would slow down a potentially urgent

message" (Poynor, 2001, p. 78, as cited in Medley, 2010, p. 57). Batman remains recognizable because his suit has been so successfully simplified.

Anthrozoomorphic costumes are not, however, straightforward reductionisms of an animal's visual appearance. These costumes must also reference behavioral characteristics of that animal. Superhero costumes can be a complex mixture of messages from several sources that prioritizes particular aspects of an animal's appearance and behavior. Visual references to lifestyle and behavior are observable in Spider-Man's costume. Despite his name, Spider-Man does not dress as a spider. The spider is simply a motif—a chest insignia that pays tribute to the animal that gave him his powers—while the larger part of his costume bears very little resemblance to a spider, instead taking inspiration from the spider's web. In this way, Spider-Man's costume avoids expressing affinity for an arachnid spirit. He is not, unlike Batman, reduced to an animalistic self. The extent to which he is a spider extends only to his abilities (speed, web-throwing), not his personality.

The bird men

As is the case with the technologically advanced costume of Iron Man (see Chapter 11), costume can enable superhuman ability. In the case of animal costumes, the suit may imbue the hero with animal powers. Of all animal abilities that the human species lack, flight is perhaps the most sought after. There are a number of flying heroes endowed with avian or insect wings, including Red Raven, American Eagle, Mimic, and Wasp. There are also heroes for whom flight is a manufactured ability, including Falcon, whose wings are artificially constructed so that he may form a closer bond with Redwing, his avian familiar. Other winged costumes, including that of the X-Man, Banshee, incorporate wings that more closely resemble the canopies of real-life wingsuits.

The real-life inventor of the wingsuit, Clement Joseph Sohn, was dubbed "The Bird-Man" (in reference to Leonardo Da Vinci), and later "Batman," by the press (Hagen, 2014). Sohn's invention features wing canopies constructed from cloth mounted on a wooden frame that can be "manipulated . . . from a closed position of non-use to an outspread position of use" (Davis and Sohn, 1935). The contraption bore remarkable resemblance to that of the augmentations worn by Falcon, whose "wing pack" features jointed "wing braces" and "spring tensioned lumbar support" (*Official Handbook of the Marvel Universe* #15, 1986), or some incarnations of Hawkman, whose artificial wings are fastened to his body with detachable leather straps (see *Identity Crisis* #3, October 2004, to see what happens when the straps fail). Sohn's glider proved successful, enabling the self-styled "bird-man" to soar safely until he met a tragic end when his parachute failed to open in 1937. Sohn's death was the first of many who made similar attempts at winged flight. Rex Pemberton (2013) records that "between 1930

and 1961, 71 out of 75 people who attempted human body flight using wingsuits died trying." In the 1990s, wingsuits saw a revival, and they are now in mainstream use for skydiving and base jumping. Contemporary wingsuit canopies now incorporate complex systems of air inlets and inflatable cells, but nonetheless, the safety of those who fly in them is still not assured. A study by Hasler et al. (2012) found that participants in airborne sports are twenty-one times more likely to suffer spinal injury than the general population, making skydiving and base jumping extremely high-risk activities.

The practice of base jumping has been criticized, largely because of the risk involved. Gunnar Breivik (2007, p. 169) singles out base jumping in his moral defense of extreme sports. He identifies three categories of risk taking: first, "pro-social risk"; "anti-social risk"; and "ludic risk." Superheroes activities may be seen to fall into the first of these categories—"pro-social risk"—in that "risk is taken for the sake of others." As defenders of others, these superheroes wear wings so that they may be more effective at saving lives. Indeed, this is true of all superhero antics, which are high-risk activities carried out with the aim of helping others. There is, however, some evidence of "ludic risk," that is, risk taken for personal satisfaction. Winged superheroes are sometimes depicted as enjoying the freedom offered by their artificial wings. Indeed, some perform advanced aerial acrobatics that serve no social purpose, but rather appear to be performed either for personal enjoyment or to impress onlookers. When Falcon gets his first set of wings, he takes pleasure in gliding through the air (*Captain America* #171, March 1974); Avenging Angel chooses self-propelled flight over jet travel, as a matter of "style" (*Uncanny X-Men* #58, July 1969).

Superheroes whose wings are natural limbs rather than costume attachments, face problems that can be avoided by those whose wings are artificial and detachable. The inability to remove wings makes it almost impossible for winged superheroes to conceal their otherness. Angel (also known as Avenging Angel and, later, Archangel) is able to maintain the alter ego of Warren Worthington III by concealing his wings inside his civilian clothing.[1] *The Uncanny X-Men* #1 (September 1963) provides insight into Worthington's disguise. Worthington is shown changing out of his civilian clothing, including a harness which features "restraining belts" to prevent his wings from "bulging under [his] shirt." The harness allows Worthington to pose as an ordinary human, while also making it impossible for him to fly. It renders him human in form and function.

Ritual and the animal spirit

The donning of animal costume is a practice that has historically been connected to sacred rituals, and the invocation of animal spirits. There is evidence to suggest that the wearing of animal masks "during ritual performance" dates back at least

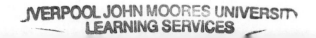

to the Bronze Age (Karageorghis, 1971, p. 262). Animal masks were often worn in combination with animal skin cloaks, and sometimes a headdress of horns that had been directly removed from a sacrificed animal. The masks were, and in many countries still are, "believed to be sacred magical objects providing a portal for . . . spirits" (Bedeian, 2008, p. 1). Wearers "enter into a direct association" with an animal god or spirit "by putting on the divine image," often entering into a trance state in which they are overcome by the spirit of the animal (Karageorghis, 1971, p. 261). The wearer is so transformed during the ritual that he is perceived as having become "invested with the spirit of the mask" and "effectively no longer human" (Bedeian, 2008, p. 11).

Bruce Wayne conceives the Batman identity in Bob Kane and Bill Finger's "Legend of the Batman" (*Batman* #1, 1940) not merely by selecting a costume that resembles a bat, but with the statement "I shall *become* a bat." His costume represents a state of being that spreads far deeper than a masquerade. In *Batman RIP* (Grant Morrison, 2008), Batman, through a focused program of mediation and sensory deprivation, is able to summon an alternative persona, The Batman of Zur-En-Arrh, who is strong enough to withstand psychic attack. This state of mind is comparable to the trancelike states entered by shaman engaged in masked ritual. Like masked shaman, Batman is able to overcome the weaknesses of his own identity, and becomes someone—or something—else.

Carlson (2011, p. 194) observes that animal costumes enable the wearer to outwardly manifest an "inner animal that exists as a kind of primitive substratum." Just as the mask invites freedom from societal constraints (see Chapter 2), "performing an animal identity provides a way out of human norms that have become unduly restrictive" (ibid., p. 195). As part-animal, the superhero is able to act savagely and aggressively, apparently without compromising the humanity of his alter ego. He may even adopt some of the combat tactics seen in the animal kingdom: many animals use particular poses to make themselves look larger, and therefore dominant, and superhero costumes enable superheroes to do the same. Batman's cape, for example, extends Batman's silhouette so that he appears much larger than other men. Particularly in the dark, and when the cape is in motion, it is difficult to gage the extent of his size, and he is able to give the impression of an inhumanly proportioned figure.

The savage spirit is evidenced in the behavior of many superheroes, not least those who dress as animals. As Danny Fingeroth (2004, p. 161) observes, superheroes are not "active agents of change," rather, they are "reactive" individuals who respond instinctively and immediately to their surroundings. To this extent, superheroes, like animals "live only in the present" (Webster, 2011, p. 29). Animals react to primitive sensations, such as hunger, rather than considering long-term goals or considering anything beyond their immediate

situation. It may be that superheroes choose to don animal costumes in order to account for such reactive tendencies.

Human and animal existence is differentiated in part by differing relationships with their environments (Carlson, 2011, p. 201). An animal has a territory or environment, and it has no concerns beyond the spaces and creatures with which it interacts. A human has wider awareness of a world that extends beyond his or her own experience. By dressing as an animal, a superhero narrows his engagement with the world. In his costume, he engages directly and almost exclusively with a criminal underworld and its victims, with the single-mindedness of an animal stalking prey (see, for example, the contrast between the philanthropic activities of Bruce Wayne and the primally reactive actions of his animal alter-ego).

It is vital to note that the superhero is never perceived as having entirely transformed into the animal that his costume represents. The superhero does not completely or permanently adopt an animal identity. In costume, superheroes, "present themselves as hybrid animal-human beings" (Turner, 2008, p. 33). By presenting themselves as hybrid creatures, superheroes are able to be simultaneously more and less than human.

Wearers of animal costumes are not subject to all of the instinctive urges of a beast; their "animal nature" restrained by "human culture" (Turner, 2008, p. 33), and so they must be feared like an animal but respected like a human. Even in costume, a superhero has the values and intelligence of a human, combined with the strength and speed (and sometimes, ferocity) of the animal. This makes them more powerful than the animal which they have chosen as their inspiration or guide. Hybridity suggests that, although they may be strong and fierce, these superheroes' actions are calculated. This is a message that is comforting to innocent civilian bystanders, who are reassured that they will not be the target of the superhero's violent acts, while terrifying for the superhero's intended targets.[2]

So, while the superhero may be driven by animalistic urges, his actions are framed in human social contexts. In Webster's (2011) exploration of zoomorphism, he equates the primal sensation of hunger to "a primitive dissatisfaction with the status quo." Superheroes use the animal identity to react primally to a sense of injustice.

Parallels can be drawn with the "inter-species affect" of "furry" cosplay. In which people dress and behave as animals or animal/human hybrids (Carlson, 2011, p. 194). In furry cosplay, Carlson (2011, p. 194) observes not just "a monstrous combination of animal and human," but an "outward manifestation of an inner animal." Drawing on archaeologists' discussions of hybrid animal/human figures, Robertson (2013b, p. 7) locates furry cosplay among wider practices of "therianthropy." Robertson's research focuses on online communities who engage in anthrozoomorphic role-playing, and who, like furry cosplayers,

feel "a profound connection with a non-human animal that . . . is an integral part of their identity" (Robertson, 2013b, p. 8).

Marla Carlson's exploration of furry lifestyles centers around "Stalking Cat" (formerly Dennis Avner), a Michigan-born man who had his body surgically altered to resemble a tiger, so that he may live as a part-human and part-feline hybrid. For Potts (2007, pp. 144; 146) the slow and permanent "shape-shifting" of Stalking Cat is a "profound example of human-to-animal body transformation," which has allowed Cat to resolve his species dysphoria. Cat has long experienced "a special affinity for cats . . . manifested on all levels: physical, emotional, psychological, and sensual . . . and he feels sure other humans would not understand" (ibid., p. 146). In conversation, Cat speaks about humans as if they are another species, with customs and characteristics that feel alien to him. In making such statements, Cat positions himself as an outside observer of the human species.

This process of animal othering places Cat in a unique position to assess the behavior of "ordinary" humans. In constructing his animal self, he has become acutely aware of those characteristics that are unique to the human race. Carlson (2011, p. 199) proposes that "freak performers," including those who inhabit animal identities, exist in order to "define humanity" through contrast. Identifying animals as "other" reinforces a sense of human exclusivity. By dressing as an animal, the superhero is able to distance his civilized human self from his savage alter-ego, and in so doing reinforces, through contrast, the humanity of his civilian self.

Stalking Cat's appearance is not wholly designed to resemble a cat. Rather, it references a combination of appearance and lifestyle. Cat has had a number of implants and alterations to his face, giving it a feline appearance, and his skin is tattooed, with tiger stripes on his face, and fish scales on his arms. The fish scales refer to feline eating habits, making the overall affect more than a direct or straightforward attempt to replicate the aesthetics of a cat (Carlson, 2011, p. 192).

Stalking Cat is not typical of therianthropes, having permanently transformed himself. These communities draw heavily on shape-shifting mythology, ranging from the Japanese *kitsune* (fox/human) to lycanthropes (wolf/human), creatures who are defined primarily not by their species but by their capacity for cross-species transmogrification. These beings, like Batman and Wildcat,[3] temporarily reside in their animal skin. Their animal instincts lie dormant while they are in human form.

The kind of species dysphoria experienced by Cat is evidenced in superheroes who seem more at home with their animal counterparts than with other superheroes. In *Captain America* #177 (September 1974) Falcon becomes frustrated by Captain America, pulls on his winged costume, and leaps out of the window to join his adopted falcon with which he shares a telepathic

connection. The hero and his bird are depicted soaring majestically into the distance as the narration box confirms that Falcon's rightful place is with his avian compatriot. Nonetheless, when violence breaks out on the streets below Falcon returns to the human world. Ultimately, the lure of the animal kingdom is not enough to keep him, or other superheroes, away from their duty to the human species.

PART THREE

HARSH
REALITIES

7

SUPERHEROES AND THE FASHION OF BEING UNFASHIONABLE

Superheroes exist out of time. They do not belong to any particular era. In any one incarnation, they may be grounded in a particular temporal setting—the fashions of their companions may reflect contemporary taste, the gadgets may reflect contemporary technology—but the superhero himself is ageless and timeless. The superheroes that emerged during the Golden Age of comics: Superman, Batman, and Green Lantern among others, continue to operate in contemporary settings in comics and other adaptations. It is because of this timelessness that superheroes cannot be fashionable.

Costume is commonly divided into two categories: *modish* and *fixed* (Barnard, 1996, p. 12). Fashion is distinguished from other costume by its capacity for frequent and continuing change. It changes not only to accommodate the practical demands of the changing seasons, but also to appear fresh and innovative, reflecting a desire to be "à la mode." Costume, conversely, tends to be relatively unaffected by the passage of time. It is static, and preserves memories of the time at which it was first introduced. It is the nature of the fashion cycle that styles fall in and out of favor.

To be fashionable is to begin the inevitable descent towards becoming unfashionable. When a character must be ahistorical, and his costume must be at least largely consistent from one incarnation to the next, it would be dangerous to incorporate elements of contemporary fashion. Timelessness is achieved through consistency, as superheroes tend to adopt a fixed costume that evolves slowly and minutely if at all. Fixed costume tends to be associated more frequently with an individual's professional role than with his or her personal identity (Stone, 1981, p. 144). It would therefore seem more reasonable to regard a superhero costume as equivalent to a uniform, signifying allegiance to a set of professional ideals rather than aesthetic trends. Much like a police uniform, a superhero costume is resistant to change except when necessitated by practicality.

However, superheroes are depicted in media that *are* subject to the whims of fashion. As audiences change, so too do their expectations; comic-book artists

are inevitably influenced by the same external forces that drive fashion forward: social, cultural, and political. Each new artist must make his mark, distinguishing their own vision of a superhero from what has come before, and this version must be believable to a contemporaneous audience. It is necessary to implement visual change to distinguish one incarnation of a superhero from another. The design of the costume must therefore be a compromise between fixity and change. It must not appear to be grounded in any particular historical setting, and yet it must retain features from a historical age. It must be fresh, but never new. The design of the superhero costume is a difficult balancing act that must negotiate the complexities of social change without ever changing too much itself.

Fashion outsiders

Those superhero costumes that remain most static over time are largely symbolic. When costumes are utilitarian, as with Iron Man's suit, extreme transformation is justifiable as a technological development. By contrast, the costumes of Superman and Wonder Woman, which do little to enhance their performance, remain relatively consistent. Such garments function through stylistic or, following Barthes, linguistic expression, more than physical usefulness (Carter, 2012, pp. 344–345). Where a costume's function is entirely symbolic, it may be equated more directly to a fashion item. Fashion is distinguished from nonfashion costume by functional equivalency, or even the impeding of function by design. A redesign for fashion purposes yields a new design that is "functionally equivalent" to what has come before (Miller et al., 1993, p. 146). Any alterations to a superhero costume that are stylistic—affecting aesthetics rather than function—can only be justified in terms of fashion, and so must be kept to a minimum to preserve timelessness.[1]

In order to remain outside of time, a superhero's costume must remain outside of fashion. The life of a comic book or film can be limited if it presents costumes that are too contemporary. Grant Morrison's Zenith (2000AD, 1987–1992) is a British superhero whose oversized jackets and shoulder-pads place the character very firmly in the 1980s. Fashion trends change quickly, and in the time it takes for a comic or film to be made and distributed, its costumes can begin to look unfashionable. This observation has led prominent costume designers to create "looks that [are not] so fashionable that they would quickly become obsolete" (Bruzzi, 1997, p. 5). Like these film costumes, the superhero's cape cannot resemble the garments on the high street or the catwalk. If it did, it would become too grounded in a particular era to have the timeless appeal that is so vital to the superhero genre.

Edith Head, a Hollywood costume designer who dressed prominent leading ladies of the 1950s and 1960s, observed that while film fashion may be

trendsetting, more often it must appear to depict contemporary settings and characters.[2] Head remarked that the role of the costume designer is very different to that of the fashion designer. While fashion designers must seek to be at the forefront, able to predict changing trends, the costume designer must avoid being fashionable. A costume cannot appear outdated by the time a comic hits the shelves, or a film appears in cinemas. Costume must either diverge from fashion so far that it cannot be caught up in the changing cycle, or must follow it so loosely that it cannot be pinned down to a precise temporal setting.

That is not to say that the superhero costume is unaffected by changing trends and new technologies. Although it may not directly reflect contemporary fashion, the superhero costume does evolve, and so it cannot be considered entirely unaffected by contemporaneous culture. As it evolves, the superhero costume inevitably adopts elements that are, consciously or unconsciously, designed to reflect the era in which a particular story is set. Darwyn Cooke's *DC: The New Frontier,* though published in 2004, is set in the 1950s, and incorporates subtle adjustments to Superman's costume to ground it in that era. The waistband is raised, and trunks elongated into shorts. In DC's *Elseworlds* series, superheroes have been transposed into various historical settings, and their costumes have been adapted to suit the style of the appropriate era. *Gotham by Gaslight* (1989) depicts Batman in Victorian Gotham. His cape has been transformed to resemble an Ulster overcoat of the kind commonly associated with Sherlock Holmes. A high collar and over-cape give the garment a nineteenth-century silhouette. In *A Nation Divided* (1999), Superman is relocated to the American Civil War. His costume appropriates the military dress of a Union soldier. Such examples are evidence that superhero costumes are not entirely timeless, and must to some extent be influenced by changing clothing cultures.

Although the designers of superhero costumes actively avoid following fashion, the influence of superhero costumes is visible in fashion. High fashion, including collections by Thierry Mugler and Alexander McQueen, bear overt resemblance to superhero costumes, and superhero insignia have widely infiltrated high street clothing lines. An exhibition, "Superheroes: Fashion and Fantasy," held at The Metropolitan Museum of Art in 2008, showcased examples of high fashion considered to be inspired by superhero costumes, with examples including Moschino's manipulation of Superman's insignia, adapted to resemble a heart containing the initial "M" (A/W 2006/7), and Bernhard Willhelm's distressed cape emblazoned with a melting "S" insignia (S/S 2006). The exhibition also features adaptations of Catwoman's catsuit by Mugler and Galliano. As if in reference to the wider superhero genre, Mugler's catsuit was complemented by a floor-length cape. Galliano (for Dior, S/S 2001) incorporated crudely stitched leather patches into a draped dress, and accessorized the outfit with glasses and a handbag. The result is a homage to a specific incarnation of the character, played by Michelle Pfeiffer in *Batman Returns* (Tim Burton, 1992), utilizing both

her alter egos. The glasses, sensible shoes, and handbag are a nod to the demure secretary, Selina Kyle, while the dress, with its patent leather and irregular white stitching, directly imitates her catsuit.

The gender divide

Arguably, the rule that superhero costumes fall outside of the fashion cycle is more applicable to male superheroes than female (Metropolitan Museum of Art, 2008, p. 85). During the 1960s, Diana abandoned her Wonder Woman costume in favor of a variety of alternatives that distinctly reflected contemporary fashion trends, including Mary Quant-inspired tunics and white jumpsuits. Even when costumed in her superhero garb, Wonder Woman adapted in response to changing fashions (see Figure 7.1). Her first appearance, in 1941, depicted the character in loose culottes (closely resembling a skirt). By 1942, the culottes had evolved into shorts, which decreased in length until they became hot-pants in the 1960s. By the late 1980s, Wonder Woman's hips were fully exposed, with a design that mirrored the high-leg briefs and leotards of 1980s fashion. Since the mid-1990s, the shorts have shrunk to such an extent that they have been occasionally depicted as a thong. This evolution may be a matter of politics more than fashion. Long-term changes in women's fashion are as much a consequence of increased freedom as they are of changing tastes.

Justified by the profession of her alter ego as a fashion designer, The Wasp's costume has undergone more frequent transformations than any other. During the 1970s, a new costume was designed for the character in every issue of *The Avengers*. Nearly 300 of her numerous costumes were collected for a gallery which spanned three full pages of *Secret Invasion: Requiem* (2009). Richard Reynolds (1992, p. 29) observes how these frequent changes were permissible only because the character was a woman. The changes were "an expression of her femininity" as well as a "submission" of sorts to the gender stereotypes of the period during which her character was most active: the 1960s and 1970s. She was often depicted as the archetypal 1960s glamour girl, with a fashionable haircut that changed almost as frequently as her costume.

Costume is, for these female superheroes as it is for many in the real world, "a mechanism for constructing and reconstructing a sense of self" (Kaiser et al., 1991, p. 167). Following Edward Sapir's (1985, p. 375) exploration of fashion, Wonder Woman and The Wasp's keenness for costume change may reflect a "restlessness and curiosity" that arises only in "functionally powerful societies." Such societies, writes Sapir, are characterized in part by "highly specialised forms of activity" leading to "a too regularized existence." The superhero community shares these characteristics, being devoted to a predictable cycle of

Figure 7.1 The cover of *Wonder Woman* #178 (October 1968) depicts Wonder Woman rejecting her previous clothing choices in favor of a new, fashionable wardrobe.

heroic activities. Perhaps female superheroes, feeling restricted by the specialized practices of the superhero community, are driven to seek "endless rediscovery of self."

When female superhero costumes follow fashion, there is sometimes the need to justify it in practical terms. It seems that superheroes cannot be seen to be fashionable without due cause. Fashion is, after all, a frivolous pursuit—a sign of "ostentatious consumption" (Roche and Birrel, 1994, p. 502) or even a "compulsion" (Sapir, 1985, p. 373)—and to imply that a superhero is a slave to fashion would imply that he or she is not fully committed to other values. A superhero may wear fashionable dress when she is in disguise, but this must be a masquerade.[3] At no time can an apparent interest in fashion compromise her core values.

In her most recent screen incarnation, Catwoman's stiletto heels were justified as functional, not fashionable, items. In *The Dark Knight Rises* (Christopher Nolan, 2012), her heels have razor-sharp edges, and are employed to slice the legs of a villain when he snidely asks whether "those heels make it hard to walk." This use of heels as a weapon recalls existing debates about stilettos and female oppression. In some interpretations, heels have represented the absurdity of conformity to fashion. Though women are aware that heels are physically damaging, they still choose to wear them, thereby demonstrating that the desire to be fashionable can be so strong that it overrides the natural urge for self-preservation. Feminists have seen heels as a tool of oppression, making it difficult for women to engage in the same activities as men. With this interpretation of the stiletto heel as a restrictive garment, we might assert that it is "inherently anti-feminist," evidence that women are more concerned with superficial appearance than practicality (Barnard, 1996, p. 160). However, other interpretations read the stiletto very differently. The stiletto heel is also seen to have the "dangerous association of gangland weapon" (Chadder, 1999, p. 67). To this extent, stiletto heels represent more masculine ideals. Furthermore, they increase the height of the wearer significantly, so that women may appear as tall as or taller than men, and thus appear physically dominant. It is these associations that Catwoman asserts with her razor-edge stilettos. They are not so much a fashion choice as a sign of physical dominance with a practical function. Anne Hathaway, already a tall woman at 5' 8", is made taller than her male assailants and victims with an extra five inches. Although her heels force a feminine walk, they result in enough aggressive connotations that Catwoman is liberated from preconceived ideals about the stiletto as a fashion item.

The cycle of superhero fashion

We have established that superhero costumes (with few exceptions) fall outside of the usual fashion cycle. That is, the features and development of superhero

costumes do not appear to reflect those in everyday dress. However, that is not to say that superhero costumes do not follow patterns of evolution that are equivalent to those in the fashion cycle. We cannot discount the possibility that there is a cycle of fashion within superhero costume that follows similar rules.

Though an outsider to the fashion world may have difficulties identifying the latest fashions, fashionistas "can tell at a glance" whether someone "is wearing this year's dress." "Each year, dresses . . . are sufficiently different from those of last year so as to be unmistakably recognisable by the initiated as being of the latest mode" (Young, 2007, p. 47). Those "initiated" can recognize micro-variation in cut or color that marks difference from one year to the next. Likewise, a comic-book fan or superhero connoisseur can identify the incarnation of a superhero by his costume. Changes may occur less regularly than in an annual fashion cycle, but they do exist and, to an extent, they mirror similar social, technical or cultural shifts.

Fashion is distinguished from fixed costume by its tendency to change, specifically, change that is not driven by "utilitarian or rational considerations." The "merit or value" of this change cannot be sought in an "objective test"; it appears irrational (Blumer, 1969, p. 286). Some changes to superhero costumes are driven by utilitarian concerns and technological advancement. These tend to be costumes whose designs are initially driven by practical concerns, such as Iron Man's suit. Largely, however, no explanations are provided for changes to a superhero costume. Each change marks a temporal or social progression, but has no functional value for the superhero who wears the costume.

The primary reason for these changes is to set one version of a superhero apart from others. They may mark a particular incarnation, just as a particular style marks an era in fashion. Variation to the suit allows new artists or authors to establish ownership of their version of the superhero, just as a fashion designer will assert his values by designing a garment that differs from others. Alex Ross has made his mark on the superhero genre by introducing a level of detail and realism previously unseen in DC Comics. Ross's costumes are stylistically loyal to the Silver Age versions, but display difference in the apparent qualities of the fabric. His illustrations feature creases and folds, as if the costumes have evolved from graphic forms to real clothing. Grant Morrison's revival of Animal Man complements the original 1960s costume with a cropped jacket that is distinctly 1980s in style. These developments mark change without compromising the core aesthetic elements of the costume. They remind us of issues of ownership; that superheroes are not the sole property of their original creator, but are handed down from one generation of artists to the next, and each artist contributes to a character's legacy.

If there is a stylistic evolution in superhero costume, there must be influences equivalent to those that move real-life fashion forward. The dominant driving force in the fashion cycle is ambition, manifested as imitation. Fashion is driven

by "elite groups" or "prestige figures" who are responsible for introducing and approving developments in the fashion cycle (Blumer, 1969, pp. 267; 287). Typically, the fashion elite are haute couturiers, fashion journalists, and celebrities. At a local scale, they can be an individual in a social group: the elder sibling; the popular student whom others imitate. Historically, the fashion elite were royalty and aristocracy. These elite are responsible for establishing and changing collective taste, and others imitate them in an effort to appear socially or economically more powerful. By imitating the elite, others express a desire for a similar lifestyle or status.

In comics, there are superhero elites. These are the first, most influential superheroes, who set the mold for future imitators. The Golden Age of comics, spanning the late 1930s to late 1940s and early 1950s, saw the introduction of the likes of Superman and Batman, establishing conventions for the whole superhero genre. Superman, Batman, and Captain Marvel, among others, were responsible for introducing the core elements of the superhero costume—the insignia, unitard, and cape. It is from these elite figures that the idea of a typical superhero costume entered the public consciousness. If we consider these Golden Age heroes as the fashion elite—the haute couturiers of the superhero genre—then more recent superheroes are the mass-market imitators. Built in the image of the first superheroes were a legion of lesser-known imitators, including The Flame, whose costume consisted of a red cape and white unitard, and Skyman, with blue cape and mask over red with a yellow insignia (Sadowski, 2009).

By marking the elite from their imitators, fashions communicate social relativity. Dressing, even if not in an attempt to be fashionable, is a "process of adopting symbols primarily to provide the individual an identity relative to others" (Reynolds, 1968, as cited in Miller et al., 1993, p. 143). Clothes communicate conformity to a social contract or a set of values, while also permitting the assertion of difference (Stone, 1981, p. 143). Conformity to a particular fashion trend is a way of asserting one's adherence to the regulations and conventions of the society in which one lives. To look "socially correct and proper" is to convey a sense that we agree with the values of a society or group (Rouse, 1989, p. 4). It is the elite who are responsible for establishing the core values of the superhero, and hence the messages communicated by features of the superhero costume. The commonly held moral values of the superhero genre—truth and justice—are signified by bright, contrasting colors. These colors, and common elements such as the unitard, chest insignia, and mask, are the height of fashion in the context of superhero costume. The social contract, the unspoken agreement between all superhero costume designers, is that conformity is expressed through these features. Even lesser-known superheroes (for example, Image Comics' aging superhero Supreme[4]) are costumed to communicate a familiar set of ideals so that uninitiated readers may understand that they share common values and abilities with other characters in the genre.

Any divergence from these fundamental design features serves the purpose of signifying difference from the classical elite. The more different the costume, the more their values challenge the superhero convention. In fashion too, while there is conformity, there is also the need to diverge from the norms. The fashion industry is reliant on the existence of the conflicting needs to adapt to society and to demonstrate "individual departure from its demands" (Simmel, 1904, p. 131). Even when a wearer loyally adheres to a particular fashion trend, thereby establishing membership of a social group, he or she makes "micro-adjustments" to communicate a certain position within that group. With small variations to an outfit, it is possible to "turn towards greater uniformity or towards idiosyncrasy" (Harvey, 2008, p. 73). Without this conflict, argues Barnard (1996, p. 11), "there [would] be no fashion."

Likewise, difference is essential to the survival of superheroes as a cultural institution. Without those superheroes that rebel against received values, audiences would be too narrow to sustain the genre. To assert a different set of values, a superhero's costume must diverge from convention. It can be black, rather than vivid, as in Batman's suit, to convey the message that Batman's methods are, in contrast to those of Superman or others, morally questionable. After losing his memory, Jason Todd, the second Robin, resorts to even more violent methods than Batman (*Batman* #645–650, November 2005 to April 2006). To signify his even greater divergence from superhero values, his costume also differs from the usual superhero uniform. In a leather jacket and red hood that covers his entire face, Red Hood more closely resembles a masked criminal than a superhero. His change of costume signifies his descent into criminality.

Evolution into eternity

The fashion cycle is characterized by continuity. It is a "continuous process . . . without destination" (Young, 2007, p. 48). Fashion does not evolve in the direction of an anticipated finale. It will continue to evolve indefinitely. In this way, the fashion cycle is very much like superheroes themselves. Superheroes continually evolve. They are reinvented. New stories, new incarnations, recombine and recontextualize familiar subjects and themes. The superhero does not progress towards an end point; he expects to live forever. Even when a superhero dies, he is resurrected,[5] just as fashion items are resurrected after they have apparently become outdated.

Through subtle shifts, the superhero costume is able to appear timeless. Any elements that reflect temporal setting (either because the artist has been inspired by contemporary fashion, or because they incorporate contemporary technology) can be abandoned or replaced without compromising the core signifying elements of the costume.

Like the superhero, fashions ultimately never die. Although styles become outdated quickly, they are never entirely discarded. The fashion cycle ensures that elements of a style always come back into fashion, through a process of *bricolage*. Bricolage "involves the continual recombination of elements" (Barnard, 1996, p. 67). Old elements are revived and recontextualized, and thereby given new life. Every reincarnation of a superhero is an act of bricolage. It revives elements from previous stories and updates them for a contemporary setting by combining the old with the new, adhering to contemporary social values. A very similar process happens with fashion items. The corset, for example, was almost universally exiled from fashion in the mid-twentieth century as a response to its connotations of oppression. In the 1980s it was revived, appearing in collections of designers and haute couturiers including Jean Paul Gaultier and Vivienne Westwood. By this time, women had asserted dominance in some sectors of the workforce, and proven themselves worthy of equality with men. In this new social context, women had ownership of fashion. Corsets, previously signs of delicacy and oppression, became signifiers of power and liberation. In order to achieve this change of value, corsets had to change. They began to be made with new materials and worn in new contexts, helping to achieve distance from the corsets of the past, and hence past values. The old garment, combined with new materials, could be redefined as an object of contemporary social ideals.

In superhero comics, costume design involves a similar process of bricolage. Elements are retrieved from previous designs, and adjusted to suit the practical and cultural demands of the new narrative. As in any kind of bricolage, the revival is rarely an exact copy of the original. In order to reflect changing values, the new costumes must be distanced from what has come before. They may be made of new materials, or incorporate subtle shifts in color. The costume of *Spider-Man 2099* (*The Amazing Spider-Man* #365, August 1992) borrows heavily from the original Spider-Man, displaying a similar spider insignia and the same red-blue color scheme. However, this future version (set in New York in 2099 AD) is dissimilar enough that it could never be confused with the original. The web that was a core feature of the original costume has vanished, and the blue is more dominant than the red. Notably, the design of this new costume is not driven by technology. The changes are aesthetic, stylistic, driven by cultural change, and signify difference.

In every incarnation, the superhero is reinvented similarly. His appearance remains largely unchanged (at least to the point where he is easily recognizable), and core values remain intact, but narrative elements reflect a contemporary setting. In the seventy-five years since Superman's first appearance, Superman's environment has changed far more significantly than the man himself. Metropolis has continued to evolve. Even Superman's alter ego has been forced to keep up with the times, abandoning his role as a traditional journalist for a new job as an internet blogger (*Superman Vol. 3* #13, December 2012). However, there is a

continuing effort to preserve objects and locations that are core parts of Superman's mythos. *The Daily Planet*, though redesigned, is still depicted as an architectural wonder of the Art Deco age. Similarly, the Kent farm remains apparently unaffected by the passage of time.

At approximately the same time as Superman's first appearance, fashion historian James Laver developed a model which aimed to identify common responses to contemporary and outdated garments. Laver's Law, as it became known, identified that fashions go through periods of appearing "hideous" or "ridiculous" within the first few years of falling out of fashion (Laver, 1938). Later however, when they are reevaluated in hindsight or revived for a new audience, they are assessed more positively. The public perception of Superman, and indeed the whole superhero genre, has experienced a similar shift. At times, superheroes have seemed ridiculous, and their costumes ludicrous, but, following Laver's Law, they have benefited from reinvention and nostalgia. Indeed, the older they are, the more "beautiful" they become. Like fashions, superheroes become more beautiful with age.

8
SUPERHERO COSPLAY

Through transmediation, superhero fictions are being integrated into mainstream popular culture. As a consequence, fan practices have become more visible. Aided by the internet, participatory fandom "is now increasingly part of the mainstream" (McCudden, 2011, p. 2). Fandom is more than just an act of consumption and appreciation. "It requires a degree of activity" such as "poaching, collecting and knowledge building" (ibid., pp. 13–14). "Cosplay is part of the feedback loop that allows fans to enter into a text and transform it, turning readers into authors and blurring the distinction between fan and critic, as well as reader and text" (Rauch and Bolton, 2010, p. 177).

Fandom is now rarely conducted entirely in isolation. It is a social phenomenon, and "fans are defined, in part, by their common activities" (McCudden, 2011, p. 13). They seek interaction with their peers "in organized group activities" (Flemming, 2007, pp. 2–3). In order to facilitate this interaction, it is beneficial for a fan's allegiances to be made visible. "Because costumes are immediately noticeable upon meeting someone" they are "the most obvious indicator of someone's fandom" (McCudden, 2011, p. 82). "This may be as obvious to the casual observer as a costume . . . or more subtle, as in mimicking the haircut of one's favourite character" (ibid., p. 17).

The costume communicates efficiently and specifically the subject of one's fandom, and their level of devotion to that particular cultural artifact. Having made this initial impression, "one is able to share their fandom through the clothes they wear and manner in which they style themselves" (McCudden, 2011, p. 17), and this common interest, though tangential to the act of consuming the source text, is an activity that preserves bonds within the fan community.

In cosplay, "the values or features of a character are projected onto the player by the spectators and player him- or herself" (Lamerichs, 2011, p. 13). In the case of professional cosplayers, aesthetic laborers invite spectators to imagine that they are in the presence of their fictional hero, and, as demonstrated on the streets of Los Angeles in Matthew Ogen's documentary, *Confessions of a Superhero* (2007), spectators are eager to suspend their disbelief.

Participatory fandom/imaginative reconstruction

The notion of a fan has moved beyond "older ideas of media spectatorship" that involve little more than direct consumption of a cultural artifact (Flemming, 2007, p. 16). Participatory fandom involves tangential activities which expand upon the fictional world and blur boundaries with reality. "Fans create a fan culture with its own systems of production and distribution that forms . . . a 'shadow cultural economy' that lies outside that of the cultural industries yet shares features with them" (Fiske, 1992, p. 30, cited in McCudden, 2011, pp. 6–7).

Bainbridge and Norris (2009) describe cosplay as a "ritual of identification" which aligns the cosplayer with his fictional hero or heroine through procedural play. Katherine Flemming (2007, p. 17) offers a number of explanations for this additional level of engagement, beyond direct consumption. She proposes that those who become participatory fans often personally identify with the subject of their fandom, and seek "false intimacy" with that character. She also identifies the "feeling of empowerment" gained by identifying with other fans and becoming part of a group with shared interests. This empowerment comes from social acceptance, as well as from the vicarious sense of strength that is experienced by embodying a superhero character. "The character provides a (protective) identity for the cosplayer, which may allow for more confident and open interactions" (Winge, 2006, p. 74).

Participatory fandom, and in particular, cosplay, has evolved from diverse origins, combining practices from fans of fiction and fact. Nicolle Lamerichs identifies cosplay as a convergence of 1960s/1970s sci-fi fandom practices, and "the tradition of Renaissance fairs and historical reenactment, as well as later practices such as live-action role-playing" (Lamerichs, 2011, p. 2). These are all practices that extend childhood play into adulthood. In this way, their growing popularity coincides with changes in mainstream clothing practices, as fashion is increasingly borrowing from childhood. Hadley Freeman of the *Guardian* observes an increasing desire to invoke memories of childhood through clothing such as animal hats, mittens, and onesies (Freeman, 2013).

Imaginative reconstruction of fictional narratives is common in childhood, and so dressing-up in costume has an apparent triviality and perceived childishness. Fashion too has connotations of frivolity (Barthes, 1983, p. 242). Herbert Blumer's (1969, p. 276) canonical writings describe how the pursuit of fashion has been seen as "irrational." Cosplay practices, however, are distanced from these connotations by emphasis on authenticity and functionality (see Chapter 3). Both role-playing and costuming have found popularity in the wake of the introduction of multiplayer online games. In role-playing games such as *World of Warcraft*, the dressing and preparation of the avatar is a significant part of the player's gaming

experience. Janine Fron et al. observe that male gamers devote a lot of time and effort into developing their costume, justified by their use of terminology such as "gear" rather than "costume." Such terminology suggests that the avatar's wardrobe is primarily a matter of function rather than style. Moreover, it is quantifiable. One choice of armour may offer more effective defense than another, enabling players to "treat the costume as a statistic more than a decoration or form of personal expression" (Fron et al., 2004, p. 6). These gaming experiences "may also serve as an entry-point for adults into dress-up, for whom its convergence with technology may dispel some of its more feminine [and childish] connotations" (ibid., p. 3).

The making and wearing of the costume are only parts of a larger act of role-play. Theresa Winge (2006, p. 65) observes that the term "cosplay" refers not only to "costume" but also to "play." In costume, the wearer often performs parts of the source text. Many conventions include a Masquerade—a competitive showcase in which fans parade their costumes (Gooch, 2008, p. 17). In these showcases, rather than just walk down a catwalk, the fans often engage in a "skit." This will typically take the form of a reenactment (or sometimes a parody) of a scene from the source text. The costume is only part of this performance, and those with acting abilities or a personality that matches the vibrancy of their costume, will be those that are received most positively by the audience.

Where cosplay differs from gameplay is that it begins with an established, pre-existing narrative. Although a game has rules that dictate its form, the precise sequence of events unfolds unpredictably as players interact. It is a performance, in which "identity is not invented but is the temporary result of imitation" (Lamerichs, 2011, p. 7). Performers costume themselves as a character with a predetermined fate, and their role-play is an act of appropriation. Henry Jenkins describes this as a kind of "textual poaching," that occurs outside of, but in imitation of, the official cultural artifact (Jenkins, 1992).

In enacting narratives, or behaving in-character, fans not only consume, but also produce, culture (Rahman et al., 2012, p. 320). Much like writers of fan fiction, they build upon their familiarity with fictional characters to construct new narratives in new environments (Thomas, 2006, p. 226). Within the environment of a fan convention, fans are able to extend the narrative beyond the confines of a particular fictional universe. Tisha Turk (2011, p. 90) identifies fan fiction as a kind of metalepsis, which "destabilize[s] the boundary between reality and fiction." Fan fiction and cosplay alike "represent the imposition of extradiegetic desires upon the fictional world and the transformation of a text in service of those desires." While adhering to the personality traits of their character, they place themselves in situations not previously encountered in any published texts, not in a rejection of the source texts, but a "re-making of it."

Cosplayers interact with source texts intradiegetically and extradiegetically. Through reenactment and construction of new content, they "explore the gaps

and potentialities with a narrative" (Cubbison, 2012, p. 144) as if "scribbling in the margins" of the source text (Jenkins, as cited in Parrish, 2007, p. 55). Cosplayers' enacted and reenacted narratives are both limited and expanded by the location of the fan convention. Extradiegetic forces permit narrative to extend and expand in new ways. These forces may be limiting, as real-life settings may not permit the events that take place in fictional worlds. However, the conference environment also offers opportunity to extend or expand the source material. Fans might "diverge from [a source text] . . . in effect transforming the source text into a kind of prompt" (Parrish, 2007, p. 32). As Laurie Cubbison observes, fan-constructed narratives can extend so far beyond the source text that we cannot always consider a fan reenactment the same text.

Convention spaces, and the presence of props and individuals that do not exist within the source text, invite improvisation. The cosplayer, as "audience turned author" devises scenarios to suit his or her real-life settings. An improvised skit can involve characters from different fictional universes. These "crossovers" are described by Turk (2011, p. 96) as an example of horizontal metalepsis, in which the boundaries of two texts are bridged.

The fan convention is typically a crossover space. Its participants are aware of multiple fictional universes, and those universes share the same physical space in the convention venue. As cosplayers move through this space, different fictional universes become blended in the same physical space. This, as Feyersinger (2011, p. 145) proposes, is a condition that allows for crossover fiction to occur. The similarities between Marvel and DC publications, for example, enable speculative but naturalistic interaction of multiple source texts from different origins.

"I'm your biggest fan": Competition and authenticity

One of the strongest factors influencing fandom is competition with other fans. Michelle McCudden (2011) identifies that fan communities develop hierarchies, in which status is achieved through various demonstrations of devotion. A fan who can prove that his or her devotion is greatest, moves to the top of the social scale.[1] McCudden (2011, p. iii) describes several methods by which devotion may be demonstrated, including: financial investment, effort, frequency of socializing with other fans, knowledge of subject. Each of these may be demonstrated in the construction and wearing of costume. "Committing to the wearing of a costume can be an indicator of a particular level of fandom" (ibid., p. 82). A fan may be considered a true devotee (and therefore worthy of respect from his or her peers) if he or she creates or buys an expensive and complex costume that is an accurate representation of the original, and wears it often.

Fandom has a cultural economy, in which value is attributed to acts of devotion. "By amassing particular pieces that are of value in a society" fans are able to build capital (McCudden, 2011, p. 9). The acquisition or creation of a costume is an investment of sorts: a way to "accrue capital which can then be converted to status" (ibid., pp. 9–10). "These activities, and the extent to which fans participate in them, play a role in how hierarchies are established both within and between fan communities" (ibid., p. 14). In a fan community, "authenticity is a currency that confers status," and is thereby the primary "means to acquire cultural capital" within a fan community (Gapps, 2009, p. 398; McCudden, 2011, p. 22). Through accuracy and authenticity in costume, a cosplayer may demonstrate knowledge of the subject, and may position him or herself as an authority, thereby increasing social standing within the fan community. "Hierarchy and power are inevitable in community formation" (ibid., p. 8).

There are "agreed-upon markers of authenticity," varying from fandom to fandom, that may be demonstrated in hairstyle, costume materials, accuracy of the chest insignia, etc. (McCudden, 2011, p. 23). True accuracy in these features does not, however, mark the pinnacle of success in recreation of a superhero costume. The cultural value of the costume is complicated by the fact that there is rarely one "true" vision of how a costume should look. As we saw in Chapter 3, superhero costumes are frequently redesigned for different incarnations of a superhero. The cosplayer's decision to imitate one version over another may significantly influence how he or she is received by the fan community. More kudos is given to some versions than others, and "collecting the 'right' works that belong to a particular canon can be a means of showing their authenticity" (ibid.). No matter how accurately they recreate the original, certain costumes may have unwanted connotations. Contemporary audiences find that the Lycra unitard of Adam West's TV Batman lacks masculinity (to the extent that articles point to homosexual overtones) (Daniels, 1999, p. 84) while other versions are simply not considered canonical enough to command the respect of fans (Brooker, 2012, p. 88). A true fan must display preference for an approved version of the costume, as agreed by his peers.

Thus, the hierarchy in comic-book fandom is governed by the same principles as mainstream fashion. Bainbridge and Norris (2009) describe the particular fashion system of cosplay as dependent on "context and timing." As in mainstream fashion, methods and styles of cosplay "have a built-in obsolescence." To be *en vogue* in cosplay invites a similar respect from peers as it would in the fashion industry. The phenomenon is defined by fashion theorist Herbert Blumer (1969, p. 282) as "collective taste," which governs perception about which brands and garments are most culturally valuable. As in cosplay, there is a drive to conform; to be as authentic as possible; to demonstrate knowledge of collective taste; and to show devotion by investing financially in the garment.

A greater level of authenticity can be achieved through the incorporation of "official" merchandize into the costume. Such merchandise and garments come with a seal of approval from the original designers, and at a cost. The licensed *Dark Knight Rises* motorcycle suit that retails on UD Replicas for $1,500 is exquisite in its detail. With Kevlar inserts, it purports to not only imitate the aesthetic of Batman's suit, but also offer "a level of protection and flare the Dark Knight himself would approve of." The purchase of this and other officially licensed garments offers a shortcut to the demonstration of devotion, through financial investment and authenticity.

The ultimate statement of devotion can be the ownership of a unique or original piece, such as "props or costumes used on the show or movie" version of a superhero narrative (McCudden, 2011, p. 20). As unique pieces, these fetch large sums at auction (often so large that most fans are priced out of the market). A costume worn by Christopher Reeve in *Superman: The Movie* (Donner, 1978) achieved $65,000 when it went to auction in 2012 (collectorsransom.com). Notably, these original garments are prized as objects more than as costumes to be worn. When props from *Buffy the Vampire Slayer* (1997–2003) were auctioned on eBay following the show's finale, it was the costumes that attracted the most attention, and achieved the highest sale prices. However, as Josh Stenger (2006, pp. 37–38) observes, the small size of these garments (reflecting the small dress-size of television actresses in general) rendered them unwearable for the majority of fans. This would suggest that they were being purchased primarily for their value as an object—to be displayed rather than worn. Indeed, Fox's legal disclaimer warned potential purchasers that the items for sale were "not to be used for their seemingly functional purposes and are only intended to be sold as collector's items."

Ownership of a costume is therefore distinct from cosplay. Cosplayers' relationship with the source text is more active, involving activities that surround and involve the costume. These activities extend to the creation of one's own costume, in an act of devotion that outweighs the cultural capital achieved by purchasing an original or official replica.

The act of creating one's own costume is more in the spirit of cosplay than purchasing official replicas or even original film costumes. Although authenticity is a central aim for most cosplayers, "authentic" is a term assigned to accurate recreation rather than official merchandize (Gapps, 2009, p. 398). Lamerichs (2011, p. 5) observes that "most cosplaying sites . . . design their user profile pages on the assumption that players make their outfits themselves" thereby introducing another opportunity for competition. By designing and producing their own costume, cosplayers demonstrate a level of knowledge and commitment that cannot be bought at auction. The cultural capital achieved from the production of one's own costume is often quantifiable, as cosplay events include costume calls and competitions, in which "costumers go on stage and compete for prizes based on their skill in assembling and presenting their outfits" (Gooch, 2008, p. 17).

In his studies of costume for reenactment, Stephen Gapps (2009, p. 98) observes the lengths to which some participants will go to achieve authenticity in their appearance. Beyond costuming, some participants choose to live a lifestyle that gives them a physique to match the costume. He acknowledges that in historical reenactment, this level of bodily authenticity is nearly impossible to achieve. The same is true of superhero cosplay, which requires participants to aspire to an unattainable physique. In order to achieve muscular definition comparable to that of Superman or Batman, participants must commit to emulating their chosen superhero even when not in costume. They become aesthetic laborers, committed to maintaining a specific appearance in preparation for events when their costumed bodies will be on public display.

It is not uncommon for costumes to compensate for the relative physical inadequacies of cosplayers. In order to imitate the muscularity of a superhero, cosplayers are often dependent on padding, sewn between layers of fabric. In this way, the boundary between body and costume becomes blurred. Taking inspiration from the ways in which superhero costumes foreground the physicality of the wearer's labor (see Chapter 1), one US patent for "costumes with semi-rigid fabric components" identifies a method of molding semi-rigid components into a superhero chestpiece with "muscle-like features" (Beige and Kearns, 2002). The patent explicitly acknowledges the ways in which the design compensates for the inadequacies of the costume's wearers, explaining how it enables cosplayers to "more realistically masquerade as a superhero." This it achieves through "an upper torso area which appears, three dimensionally, to be extremely well-developed."

Such padded costumes enable the wearer to not only dress like a superhero, but also to extend his physical presence. With chest padding, a cosplayer may occupy equivalent physical space to his favorite hero, thereby more accurately replicating the experience of being that character. Fashion has long recognized the potential for clothing to expand the masculine form in this way: false calf-muscles were not uncommon in Regency-era fashion, since a toned calf was the ideal accompaniment to breeches and stockings (Osbourne, 1985, p. 265); the "heroic ideal" was achieved historically with "felted padding," and during the twentieth century with shoulder-pads (Koda, 2001, pp. 17; 67); designer Issey Miyake incorporated "inflatable pectorals" into his fall/winter 1997 menswear collection, which, as Harold Koda (2001, p. 67) observed, invoked a "superhero masculinity." For cosplayers, this additional padding is more than just a signifier of masculinity. It suggests supernatural strength, as if the superhero's physical abilities cannot be separated from his costume.

Spectatorship and the cosplay spectacle

Typically, attendees take one of two roles: "a participant or a spectator" (McCudden, 2011, p. 44). For the latter, costumes are part of the spectacle of

the convention. They act as observers rather than participants, taking the role of voyeur. The role of spectator is fundamental at these events, partly because it is these spectators who preserve records of the cosplay. They not only watch, and praise, but also make photographic records. Rauch and Bolton (2010, pp. 176–178) argue that in this act of fandom, "the cosplayer is really only half the equation: the other half is the cameraman (or woman)." Cosplay photography is "a form of fanthropology" that is considered as vital to the community as the costumes themselves. These images "are made for and by the community" and "there is a strong sense that the photograph is the privileged end product of the entire enterprise."

The numerous cosplay photography archives that litter the web have provided the world with images of cosplayers, and many depict fans posing "in-character." Gapps (2009, p. 402) describes how costumed reenactors imitate "classic poses" for photographs. Many such images have the qualities of a "tableau vivant." Tableau vivant, which predate photography, were living pictures which traditionally recreated scenes from art or history. Most were performed in costume, allowing participants to more fully embody that character that they portray. A photograph, staged in imitation of a panel from a comic or a frame from a film, offers cosplayers opportunities to embody the superhero. In Figure 8.1, cosplayers pose in-character as Spider-Man and Doctor Octopus from *Spider-Man 2* (Raimi, 2004). One cosplayer strikes a pose typical of Spider-Man since his original depiction by Steve Ditko, while one of his greatest foes apparently prepares to attack. The tableau is performed for spectators in the room, as well as for the photographer. This audience observes the costumes within the frame of a reenacted narrative.

While other contemporary photography seeks authenticity by spontaneously capturing subjects unprepared, these photographic tableaus aim for authentic reproductions of "the visual qualities" of the film frame or comic-book page (Rauch and Bolton, 2010, p. 177). In the spontaneous photograph, the photographer can claim ownership over his image. Here, however, the photograph becomes a collaboration between cosplayer and photographer.

These photographs necessarily draw cosplayers away from the fictional worlds that superhero role models inhabit. Backdrops of convention centers and car parks locate these surreal costumes in real-world environments, forcing viewers to assess their otherworldliness in contrast to the mundanity of real life. In Figure 8.1, the setting of the Los Angeles Convention Center, along with un-costumed attendees eating their lunch in the background, are a reminder that this is an act of play. The costume is anchored in reality, revealing it as an imitation rather than the real thing. As in fashion photography, the garment is photographed outside of its primary context, and the wearer is exposed as a "counterfeit body" rather than a real superhero (Butler, 2005). Reality is exposed further when these bodies display physical imperfections that do not exist in the bodies of the

Figure 8.1 Cosplayers pose in-character as Spider-Man and Doctor Octopus at the Third Annual Stan Lee's Comikaze Expo in Los Angeles, 2014.

© Albert L. Ortega/Getty Images

fictional characters they represent. Fans with a podgy belly who dress themselves in skintight Superman unitards highlight "the disparity between [a] real-life body and the imaginary body of Superman," so vast that it produces "a kind of cognitive dissonance when we look upon him" (Yockey, 2009).

Rauch and Bolton (2010, p. 178) argue that "[c]osplay photography clearly borrows some of its visual logic from high-fashion photography—both its formal features and its underlying assumption that the clothes exist to be photographed as much as to be worn." The categories of fashion photography developed by Roland Barthes ([1967] 2007) in analysis of the relationship between garment and backdrop, are equally applicable in images of cosplayers. Barthes argues that the backdrop for fashion photography is always "thematic," contributing themes and meaning to the depicted garment. In the environment of a cosplay convention, the "theatre of meaning" is limited. Nonetheless, photographers find ways of staging "poetic" or "outrageous" tableaux, staging extravagant and unlikely battles in food courts and car parks.

Photographers capture "the construction and confusion of boundaries between fan and character, fan and critic, or observer and observed" (Rauch and Bolton, 2010, p. 177). Some cosplayers mix-and-match costumes with their everyday wardrobe, or add playfully inauthentic embellishments, and photographers encourage these departures from source texts. "Some allow fans to emerge from underneath their costumes or try to pry them violently out of character," thus provoking a rift in the boundary between fact and fiction (ibid.). In such instances, the player demonstrates media awareness. Breaking the frame of the performance (Sawyer, 2003, p.108), he or she invites the viewer into the world of cosplay, and makes visible the relationship between the fan and the subject of their fandom. In images like this, it becomes evident that cosplayers "have a dynamic relationship with stories and characters" (Lamerichs, 2011, p. 13). They "want to bring something of their own, such as elements of their own appearance, into the cosplay" (ibid.). By presenting their true selves, they are able to take personal credit for the effort that has been invested in the production of their costume, taking ownership of a unique act of cosplay.

Sewing and making: Masculinity and manufacture

Prior to the acts of display that occur in fan conventions, cosplayers must acquire or construct their costumes. Costuming—the design and creation of costumes—has been viewed as a gendered activity. Sewing in particular has been presented as a feminine pursuit, or domestic chore (Gordon, 2009). However, contemporary events and artifacts frame dressing-up in contexts that are more acceptable to male audiences. In superhero narratives, costumes are associated with masculine

displays of power and aggression, and with masculine performance as a goal, male cosplayers are willing to engage in craft practices that might otherwise be considered uncharacteristic for their gender.

When cosplayers sew their own costumes, they are perhaps inspired by depictions of fictional superheroes doing the same. Comic books depict superheroes designing, acquiring or manufacturing their costumes, in the pivotal transition from civilian to superhero. Although they may have acquired their superpowers previously, it is not at the time of power-acquisition that they become a superhero. The transformation is not complete until they don a new costume, and adopt the super-identity. Although some superheroes do adopt a ready-made costume, many design and make their costumes themselves. It is in this conception of their superhero identity, via costume, that they achieve their destiny.

The journey to becoming a hyper-masculine superhero is, in this way, dependent on getting in touch with the inner-feminine. This is particularly true of Spider-Man, who is depicted designing and sewing his own costume in the domestic space of his own home. *The Amazing Spider-Man* comics present sewing one's own costume as a domestic task that is beneath a "big-name" superhero. Issue 129 (February 1974) depicts Peter accidentally piercing his finger with a sewing needle, protesting that, despite his fame he has "*still* got to do [his] own sewing." In *Amazing Spider-Man* #4 (September 1963) he declares "I'm no cotton-pickin' seamstress! . . . I wish I could ask aunt May [for help]." The feminine connotations of costume sewing continue to persist outside of Spider-Man's fictional world. Interviewed about his role in *The Amazing Spider-Man 2* (Marc Webb, 2014), actor Andrew Garfield described Peter Parker's sewing of the costume as "a kind of feminine thing to do." Pressed for details by his co-star, he continued, "femininity is about . . . delicacy, precision . . . and craftsmanship." He emphasizes that the result of this feminine act was a "very masculine costume" (Miller, 2014).

Earlier incarnations of Spider-Man, as depicted in Stan Lee and Steve Ditko's *The Amazing Spider-Man*, make reference to the contradiction between the feminine act of sewing, and the masculinity of the superhero. Parker sews his own costume, but protests that the task comes unnaturally to him. In issue #20 (January 1965), he is shown stitching his tattered costume back together, and hyperbolizes that "my biggest problem is getting this sewn without stabbing my finger to death." Later, in issue #27 (August 1965) he describes sewing as "the one thing I hate most in the whole wide world." It is worth noting that, in contrast, his aunt is depicted sewing in the background, and seems to take to this task much more willingly (see, for example, issue #2).

Cosplayers who design and sew their own costumes recreate the actions of their heroes in this act of personal reinvention. The construction of their costume is a means by which they can engage in equivalent behavior to their heroes. Like their fictional heroes, cosplayers devote themselves to the task of creating their costume as a rite of passage: a means of fulfilling their destiny.

As explored in Chapter 3, adaptations of superhero costumes increasingly focus on function, and in so doing emphasize the masculine process of manufacture over feminine and aesthetic processes of clothes design. When technology is incorporated into the costume, the costume grants access not only to the aesthetics but also the abilities of a superhero. Iron Man's costumes are entirely responsible for his superpowers, while Batman's gadgets significantly enhance his abilities. This category of post-human superheroes, described by Fred Patten (2004, p. 293) as "skilled athlete[s] whose natural powers are aided by the use of scientific equipment," are perhaps more appropriately labeled as cyborgs. Cyborgs are "liminal creatures, between the human and the machine" (Nayar, 2014, p. 22). The technologies incorporated into superhero costume disintegrate distinctions between human and nonhuman. A hero may, through invention and appropriation of technologies, make himself more-than-human, or, superhuman.

Though superheroes gain their powers from fictional technologies, real-life technologies do not lag far behind. Opportunities have arisen for mechanically-minded cosplayers to develop real-life devices that resemble aspects of superhero costumes. Web-shooters became an integral part of Spider-Man's costume in his first appearance in *Amazing Fantasy* #15 (August 1962), *The Amazing Spider-Man* comics continued to depict the web-shooter as a mechanical device, loaded with cartridges of web-fluid. The device enhanced Spider-Man's abilities, transforming him into a cyborg-superhero. Inspired by Spider-Man's gadget, German designer, Patrick Priebe, has developed a similar device which allows wearers to shoot artificial webbing. The device, attached to a glove with concealed button, shoots harpoon-tipped webbing when the wearer performs the same finger gestures as Spider-Man does in comic books. The webbing is attached to a winch hidden under the sleeve of the costume, so that the web may be wound up, dragging whatever object is attached to the other end into the wearer's grasp. Other inventions by Priebe include a functioning "Iron Man Laser Gauntlet," and laser-shooting goggles styled to resemble the visor worn by X-Man Cyclops (laser-gadgets.com). The creation of such devices is more an act of engineering than of costume design. It requires the application of skills that are traditionally perceived as masculine.

As designers like Priebe develop these technologies, the line between cosplayer and real-life superhero is increasingly blurred. As the following chapter will observe, real individuals and organizations draw on superhero values, costumes and technologies. Gadgets like those developed by engineer cosplayers create the potential for fans to demonstrate skills comparable to real-life superheroes. Similar technologies have been developed for application in real combat situations. The US Army is developing a tactical assault suit, TALOS, which has been jocularly described by Barack Obama as a real-life Iron Man. Such technologies increasingly blur the boundaries between fact and fiction, and between cosplay and real-life superheroes.

9
REAL-LIFE
SUPERHEROES

Cosplay fandom, fueled by obsessive passion and attention to detail, is no longer confined to the halls of comic conventions. Indeed, it can be taken to the extreme, employed to actively encourage social change. These "real-life" superheroes are not solely evoking the traditional guise of crime-fighters; many are environmental or political activists, using the power of a mask to attract attention to their various causes. Elements of the superhero costume, particularly masks—which dramatically alter the wearer's psychology—provide real-life wearers with strength and freedom that they might not otherwise have. This reflects evidence that masked individuals may be more aware of the needs of others (Mullen et al., 2003), and are more confident in their actions (Cooper, 1999).

Taking inspiration from their fantastical heroes, real-life wearers of superhero costumes assert their values and rights from behind a mask. Masked vigilantes present themselves as superheroes, benefiting equally from the anonymity afforded by the mask, and the public attention that it attracts, whereas Russian musicians and activists, Pussy Riot, employ brightly colored dresses and balaclavas in anonymous expression of their shared feminist values. Similarly, campaign groups such as Fathers 4 Justice exploit the explicit connection between superhero costumes and justice in their campaign for access to their children. All of these groups demonstrate that the superhero costume is as powerful and transformative in reality as it is on the cinema screen or the pages of a comic book.

For these groups, the costume signifies a set of values borrowed from superhero comics—benevolent power, righteous action, the defense of truth and the ceaseless pursuit of justice—and imbues them with a simplified sense of right and wrong which presents their actions, regardless of their legality, as morally just. In each case, wearers of the superhero costume are empowered by imagining themselves as a powerful Other. Like the comic-book superhero, they become seemingly invincible, and yet are unquestionably located on the side of right.

As it does for comic-book superheroes, their transformation of dress does not suggest a process of becoming Other, but rather, a process of bringing to the

fore qualities of heroism that are already present, but normally hidden from view. This revealing of potential is surely the most resonant and enduring effect of the superhero's costume. When Clark Kent rips open his shirt to reveal Superman's S-shield, or when Bruce Wayne pulls Batman's cowl over his head, they are throwing off the shackles of ordinariness and embracing their inner strength, both physical and of character.

Real-life superheroes, however, have real-life concerns. Though their appropriation of the costume may be symbolic, the wearing of it introduces practical and legal concerns that are rarely raised in fictional narratives. While campaigning against grand injustices, they must also concern themselves with matters arising from the everyday maintenance of costumes that are frequently impractical and uncomfortable.

Masked vigilantes and the reality of costumes

The appropriation of the superhero costume often comes in conjunction with the performance of a superhero lifestyle. Masked vigilantes patrol the streets of cities including Seattle, Atlanta, New York, Toronto, Mexico City, and London, and congregate in cyberspace via the *World Superhero Registry*. Though they are too numerous to list here, those real-life superheroes that have been the subject of academic study include Phoenix Jones, who patrols the streets of Seattle (Newby, 2012), and Mexico City's Superbarrio, whose use of a costume refers both to superheroes and lucha libre (Cadena-Roa, 2002). Lacking superpowers, these vigilantes find strength in numbers. Following the example of *Batman Incorporated* (see Chapter 4), Phoenix Jones established the Rain City Superhero Movement in Seattle, then later expanded his franchise internationally.

Costumed vigilantes predate American comic-book superheroes. Masked bands of vigilantes have typically emerged in poorly policed societies, or when the values of some social groups do not fully align with those of lawmakers—most notoriously, the Baldknobbers, who acted in retaliation against Confederate rebels at the end of the American Civil War (McLachlan, 2009, p. 61). These vigilantes frequently failed to win public sympathy, as their masks tended to make them fearsome figures. Contemporary real-life superheroes are able to rely on widespread understanding that the superhero is a force for good, and have appropriated superhero costumes to assert their status as crime-fighters rather than criminals. They position themselves as a viable crime-fighting force, comparable in some respect to law enforcement and military organizations. Their body armor directly appropriates from military technologies, often purchased second-hand on eBay or through military supply stores. Through customization—acts of invention and adaptation—they assert their individuality as a superhero,

setting themselves apart from the identikit, uniformed police officers who patrol the same streets.

These individuals take their inspiration from the superhero genre as a whole. Unlike cosplayers, who identify with a particular fictional hero, they develop their own identities, their own mission, and their own distinct costume. They have generated a lucrative industry in costume and weapon manufacture. Customized costume creators such as Atomic Hero Wear are commissioned to produce costumes with all the hallmarks of a fictional superhero wardrobe, including themed insignias and distinct color schemes (Krulos, 2013, p. 60). Lone manufacturers with engineering expertise, often operating outside of the law, supplement these costumes with defensive technologies.

The *World Superhero Registry* provides evidence of the range of costumes worn by real-life superheroes on active duty. Makeshift protective costumes, constructed from painted, second-hand body armor, decorated with custom insignias, assert the assumed identity of wearer. Those who can afford a custom costume may seek the expertise of costume engineers such as "Professor Widget" of Conquest, Oregon, who advertises his "electrified body armour" on the registry. Building on technologies established for military applications, these engineers develop costumes worthy of Batman, which are ostensibly functional, but that consider the superhero's identity as integral as the many utilitarian features. To the members of the registry, the costume demonstrates purpose and preparedness. It communicates intent to act, in the face of inaction from others, and "commitment to an ideal" (*World Superhero Registry*). It is the costume that separates the real-life superhero from a heroic civilian who happens to be in the right place at the right time.

Real-life superheroes are keen to assert the seriousness of their work, in contrast to the perceived frivolity of cosplay. Many of these superheroes dislike the use of the term "costume," feeling that it trivializes their actions (Krulos, 2013, p. 36). Like players of *World of Warcraft* (see Chapter 8), many favor the term "gear," classifying their costume as defensive equipment; others prefer the word "uniform," thereby defining their activities as labor in the service of others, rather than play. Some use the term "gimmick," a term used in wrestling to interchangeably refer to the costume or its wearer's assumed name, and in so doing stresses the inextricable connection between superhero costume and identity.

Despite their resistance to being viewed as carnivalesque, Jorge Cadena-Roa (2002) observes that Superbarrio employs "humor and drama" in his arsenal. The theatricality of lucha libre permits dramatic uses of the mask, and other superheroes also invite audiences to view them as spectacle. In their online profile pictures, they pose like movie stars, fully masked and costumed, in a curious contradiction of secrecy and self-promotion.

Research conducted by Mike Cooper (1999) into the psychological effects of the mask found that the many advantages of concealing one's face all stem from

a feeling of being less identifiable, and in turn less self-aware and self-conscious. Arguably, superheroes are not deindividualized in the way that wearers of plain balaclavas or expressionless masks may be. Each superhero has an identity that is as unique as his alter ego, making his masked self as individual as the face hidden underneath. However, real-life superheroes construct their alter egos in a way that seems to combine the benefits of anonymity with those of individuality.

The Web offers a safe space for showcasing their superhero identity, while maintaining their anonymity, away from the potential dangers of the street. Robin S. Rosenberg (2009) observes that, in the internet age, the wearing of a superhero costume is just one of many ways in which individuals use anonymity or false identities while aggressively promoting themselves and their values. Online, they perform and promote their concocted identities in ways that are very similar to other anonymous users of the internet. The mask of anonymity that is afforded by the internet is as liberating as a superhero costume. Its users are doubly protected from critics and criminals by their real and electronic masks, by performing in the safe space of the *World Superhero Registry*, as well as in their costumes.

By necessity, real-life superheroes are more concerned with the practicality of their costume than their fictional counterparts. It is an unfortunate reality that some clothes are "designed without consideration for the human form . . . through neglecting to consider the body's needs" (Bryson, 2009, p. 95). Superhero costumes fall into this category, having been initially designed for the page or screen, and therefore primarily according to aesthetic considerations. They are not designed to take account of the anatomical, physiological and psychological demands of the real body, as identified by Bryson (ibid., p. 96).

Fictional superhero narratives do acknowledge the impracticalities of costumes. Spider-Man comics explicitly confront various problems with the character's costume. After his aunt hides his costume in *The Amazing Spider-Man* #26 (July 1965), Peter Parker realizes that he can save himself the trouble of making another by purchasing a replica from a costume shop. Dressed in his false costume, Spider-Man soon finds that the fabric is not well-suited to his acrobatic antics. The top begins to ride up his torso, and the mask pops out of his collar, leaving him vulnerable to exposure. He makes an attempt to glue the separate parts of the costume together with his webbing, but is ultimately forced to abandon a fight or risk revealing his identity. In the following issue, he falls into the sea and the costume begins to shrink. Peter resolves never to buy a replica costume again.

The reality of a real-life superhero's mundane existence is that he or she will spend many nights patrolling the streets in costume, seeing very little action, if any at all. As parodied in James Gunn's *Super* (2010), a real superhero may spend more time searching for crime than actively engaging criminals. The primary concern in constructing a costume must therefore be comfort rather

than durability. As one online tutorial observes, "pinching and chafing can be very distracting." The same site advises costume wearers to test out their costumes by wearing them for everyday activities: "do some housework, work out or go for a jog" (*World Superhero Registry*).

Despite this reality, real-life superheroes relish the possibility of engaging in combat and, somewhat optimistically, ready themselves for the worst. These are mere mortals, and do not have superstrength or agility to protect themselves. They go to great lengths to develop a costume that is protective enough to minimize the consequences of an attack, and flexible enough to allow for evasive maneuvers. With these demands, real-life superhero costumes must incorporate wearable technology.

On the rare occasion when the real-life superhero does face a criminal, he or she must compensate for the inadequacies of the real human body. Without any supernatural strength or healing ability, the real-life superhero must consider the weight of body armor, and limited access to protective materials. He or she may "opt for minimal protection in order to avoid sacrificing speed and mobility," but this is a difficult balancing act. Speed and safety are mutually exclusive in this context. Technologically advanced lightweight protective materials are available at a cost, but are prohibitively expensive. Cheaper materials such as Kevlar may be sourced online but, as the *World Superhero Registry* is quick to point out, even in a Kevlar suit, "blunt trauma can still occur, sometimes resulting in death." Bryson (2009) argues that engineers of wearable technologies must be more aware of the needs of the human body than designers of everyday costume. She identifies particular concerns in "the inter-relationship between the body" that are necessary in the development of wearable technology, such as the delicate balance between stability and mobility. These concerns are "an essential part of the design process, not just in terms of fit but how the clothes affect the body's ability to function" (ibid., p. 99).

The extent of functionality is a mark of each superhero's commitment to action. There is a visible difference between those who anticipate real combat, whose costume is armored and accessorized, and those who merely perform good deeds, using the costume for symbolic reasons. Phoenix Jones presents himself as an active crime-fighting agent. In 2012 he made a public appeal for a new bulletproof suit, at a cost of $10,000, equipped with a pepper launcher and flashing light to blind assailants (Kerns, 2012). He uses this equipment to protect himself against acts of extreme violence, which he actively seeks out on the streets of Seattle. In contrast, Britain's Angle-Grinder Man engages in the much tamer activity of removing wheel clamps. His unitard costume expresses the message that he does not intend to engage in combat. It features an impractical cape, and has no padding apart from the kneepads which enable him to kneel down comfortably on the pavement while removing a clamp.

There is evidence to suggest that the good deeds of these masked vigilantes may directly arise from their wearing of a costume. Studies show that masked individuals are less self-aware (Mullen et al., 2003), and therefore likely to be more concerned with the needs of others (Rosenberg, 2009). Despite their eager self-promotion, real-life superheroes do actively concern themselves with the needs of their communities in ways that others do not. Further, the self-confidence afforded by the mask makes them feel more capable, and therefore more inclined toward action.

However, as Cooper (1999) finds, the psychological effects of a mask are very dependent on context. The mask inspires the confidence to act as one would if nobody was watching. It motivates wearers to behave as they would if unrestrained by social convention or the fear of negative consequences. This effect is dependent on an environment of fear and uncertainty. The "disinhibiting effect is limited to situations in which an individual wants to behave in a particular way" but feels that he or she cannot (ibid., p. 4). Real-life superheroes wear costume because they feel, as Phoenix Jones recorded on his blog, that "this world needs help." If any of these real-life superheroes found themselves in perfect worlds, free of discrimination and crime, their masks would be drained of all their power. Whenever a superhero costume is worn in reality, it serves a desire to transform or improve the wearer's own circumstances, or to resolve a widespread social injustice. Though they do not fight crime as directly as Phoenix Jones and his ilk, other groups and individuals employ superhero costume similarly, in expression of their defiance of the status quo. Feminist campaigners and punk rock band Pussy Riot resort to wearing balaclavas because they exist in a state which punishes free expression of their political views; Fathers 4 Justice wear costumes because they feel unable to carry out the duties of fatherhood.

Masks and manifestos

Nadezhda Tolokonnikova, Maria Alyokhina, and Yekaterina Samutsevich came to international attention in 2012 when they were arrested following an unsolicited performance in a Moscow cathedral by their punk rock band, Pussy Riot. A video of their performance was uploaded to YouTube, showing five masked performers running to the altar, stripping off their overcoats to reveal brightly colored dresses, and beginning an anti-Putin chant before being forcibly removed by security guards. Over the following three weeks, three of the five were charged with hooliganism. They were later sentenced to two years in prison (Smith-Spark, 2012). The three imprisoned performers, and other members of the group, have since spoken about their decision to wear masks during protests and performances, and the extent to which the costume presents them as real-life superheroes.

The Pussy Riot uniform shares some of key elements of a superhero costume. It contains a mask and contrasting tights, usually accompanied by a knee-length, brightly colored dress. "The mask, in this case, [is] a balaclava. It [can] be any colour as long as it [is] bright and one [wears] tights to not match it" (Gessen, 2014). These rules are strikingly similar to those that underpin the design of any new comic-book superhero costume. Members of the group typically select bold primary and secondary colors, and are often seen posing with fists thrust in the air in a defiant gesture that resembles the pose of Superman in flight.

Pussy Riot members have likened wearing a balaclava to "being like Batman" (Gessen, 2014) and Spider-Man (Cadwalladr and Narizhnaya, 2012). The mask offers them the sense of liberation and empowerment that comes with wearing an anonymizing costume. Through deindividuation, they become disinhibited (Langley, 2012, p. 63). As one unnamed member explains, "when I put on the mask, I feel like a person who can do everything. I am the same person, but this is another part of me which has courage . . . who has enough power to change something; enough strength" (Cadwalladr and Narizhnaya, 2012).

With this power comes responsibility. The Pussy Riot uniform is a statement of values which have to be upheld. There is also great risk in demonstrating

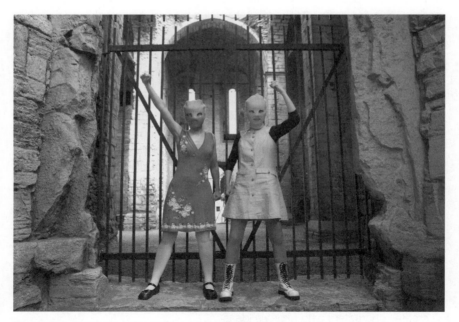

Figure 9.1 Members of Pussy Riot, photographed in Gotland, Sweden, 2013, dressed in their block-colored uniform of balaclava, tunic dress, and contrasting tights. The anonymous figure on the left throws her fist into the air in a gesture that is reminiscent of the pose struck by Superman in flight.

allegiance to the group. Merely wearing a colored balaclava is enough to get one arrested, not only in Russia but in Europe and the United States too. In 2012, thirty masked demonstrators were arrested in Marseille while protesting against Pussy Riot's imprisonment. French law prohibits the wearing of veils or other full-face covering in public spaces (Chrisafis, 2012). In New York, anti-loitering laws outlaw the wearing of masks, disguises or other "facial alteration" while congregating in groups of three or more (NY Code Section 240.35).[1]

These two countries have vastly different motives for their anti-mask laws. France's law, implemented in 2011, colloquially known as the "burqa ban," was an extension of their "rigorously enforced secularism" (Mullen, 2014). The law implicitly targets women, in an effort to erode the gender inequality that results from religious dress. Speaking in defense of the law at the European Court of Human Rights, Edwige Belliard argued that the veil anonymizes, and thereby erodes the identity of the woman who wears it (BBC, 2013). By this reasoning, any facial covering may impede the recognition and liberation that is desired by the women of Pussy Riot.

By contrast, New York City does not consider the mask itself to be problematic for the wearer. Its loitering laws are intended to prevent more serious criminal behavior that is associated with masks as disguise. As discussed in Chapter 2, a mask often indicates an intention to act outside the law. Anti-mask laws therefore act as a deterrent, saving potential victims from more severe crimes (Moynihan, 2012). It is this law that prevents, for example, armed robbers from patrolling the streets or the Ku Klux Klan from staging a rally that might descend into violence.

New York law recognizes that the anonymity of the mask may work in favor of its wearer. It exists, in part, to facilitate "the apprehension of wrongdoers" (Moynihan, 2012), and thereby acknowledges that anonymity can empower the wearer to act outside the law without reprisal. Though opinions differ as to whether they may be classified as "wrongdoers" members of Pussy Riot, and their supporters, have avoided apprehension by concealing their identity (ibid.).

In her *Human Manifesto*, Pussy Riot member Nadezhda Tolokonnikova claims that her group's balaclavas have been wrongly labeled as a disguise:

> The prosecution argues that we intentionally bought clothes for this performance. The materials of our case directly refute this point. Tights and dresses are a part of the Pussy Riot image, and the balaclavas, named in this indictment "masks", are not a disguise, but a conceptual element of our image. Pussy Riot does not want to focus attention on girl's appearances, but creates characters who express ideas.
>
> TOLOKONIKOVOY, 2012, p. 292

As an element of Pussy Riot's "image," the balaclavas serve to create a united identity that supersedes the individual identity of any member. Even if the

concealment of individual identity is not intended as a "disguise," it does serve the purpose of rendering every member as anonymous. Tolokonikovoy and her compatriots elect to temporarily relinquish their individual identities in favor of a shared, group identity. Aspects of individuality are replaced by a shared set of values, common to all members.

This set of shared values, bound up in the wearing of the mask, extends beyond official band members to audiences who wear similar masks in solidarity. Pussy Riot is not an exclusive group, rather it has "an open-membership collective in which every participant perform[s] anonymously" (Gessen, 2014). The group invite others to become honorary members through the act of donning their own balaclavas. Since the arrest of Pussy Riot performers, this group of masked supporters has expanded across international borders. Supporters have adopted colored balaclavas: women who have had no previous contact with the group have started to make and sell colored balaclavas, with proceeds donated to the Pussy Riot Legal Defense Fund; and the website Change.org has created digital images of balaclavas that supporters can substitute for profile pictures on social networking sites (Levy, 2012).

By wearing their own masks, supporters have chosen to anonymize themselves—to temporarily abandon their own identity—in favor of expressing solidarity for the oppressed women of Russia. Their actions are not dissimilar to those depicted in James McTeigue's film adaptation of *V for Vendetta* (2005). In the film's final act, the masked freedom fighter, V, implements a Guy Fawkes-inspired attack on a fictional, corrupt British government. Following the death of the titular superhero, masked civilians take to the streets in droves. Their identical masks make it impossible for law enforcers to differentiate civilians from the real "terrorist." In the absence of the real hero, the crowd adopts his identity, sharing it between them. By distributing copies of his mask, V creates an open-source identity. In doing so, he succeeds in rendering himself even more anonymous.

Although V loses his life, his values live on in his open-source identity. "Beneath this mask," he says, "there is an idea . . . and ideas are bulletproof." The mask transforms one man into the custodian of a set of values that is much bigger than himself, making him representative of the wider oppressed population. When Inspector Eric Finch asks V's co-conspirator, Evey, to reveal the man's identity, she replies, "He was my father and my mother, my brother, my friend. He was you and me. He was all of us." The V identity has even extended into the real world, where fans of the comic or film may buy their own copy of V's mask. Anti-establishment protest group, Anonymous, has adopted the *V for Vendetta* mask as a means of indexing a "protest against tyranny" (Waites, 2011).

As with V and numerous other comic-book superheroes, the Pussy Riot identity is bound up in the mask more than in the identities of any of its individual members. One unnamed participant told Masha Gessen (2014) "you put on the mask—and you become Pussy Riot. You take it off—and you are no longer

Pussy Riot." Wolf-Meyer (2006, p. 192) notes that "once Batman's ideologies are secured and sanctioned by the system, anyone can wear the costume and be similarly sanctioned." The costume is recognized as representing a certain set of values and abilities, and so the identity of the wearer becomes irrelevant. The identity of the superhero is removed from the wearer, and can become entirely bound up in the costume itself.

Once the identities of the costume and its wearer are separated, there is the possibility that the costume identity can be inherited or appropriated by another. As with Batman's young sidekick, Robin, a title can be passed, along with the costume, to younger generations. The identity of the superhero is so bound up in the costume that its wearer is often merely a custodian of a legend much larger than himself. When that identity may be multiplied, as is the case for Pussy Riot and V, masked members become part of a legacy that is greater than themselves.

Many of the custodians of the Pussy Riot identity are international, and so recontextualize the wearing of brightly colored balaclavas, transporting them into different cultural and social environments. While Pussy Riot's original members may have specifically protested oppression in their native Russia, global audiences use the costume to highlight the universality of these issues. In August 2012, a flash mob descended on the Southbank Centre in London. The mob, dressed in Pussy Riot uniform, "froze for 5 minutes in their best superhero pose," with hands on hips and chests arched heroically forwards (Comiskey, 2012). The event was remarkable in part for the participation of men. Among the mostly female crowd were several male participants in similarly vivid costumes, demonstrating solidarity for their female counterparts. This gender diversity demonstrates the evolution of the meaning of the colored balaclava. Having originally been employed as an expression of a specific set of feminist ideals, its meaning has expanded through wider participation to signify a more universal set of values.

Parent power

The universal appeal of the superhero costume is demonstrated not least by Pussy Riot's supporters. The broad applicability of superheroic values in political contexts can be expressed in any number of struggles, be they against the tyranny of a state, or the rights of a parent.

Parenthood shapes the values of an individual. New parents experience upheaval and "a period of disequilibrium," forcing reassessment of personal identity, and redefinition of roles and relationships. Antonucci and Mikus (1988, p. 63) go so far as to describe the birth of a first child as an unresolvable "crisis" which marks a transition into an entirely new approach to life and self. This period of sudden change is comparable to the cataclysmic event that prompts the emergence of a superhero. As the death of family provoked the adoption of

heroic identities in Batman and Spider-Man, new parents find themselves transformed by the birth of a child.

New mothers and fathers who may have previously defined themselves according to their occupation or other aspect of self, begin to define themselves primarily as a parent (Chilman, 1980, as cited in Antonucci and Mikus, 1988, p. 64). Parenthood becomes their defining characteristic, overshadowing all other aspects of self. It is just as impossible to define any parent without acknowledging their parenthood, as it is to define Bruce Wayne without acknowledging Batman. Turner (1978, as cited in ibid.) observes that the personal importance of this role is heightened by the strain of the role. Parenthood, like crime-fighting, is labor-intensive, exhausting and emotionally draining. It is this constant strain, and the investment of time and emotion, that leads parents and superheroes to associate themselves primarily with these roles.

Superhero imagery allows parents to express the tremendous strength that is required in parenthood, along with the new sets of values that emerge with their new identity. The image of the Super-Dad or Super-Mom is prevalent in birthday cards and novelty items, including garments such as T-shirts and pajamas. More extreme adoption of the superhero costume is demonstrated when individuals are required to assert their parental identity to wider audiences. Fathers 4 Justice is one such example, a father's rights organization founded in the UK in 2004. The group primarily campaigns on behalf of divorced parents, for equal rights to contact with children, and do so dressed as superheroes.

The pursuit of justice has been a defining component of the superhero genre since the early days of Superman. The superhero represents a particular kind of justice for "those victimized by a blind though well-intentioned state" (Reynolds, 1992, p. 14). It is exactly this kind of justice that Fathers 4 Justice seek. They do not oppose the state or the ideals that it represents, but do feel that they have been let down by inadequacies and inequalities in its laws.

The costumed protests of Fathers 4 Justice seek to address the loss of control experienced by their members. The superhero alter-ego is frequently developed to gain control where it has previously been lost. Batman emerged to regain control of crime-ridden Gotham City; the X-Men formed a union to gain control when their existence was threatened; and Fathers 4 Justice seek to regain the rights to spend time with their children. Loss of control is experienced even before the birth of a child, and continues into early parenthood (Antonucci and Mikus, 1988, p. 65), and parents seek to balance or resolve their loss. Fathers 4 Justice feel more loss of control than many other parents, having lost not only control over their own lives, but also their identities as fathers through lack of access to their children. In this case, loss of parental control is offset by costumed acts of vandalism or occupation, in which campaigners take control of state-owned property.

Presenting themselves as superheroes, individuals overtly draw parallels with the balance of power and responsibility that characterizes the superhero's

struggle. The mantra inherited by Peter Parker, "with great power comes great responsibility," reflects the balance observed in parenting by Mill Mass (1997, p. 241). While parenthood marks progression into the next step of adulthood, the negotiation between power and responsibility involves, in part, positioning oneself as both responsible role model and playfellow. Parenthood often invites regressive, childish behavior (Antonucci and Mikus, 1988, p. 65), and engagement with superhero narratives or dressing up is one possible manifestation of this return to childhood diversions.

Barcelonan artist, Ana Álvarez-Errecalde, expresses aspects of superhero play, combined with the feelings of power and powerlessness, in her self-portrait, *Symbiosis* (2013; see Figure 9.2). The photograph depicts the artist breastfeeding

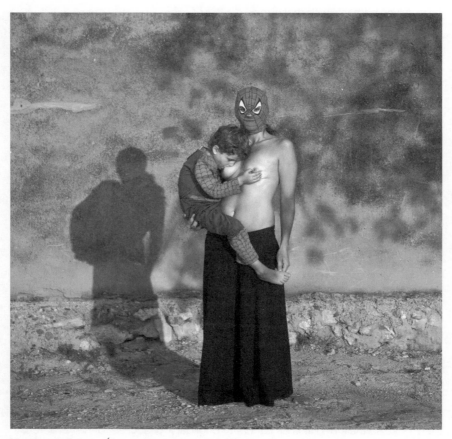

Figure 9.2 Ana Álvarez-Errecalde, *Symbiosis,* 2013. The artist depicts herself breastfeeding her son, symbiotically sharing the Spider-Man identity. Álvarez-Errecalde's image represents the feeling of being empowered by motherhood, and yet ashamed when performing that motherhood in public. The superhero mask expresses power while protecting her from the accusatory gaze of others who disapprove of public breastfeeding.

her son. She wears a Spider-Man mask, while her son wears the rest of the costume. Álvarez-Errecalde (2014) recounts how her four-year-old boy would dress up as a superhero, then "fall while playing" and run to his mother for comfort. In providing that comfort, Álvarez-Errecalde felt powerful, able to provide physically, emotionally, and intellectually for her growing children.

Despite the empowerment that she feels in her family environment, the artist feels that acts of motherhood are not given the respect that they deserve outside of the family home. She recounts how friends and strangers would demand that she "cover up," rather than exhibit the apparently shameful act of breastfeeding in public. By wearing her son's mask, while topless, she intends to mock "all that unsolicited advice." Much like members of Pussy Riot, she aligns herself with a guerrilla campaign for gender equality, viewing this photograph as an unapologetic assertion of her parental responsibilities.

Álvarez-Errecalde (2014) is quick to stress that she does not see mothers as superwomen. She views the relationship between mother and child as "symbiotic," with both parent and child "strengthened by their relationship" with each other. This interaction is signified in the sharing of the costume.

Superhero comics may have originally been aimed squarely at children (Tye, 2012, p. 26), but appropriations like these evidence the importance of superhero mythology for strengthening familial bonds, particularly between parent and child. Engagement with superhero narrative and costume prompts interactions between generations. Indeed, Warner Bros. Entertainment's Chief Executive Officer, Kevin Tsujihara, describes a strategy of cultivating Batman's "multi-generational appeal" (Warner Bros., 2014). Superhero costumes represent significant cultural heritage, and appropriation of those costumes allows parents to act as custodians and purveyors of a cultural history that extends far beyond the officially sanctioned narratives of comics and films.

PART FOUR
CASE STUDIES

Introduction to case studies

The following three case studies have been selected in order to introduce issues that arise in the discussion of particular superheroes. The case studies demonstrate how issues raised in previous chapters may be applied and combined in detailed analysis, while also establishing that there is scope for varying or challenging the generalizations made elsewhere. There are numerous conventions in the design of superhero costume, and those have been explored within previous chapters. The case studies below challenge or complexify those conventions, or even diverge from them in noteworthy ways.

While these examples have been briefly referenced in previous chapters, each is rich enough to warrant substantive further discussion. Furthermore, they raise questions that are specific to each case. Examples used in previous chapters tend to be reflective of wider trends. Whereas these case studies raise issues that are unique to particular examples. The first study explores the consequences of wearing a costume, which go largely unexplored in original superhero narratives, but that are explicitly explored in Alan Moore's *Watchmen*. Secondly, *Iron Man* has been explored because of his unique dependency on his costume. This case study examines the extent to which Iron Man's costume is responsible for the character's identity and abilities. Lastly, *The X-Men* are introduced as an example of the superhero costume as a uniform, uniting disaffected Others and sheltering them from a society that stigmatizes their heroic abilities.

10
WATCHMEN

Deconstructing the costume

Alan Moore and Dave Gibbons' *Watchmen* (1986–1987) is a deconstruction of the superhero comic that poses the question "what if superheroes [and their costumes] were real?" (Thompson, 2005, p. 105). Such self-conscious responses to genre occur, writes Geoff Klock (2002, p. 3), when the "building density of tradition becomes anxiety." The superhero genre has mushroomed to such proportions that it seems uncontrollable, providing audiences with a glut of source material so overwhelming that it demands critical response (Reynolds, 1992, p. 34). Decades of comics and film and television adaptations have constructed a mythology for the superhero and his costume, which has become so extravagant that it needs to be reflectively reappraised.

Watchmen, visually and thematically, is "self-consciously immersed in superhero nostalgia" (Sheets, 2009). Its superheroes, collectively called the Minutemen, were all created with reference to existing superheroes, previously published by Carlton Comics (Gibbons, 2008, p. 28): Dr. Manhattan is modeled on Captain Atom; Silk Spectre on Nightshade; Ozymandias on Thunderbolt; The Comedian on Peacemaker; and Rorschach on The Question. Gibbons' costume designs directly appropriate from his source materials.

Moore's text, and Gibbons' illustrations, present costumes as infantile, provocative and impractical. The first Nite Owl's fictional autobiography tells of failed experiments with an unwieldy cloak, and how a "drunk with a knife hooked his fingers into the eyeholes of the [mask]" ("Under the Hood," p. 7). His successor, the second Nite Owl, speaks about having to redesign his costume in order to save time in the bathroom (Chapter VIII, p. 20). The cloak, in particular, is presented as a potentially lethal inconvenience: Dollar Bill is shot dead after his cloak becomes trapped in a revolving door.

Men without humanity

Far from the united team presented in *The X-Men* (see Chapter 12), the Minutemen is a sometimes disharmonious band of independent masked

vigilantes, each with his or her own identity. These identities have been constructed before the beginning of the book, by which time their costumed activities have been outlawed. Through conversation and extracts from the first Nite Owl's autobiography we learn that Nite Owl and Silk Spectre have inherited their costumes from predecessors, that Dr. Manhattan was once given a costume by the US government, but abandoned it over time, piece-by-piece, and that Rorschach created his mask from scraps of an unwanted dress.

Working in a garment factory, Walter Kovacs, Rorschach's alter ego, encounters a dress manufactured from "viscous fluids [sealed] between two layers [of] latex" (Chapter VI, p. 10). Kovacs takes the dress when it is rejected by its intended wearer. The dress, like Kovacs himself, is ugly and unwanted, and can only be saved through transformation. He gives the dress, and himself, purpose, by cutting it into strips. After the woman who ordered the dress is brutally murdered, Kovacs is so disgusted with humanity that he feels the need to distance himself from the rest of his species (a need also felt by Dr. Manhattan). He ties a strip of the dress fabric around his head, giving himself "a face that I [sic] could bear to look at in the mirror."

Rorschach continues to refer to his mask as his "face" throughout *Watchmen*. Indeed, he seems to display such abject terror at losing his mask that it is as if the inkblot fabric really is his own skin, and he cannot comprehend the possibility of his own existence without it.

Reflecting his feelings of shame about all things human, Rorschach's "face" is absent of facial features. It presents itself as an inkblot test, used by psychiatrists to discern an individual's subconscious desires and intentions, from which Rorschach also takes his name. The Rorschach inkblot has no meaning of its own. Its meaning is projected onto it by the viewer. Likewise, Rorschach's mask is designed to reflect back on the viewer, "a blank onto which others would project their own fears" (Thompson, 2005, p. 107). Thompson (ibid.) proposes that this mask makes a wider observation of the superhero genre, that "comic book heroes are projections of the fantasies of their readers."

In his facelessness, Rorschach seeks true anonymity. Having suffered abuse and bullying as a child, he needs to create such distance from himself and his kin that he becomes Other. Michael Cooper (1999, p. 20) cites leading hypotheses for the mask's power to disinhibit its wearer as a "reduction in identifiability" that will lessen the "likelihood that [he] will be judged, shamed, ridiculed, spoken ill of, or punished in any other way for [his] behaviours." Rorschach's anonymity seems to protect him from the cruelties that he experienced in his own past, and from persecution in the present, where his activities are outlawed.

Those characters in superhero narratives who plot to reveal the hero's identity do so because they understand the true power of the mask. For Rorschach, the mask is explicitly the last line of defense when he is finally arrested and imprisoned. Having cornered the rogue vigilante, the police's first instinct is to "get his mask off!"

knowing that this will immediately reduce his power. Rorschach, whose civilian face is not explicitly revealed to the reader until his unmasking, is suddenly neutralized. The antihero, whose strength came in part from the ambiguity of his masked face, is reduced to a powerless "little zero." The police officer's need to unmask him stems from the notion that so long as his mask remains on his face, Rorschach is still a threat, and still a free man. The arrest is only complete when the unmasking has been accomplished, as an equivalent gesture to placing the captor in handcuffs.

Cooper further proposes that the mask may act as a "container" for a "self that is dangerous" (Cooper, 1999, p. 24). Rorschach creates a boundary between himself and others, not only so that he may be protected from them, but also so that they may be protected from him. Having witnessed violence and "self-deception" in his fellow man, he feels personally "ashamed" (Chapter VI, p. 10), as if he is as guilty as the rest of the human race for the cruelty that they inflict on one another.

Kovacs' own cruelty is distanced from human behavior first, when he is a boy, when he is compared to a "filthy little animal" and a "mad dog," when he viciously attacks his bully (Chapter VI, p. 7). Later, he is dehumanized by his Rorschach mask as he commits numerous more severe acts of brutality in the name of vigilante justice. Kovacs appears to understand, perhaps paradoxically, that his own mask dehumanizes him, and yet enables him to partake in the kind of cruelty that made him turn his back on humanity in the first place.

A more severe indifference to humanity is exhibited by Dr. Manhattan, who begins life as a human but, after a nuclear accident, exists as particles scattered throughout time and space. Soon after his accident, his government handlers provide him with a costume and insignia. He rejects the mask and insignia, initially willing to wear the rest of the costume. As the narrative progresses, he becomes disillusioned with the values of his handlers, and his costume is slowly discarded. As he takes control of his identity, he abandons the government-issue costume piece-by-piece, illustrating his liberation. Eventually his understanding of the universe, and everything in it, advances to the point at which he perceives everything at an atomic level. As atoms, everything loses its meaning, including human life, which he recognizes as "brief and mundane" (Chapter IX, p. 17). In his post-human state, he has no need for clothes—the unnecessary trappings of a doomed culture—and chooses a state of total nudity.

Masks without men

Many of the costumes that appear in *Watchmen* are first introduced as empty vessels, removed from the bodies of the heroes who once inhabited them. In Chapter 1, Rorschach uncovers the costume of the recently murdered Comedian in a hidden compartment at the back of his wardrobe, hanging limply on a hook.

He lays the costume out on the floor, as if laying to rest a lifeless body. The holes of the mask mark the location of eyes, nose, and mouth, as if a face is still party present. The boots retain their shape, as if still occupied by feet.

A panel on page 13 depicts Daniel Dreiberg sitting slumped on a crate in his civilian suit, looking disheveled and melancholy (see Figure 10.1). To his left there is an open locker, in which his Nite Owl costume stands tall and proud. It is as if the costume, despite the absence of the hero's body, has more pride than the former hero who once wore it. Daniel, without the costume, cannot stand tall. His sense of self-worth is entirely bound up in the costume, and the Nite Owl identity.

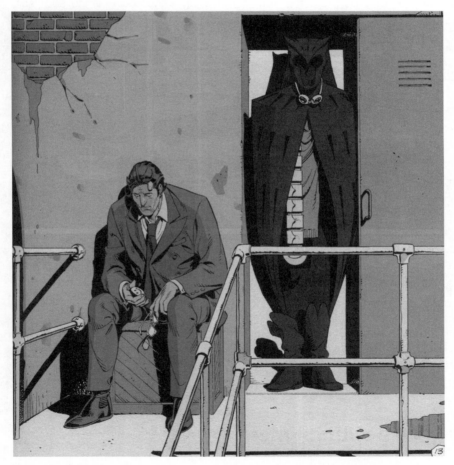

Figure 10.1 A panel from Chapter 1 of *Watchmen* depicts Daniel Dreiberg wearing his civilian suit, with his Nite Owl costume visible in an open locker behind him. Dreiberg is slumped, disheveled, and melancholy, while his empty costume stands tall, as if the character's pride is entirely bound up in his superhero identity.

© DC Comics

Costume is so rarely encountered apart from its wearer that the body is notable in its absence. As if they are the shadows of superhuman bodies, these costumes "bear impressions of the people who wore them" (Feldman, 2008, p. 123). They retain the uncanny form of the body, but are lifeless—"lived in" but not alive—telling "the story of a life once lived" (Greenbaum, 2001, p. 277, cited in ibid.).

Watchmen's empty costumes are memorials to the Golden Age of superheroes. They can be considered in similar terms to the piles of abandoned clothes that memorialize the victims of Auschwitz and Dachau, or the field of 2,974 empty shoes laid at Ocean Grove to commemorate the lives lost on September 11, 2001 (Shields, 2011). These empty garments speak of the nonexistence of people to wear them. They take on additional significance through their worn appearance. The dirt and tears are evidence of the conditions suffered by the wearers before they died. "Not only do these traces evoke the bodies of the people that are now absent, but the wear and tear of abandoned clothes . . . furthermore stir an empathetic flow between the body in the present and the body that is absent" (Bille et al., 2010, pp. 12–13).

This reading is reinforced later, when Dreiberg is revealed to be impotent without his costume. In Chapter VII (pp. 14–15) he is seduced by Laurie (Silk Spectre), but fails to perform. Later, when they are both on a mission and in costume, he satisfies her. His virility, he confesses, "had something to do with [the costumes]" (pp. 27–28). Silk Spectre's own costume plays a vital role in this encounter too. The pair make love as Silk Spectre and Nite Owl, not Daniel and Laurie.

The Silk Spectre costume is the cornerstone of the relationship between Laurie and her mother, Sally Jupiter. In Laurie's earliest memory, told in flashback, she overhears her mother and father arguing. Gibbons' illustrations show only a glimpse of Sally behind a door. Instead, Laurie's memory shows us the costume hanging in a cupboard (Chapter IV, p. 7). The mother–daughter relationship revolves around the passing-on of the costume, along with the Silk Spectre identity. Laurie's retirement is illustrated by her putting her Silk Spectre costume away in a drawer (Chapter IV, p. 23). When an identity is so bound up in a costume, it can be adopted and abandoned with ease. As Hollis Mason tells readers, "vanishing is no big problem when you're a costumed hero—you just take your costume off" ("Under The Hood," p. 12).

11
IRON MAN

Who is Iron Man?

Once a costume is established as a representation of a certain set of values and abilities, the superhero identity can become more attached to the costume than to its wearer. In the case of Iron Man, identity is more bound up in the costume than with any other superhero. Indeed, Iron Man is not a man, but an augmentation.

Technological enhancement of the human body disintegrates distinctions between human and nonhuman (Fletcher, 2012, p. 1) and, in the case of Iron Man, distinctions between the man and the superman. Tony Stark is responsible for his suit, physically and intellectually; but although no one can challenge his ownership of the Iron Man identity, without the suit, Stark would not be a superhero.

The complex relationship between Stark and his suit provokes questions about the uniqueness of a hero with manufactured abilities. Cyborg technologies problematize notions of human uniqueness (Fletcher, 2012, p. 1). Martin Heidegger distinguished humans from nonhuman entities according to their "essence." The man-made Iron Man suit is infinitely replicable, and so Iron's Man's powers and appearance are replicable too. Fetcher (2012, p. 2) posits that the essence of humanity, which marks every human as unique, cannot exist where components of identity are duplicated, as when artificial technologies are integrated into the body. In becoming cyborg, Fletcher proposes, a human must compromise his privileged position of uniqueness.

Tony Stark's lab, as depicted in *Iron Man 3* (Shane Black, 2013) is lined with a collection of six different versions of his exoskeleton. Each suit has carried the Iron Man identity, and yet there is only one Iron Man. Every time Stark constructs a new suit and abandons the old one, the Iron Man identity is transferred, attached at any one time to the latest version of the suit. It is Tony Stark's presence within any one of these suits that elevates its status to that of the one true Iron Man.

In *Iron Man 2* (Jon Favreau, 2010), Stark faces a demand to hand over his suit to the US military. He responds that "I am Iron Man. The suit and I are one. To turn over the Iron Man suit would be to turn over myself which is tantamount to

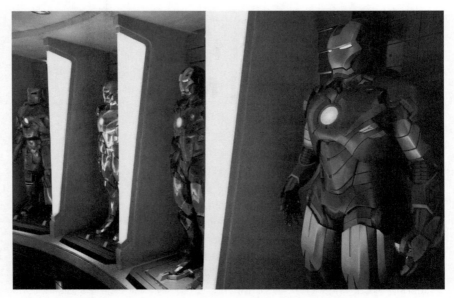

Figure 11.1 Four versions of Tony Stark's Iron Man suit on display in *Iron Man 2* (Jon Favreau, 2010). Each version includes new upgrades, thereby enabling new abilities. Though Iron Man's appearance and abilities differ depending on which suit he wears, Iron Man has only one identity, as defined by Tony Stark's presence inside the suit.

© Moviestore Collection/Rex

indentured servitude, or prostitution." Stark views the Iron Man identity as a complex whole, consisting of himself and his suit. In gestalt terms, the whole is more than the sum of its parts.

Tony Stark retains his distinct identity as Iron Man by ensuring his own suit remains at the forefront of fictional technology. Other organizations make attempts to replicate the suit, but frequently fail. In other superhero narratives, villains and competitors pursue the goal of unmasking the costumed hero (see Chapter 2). In *Iron Man*, that goal is replaced by the drive to outdo Stark: "to make Iron Man look like an antique" (see *Iron Man 2*). By unmasking himself, as he does in the *Iron Man* films, Stark denies his enemies the thrill of chasing his identity, and instead sets them the challenge of creating technologies capable of competing with his.

In recent incarnations, he also avoids erosion of his human identity by being one of few superheroes who promotes his true identity. Tony Stark flaunts himself in front of audiences in and out of his Iron Man suit.

The uniqueness of the Iron Man identity is problematized by Stark's decision to deputize others. In *The Invincible Iron Man* #21 (January 1970), Stark employs a boxer, Eddie March, to take over his role as Iron Man. As creator and custodian

of the Iron Man identity, Stark is able to delegate his responsibilities, and his title. Though Stark is still alive, and still has control over the suit by proxy, through his actions he ceases to be Iron Man himself. His retirement is short lived, as he soon realizes his mistake and runs to March's aid. As soon as he is dressed in his own Iron Man suit, the identity is transferred back to Stark. In this case, March is permitted by Stark to occupy the Iron Man identity. Conversely, in *Iron Man 2* (Jon Favreau, 2010), when one of Stark's suits is appropriated by the US military and given to another wearer, it is given the alternative name of Iron Patriot. Although the suit is Iron Man's, Stark does not sanction its use or its actions, and it therefore cannot retain the Iron Man name or identity.

Ironically, the uniqueness of Tony Stark is called into question more often than that of Iron Man. Having concluded that his secret identity could be more believably maintained if Stark and Iron Man could appear in public together, Stark develops "life model decoys" for himself (*The Invincible Iron Man* #11, March 1969; #17, September 1969; and #109, April 1978). By developing these visually identical decoys, Stark has placed himself in the curious position of being less visibly unique as Stark than he is an Iron Man.

Automated dressing

Iron Man's suit remains futuristic and yet feasible. The upgrades are presented in the same terms as real-life technologies. *The Definitive Iron Man* (2008) concludes with an annotated schematic of the various components of his "metalo-mimetic suit series MkIII." Such explanations give an air of believability to Iron Man's more bizarre capabilities. Several of these upgrades and enhancements relate to the ease at which Stark is able to climb in and out of the suit. For Stark, the transformation into the superhero alter-ego is as technologically enhanced as all of Iron Man's other abilities. The most notable upgrade to Stark's suit in *Tales of Suspense* #48 (December 1963) is a system which constructs the suit around Stark's body. Stark only needs to pull on cuffs and boots, and these expand to cover the rest of his body, pulled by the force of magnets in his chest-plate.

The films present the act of dressing as a fully automated process. In *Iron Man 2*, Iron Man/Stark makes a theatrical performance of his undressing. As Iron Man, Stark flies into an arena full of adoring fans. As the crowd cheers, the stage beneath him fragments, and robotic arms emerge. The arms remove the exoskeleton, piece-by-piece, revealing Stark's smiling face, followed by the rest of his body. The transformation is presented as spectacle—a theatrical gesture of undressing. In *Iron Man 3* (Shane Black, 2013), Stark's latest upgrade allows him to command the separate components of the suit to fly toward him as independent pieces, and construct the suit around his body. Dru Jeffries (2013, p. 36) argues that these transformation sequences are essential in legitimizing

the CGI sequences of Iron Man that occur later in the film. Having directly witnessed Stark's transformation into Iron Man, audiences are more inclined to believe that the wholly computer-generated models of the suit do contain Tony Stark's real body.

Vivian Sobchack presents "quick-change" as a form of spectacle, originating from the theatrical performances of dressing and undressing through sleight-of-hand that existed for many centuries before the introduction of mechanical or electrical technologies that could make Iron Man's transformation possible. A long history of "quick-change" on the stage included, for example, sleight-of-hand substitution of masks in Sichuan opera (see Chapter 5). These theatrical illusions often involve transformations in which speed or "physical dexterity" combine to create unexpected and "striking transformations" (Solomon, 2000, p. 3). In more recent performances, quick-change artists employ contemporary clothing technologies to enhance the spectacle of their rapid transformations, ranging from color-changing fabric to "rapidly disconnectable fastenings" (Mass, 2001). The spectacle of quick change has also migrated to film and television fiction, where it is performed with digital or electronic tools, sometimes employing a combination of latex masks and CGI (as in Brian De Palma's *Mission Impossible*, 1996). Visual effects have enabled the on-screen transformations of Diana Prince into Wonder Woman (in the 1975–1979 television series), Clark Kent into Superman (see Richard Donner's *Superman: The Movie*, 1978) and Johnny Blaze into a flaming Ghost Rider (Mark Steven Johnson, 2007). Thus, on-screen quick-change is generated using the same digital trickery as the numerous other superpowers that are re-created in cinema adaptations of superhero comics.

The spectacle of quick-change is, for many superheroes, a vital addition to their repertoire. Without the ability to change out of his costume and back into his civilian suit, Superman would struggle to maintain his secret identity, thereby undermining a defining characteristic of the superhero genre. Given the importance of super-undressing for other heroes, it is consistent for Iron Man to mechanize his dressing and undressing just as he has mechanized his powers. The upgrade has no military applications, but it does provide Iron Man with one vital superpower that Superman, Wonder Woman and the Flash have had before him: the ability to dress up at speed.

The hyper-abled hero

Iron Man stories oscillate between technophilia and technophobia. They celebrate the post-human cyborg, but also warn of the dangers of over-dependence on technology. The suit is sometimes presented as a handy multi-tool (the first suit is akin to a full-body Swiss Army knife and his many "attachments" range from suction cups that fasten to the palms to a "miniature buzz saw inside [the] index

finger" — *Tales of Suspense* #39, March 1963), and at other times, as a dangerous weapon (in *Iron Man 2*, Vanko electronically takes control of Rhodes' War Machine armor, effectively using Rhodes as a puppet to attack Stark).

Travis Wagner (2014) considers the *Iron Man* films as disability narratives. Stark, wounded by shrapnel, is physically disabled, and becomes dependent on a magnetic implant for his survival. His injury and subsequent implant, the "arc reactor" embedded in his heart to prevent a fragment of shrapnel from killing him, limit Stark's ability to function as he did before his accident. Stark is unable to partake in everyday activities. *Tales of Suspense* #40, for example, depicts him as unable to swim because of the iron chest-plate and reactor that is constantly concealed beneath his shirt.

Wagner (2014, p. 5) describes Tony Stark's story as one of "disability denial." After his life-altering injury, he refuses to accept anything less than "normative able-bodiedness" and his suit simply reestablishes the privilege already experienced by billionaire Stark. Rather than acknowledging and accepting disability, he "uses his privilege and eventually his Iron Man suit as a means to renavigate his identity, denying his debilitation through technology" (ibid., p. 6). The mobility afforded by the suit "is one of admiration and power, not debilitating loss; therefore it does not cause Stark to question what he has lost post-accident" (ibid., p. 9). Wagner makes Stark "hyper-able" (ibid., p. 5). Stark himself refers to the suit as a "high-tech prosthesis" (*Iron Man 2*) — referring to a prosthetic runner's "blades" which enable athletes to run faster than men who have real legs.

Though his suit is the most technologically motivated of all superhero costumes, Iron Man's concerns are not entirely utilitarian. Roger Caillois (1990, p. 6) proposes that "the utilitarian role of an object can never completely justify its form." However much it presents itself as a functional object, "it is possible to discover in each object an irrational residue." Iron Man's suit, like any other costume, contains what Michael Carter (2012, p. 350) describes as "stylistic surplus." Like the manufacturers of sports cars, Stark streamlines his suit for aesthetic as well as functional purposes. The Iron Man depicted in Marvel's films is a narcissist comfortable with frivolity.

Iron Man's suit may be ostentatious, but it is clear that his concern for the aesthetic properties of his costume does not compromise his virility. In *Iron Man* (Favreau, 2008), Stark selects "Hot Rod red" for his new suit. By framing the color choice in reference to a mechanical object, one of the many cars in his garage, he presents it as unquestionably masculine. Like other superheroes (see Chapter 7) his masculinity cannot be compromised by frivolous concerns about fashion or glamour. Any purely aesthetic change in his suit therefore has to occur at the suggestion of a woman. In *Tales of Suspense* #40 (April 1963), one of Stark's many beaus, Marion, complains about the "awful dull grey" of his suit, and proposes instead a more glamorous "golden metal." Her suggestion is presented

as not entirely superficial. She reasons that the proposed color change is not a matter of fashion, but a reassuring expression of heroic values. "When people see golden armour . . ." she tells Stark, "they will know he has a heart of gold."

Marion refers to Iron Man as a "modern knight in shining armor," and in doing so she acknowledges the power of the suit to transform Tony Stark not only physically, but symbolically too. Stark's ego is masked by a suit that expresses selflessness. As Stark, he appears to have only his own interests at heart, but as the "knight in shining armor," Iron Man, he is presented as a savior.

12
THE X-MEN

Uniforms and unity

Reynolds (1992, p. 26) observes that all superhero costumes function "as a uniform, binding together all super-beings." The superhero uniform asserts his readiness to perform acts of heroism, and aligns him with crime-fighting values. Costume "creates a community between its wearers" (ibid.), communicating to audiences that even the most isolated or rebellious superhero conforms to a core set of ideals that define the superhero genre. More so than other superhero costumes, the wardrobes of the X-Men "gather and group" (Harvey, 2008, p. 72). The X-Men's costumes are uniforms, to the extent that they express membership of a group that is both legitimized and regulated by their leader, Charles Xavier.[1]

The wearing of the uniform expresses identification with a shared set of values, and a willingness to actively participate in the role assigned to them by the rest of the team (Rouse, 1989, p. 29). Though these heroes have been outcasts in their former lives, having donned their costumes they are "no longer alone: [they] have put on membership" (Harvey, 2008, p. 72).

The need to present a united front stems from the X-Men's status as mutant outsiders. Their minority status leads them to seek strength in numbers; a shared uniform is a display of strength through unity. Simultaneously, the uniform protests the ghettoization of mutants by displaying pride in mutant status. The X-Men uniform expresses both sameness and otherness simultaneously: they are other than human, and united in their otherness.

However, the X-Men uniform does not clothe all its wearers in the same cloth. There is considerable variation, expressing the individual principles and abilities of each member of the group. These differences are far greater than the micro-adjustments that are made by school pupils or workers in uniform. The heroes of the first *Uncanny X-Men* (September 1963) wear matching uniforms of blue unitards with yellow torsos and X-insignia belt buckles. Later comics saw the heroes diverge from the standard uniform to mark their individual identities. While the uniforms of some characters, notably Cyclops, express allegiance by remaining relatively faithful to the archetype, others break the mold. Beast's costume shrinks and expands between extremes of total or minimal coverage, and Jean Grey (aka Marvel Girl and later Phoenix) designs

radically different costumes for herself and Avenging Angel: a green mini-dress for herself, and a red unitard for him. Danielle Moonstar explicitly rejects the X-insignia belt and boots worn by the rest of the "New Mutants" team, preferring to wear accessories that reflect her cultural heritage (*Marvel Graphic Novel* #4, September 1982).

These heroes' reluctance to wear a full costume marks them as loners, outside of the X-Men as well as outside of the rest of society. To Moonstar, the uniform signifies the erosion of her cultural identity. Her refusal to wear it reflects a desire to not be viewed as wholly mutant. She has dual identity—mutant and Cheyenne—and her decision to join the X-Men will not force her to compromise the other aspects of her identity. Thus for her, the civilian alter-ego is present even when she is in costume. Xavier's response is to view her clothing choice as a rebellion. To Xavier, uniform signifies obedience to rules and regulations, to a moral code, and to superiors within the group hierarchy. He interprets her nonconformity as a rebellion against the X-Men's code and against his authority as the group's leader.

Despite his insistence that his recruits wear uniforms, Charles Xavier is himself commonly depicted without a costume. For Xavier, the lack of costume signifies seniority. As a young man, Xavier is depicted wearing a complete costume, but as the mature leader of the X-Men he dresses as a civilian. His civilian clothes represent privilege, as if he has risen through the ranks and earned enough status to grant himself freedom to dress as he chooses. It also marks him as a nonoperational member of the group. His paralysis has rendered him unable to take part in combat along with other X-Men, and although he does offer vital reconnaissance, he does so remotely and has no need for combat dress. When Xavier's disability is miraculously healed thanks to transference of his consciousness into a cloned body (*Uncanny X-Men* #163, November 1982), he is once again depicted in costume. His new body has greater physical mobility, and his wearing of the uniform signifies readiness for combat.

Despite their camaraderie, these heroes feel the need to "proclaim [their] individuality" within the group, setting themselves apart from their peers (Reynolds, 1992, p. 26). As in all fashion, they seek compromise between conformity and his or her abilities apart from the rest (Stone, 1981, p. 143). There must be similarity—to present a united front, and difference—to assert the particular qualities that each member brings to the group. These are different superheroes working together toward a common goal; united, yet distinct.

This deviation from the uniform is reflective of the X-Men's status as a minority group. Erenberg (1998, p. 231) proposes that minority groups dress not only in defiance of mainstream convention, but also in defiance of each other. "The rejection of mainstream middle class society," he proposes, results in a generally nonconformist attitude, manifested in a desire to mark oneself out as

"unorthodox." When everyone in a ghettoized group is viewed collectively as Other, dress is a means by which individuals can "assert their personalities against a depersonalized world" (ibid., p. 232).

The yellow "X": Marking the mutant "Other"

In some incarnations, the costumes of the X-Men differ so dramatically that the only uniting identifier is the presence of the yellow "X." The "X" acts like a brand, declaring allegiance without the need for a complete uniform. Branding the X-Men as Other, it may also have more sinister connotations of imposed ghettoization.

Staszak (2009) observes that, while Others may be outsiders, they may also be "found among the self." Other and self cohabit (as in men and women, heterosexual and homosexual individuals and communities), making it difficult to identify and maintain the "particularities . . . and stereotypes that distinguish the Self from the Other." This inability to distinguish Self from Other can be emotionally unsettling, and a desire to resolve this feeling of unease leads to attempts to separate the self from the other, as in segregation and ghettoization. It is this situation that is at the heart of the fictional world imagined in *The X-Men*.

X-Men narratives depict the X-Men as genetic mutants, whose supernatural powers make them outcasts, exiled from the communities in which they were born. Xavier is the victim of an anti-mutant hate crime, savagely beaten by his own students when he makes an effort to integrate into the faculty at Columbia University (*Uncanny X-Men* #192, April 2985). Holocaust references litter the pages of the X-Men comics (not least in Magneto's status as a Holocaust survivor). *Uncanny X-Men* #141–142 (January–Febuary, 1981) depicts a dystopian future in which all mutants are hunted down and imprisoned, and in some cases, exterminated. In this segregated world, the X-Men and other mutants suffer as a consequence of their otherness. They face discrimination and, at worst, genocide. Issue 141 (January 1981) woefully predicts "registration of mutants today, gas chambers tomorrow," and the following issue sees Wolverine burnt to ashes by a "mutant-discriminatory" sentinel, leaving only his adamantium skeleton as evidence of his existence.

With so many explicit references to the Holocaust, it is reasonable for readings of the X-Men to make connections between the "canary yellow star" which the Jew was legally required to pin to his or her clothes during the Holocaust (Cole and Smith, 1995, p. 303), and the yellow "X" which brands the X-Men. The same vibrant "marigold yellow" of the X-Men's uniforms is also "the most pervasive symbol of socially constructed Jewish . . . identity" (Greene and Peacock, 2011, p. 93). Just as the Star of David became a "shorthand for division" when Christian

and Jewish communities were forced apart under the Third Reich (Cole and Smith, 1995, p. 303), the yellow "X" divides the X-Men from nonmutant society.

For Jews in the Nazi State, the Star of David, pinned to their clothes and painted on their homes, "made them subject to a variety of victimizations." The symbol became objects of "shame, harassment, and intimidation," and for many it also sealed their fate, leading them "eventually to the gas chambers" (Greene and Peacock, 2011, p. 93). Given this history, such a visible declaration of otherness as the X-insignia could invite persecution. It may be that resistance to subjugation is what makes the X-Men so keen to limit the uniformity of their clothes. They seek just enough of a visual signifier of their unity to express membership of the group, but not enough similarity to suggest that they are somehow being controlled. Identical uniforms, like the striped trousers of concentration camp prisoners, would indicate a loss of control over their identities and their destinies (Taylor, 2014, p. 146).

Despite the dangers inherent in acknowledging their mutant identity in a prejudiced world, the X-Men remain keen to visibly assert their otherness through costume. By declaring their solidarity and otherness, they reclaim the label of mutant outsider that has been imposed upon them by mainstream society. Lewis A. Erenberg (1998, p. 232) observes that "ghetto dress . . . embod[ies] defiance of a world that usually belittle[s minorities]." The X-insignia, by asserting collective otherness, is a statement of pride.

The significant difference between the Star of David and the yellow "X" is that the X-Men have elected to wear their symbol themselves. It may be that, by marking themselves, the X-Men are preempting attempts by others to mark them, thus claiming the symbol for themselves before it can be commandeered by mainstream society. Jewish communities were able to take ownership of the meaning of the Star of David when it was no longer imposed upon them. Greene and Peacock (2011, p. 93) observe how "after the war Jews around the world . . . turned this socially constructed symbol of humiliation into a badge of honour and community." The yellow star, which once "signalled acts of degradation" was reclaimed as "a source of deep pride," and a sacred marker of a social and cultural bond that extends beyond its religious meaning (ibid., p. 92). By marking themselves, the X-Men retain ownership of the X-insignia, and therefore of their own fates.

NOTES

Introduction

1 This book will use the term "masquerade" in the general sense, as superficial disguise or pretense. Although the term has been associated with femininity (following Joan Riviere's "Womanliness as Masquerade," 1929), this book does not aim to invoke ideas about gender.

2 As evidenced by Batman or Black Widow, who are classified as superheroes despite not possessing any supernatural abilities, and characters such as Sherlock Holmes or Indiana Jones who are arguably extraordinary enough to set them apart from ordinary folk, and in this respect comparable to Batman or Black Widow, and yet do not command the title of "superhero."

1 Superman: Codifying the superhero wardrobe

1 Clark Kent, transforming into Superman, refers to his heroic deeds as "my other job" in *Action Comics* #866 (August 2008).

2 Clothes have largely been responsible for introducing notions of masculinity and femininity. In the 1830s and 1840s, femininity was associated with inactivity, not because of naturally refined behavior, but because the clothes of the day, particularly corsets and tight sleeves, restricted movement. As a result of such restrictiveness, "the gender identity of women . . . may be said to be constructed" (Barnard, 1996, p. 115). Conversely, the simple garments worn by men in the Victorian era allowed free movement.

3 See, for example, the work of costume designer Sonia Biacchi (2006), who creates sculptural, purposefully impractical garments from severely restrictive materials, including plywood, rubber and stainless steel. Biacchi aims to consciously limit the movement of the wearer: to alter his/her natural motions so that walking in the costume itself becomes an enforced performance art.

4 The image of Superman's torn cape is also used as the cover of *Superman Vol. 2* #75.

5 At the *Criptease* event at London's Southbank Centre in 2010, wheelchair-bound comedian Liz Carr performed a Superman-inspired striptease. In her performance, Carr, a self-described "cripple," initially appears to struggle with the task of removing her clothes, every action seemingly an immense effort. Just as her strength begins to wane, she unbuttons her shirt to reveal a Superman costume beneath. The theme from *Superman: The Movie* plays, and Carr, suddenly imbued with the strength of a

hero, rises from her wheelchair and triumphantly removes the rest of her suit to reveal the Superman costume in all its glory. As she exits the stage, with her wheelchair at full speed, the scarlet cape flaps behind her.

2 Identity, role and the mask

1 Texts have argued that, in the case of Superman/Clark Kent, Superman is the authentic identity, and Clark Kent the mask. This is explored in more detail in Chapter 6.

3 Evolution and adaptation: Form versus function

1 The shredded costume is a signifier of weakness, and therefore realism, both in the costume and the hero who wears it. Ripped and broken costumes are problematic for superheroes on many levels. First, they express vulnerability, reducing the superhero's ability to intimidate assailants or reassure victims. Secondly, a torn costume has the potential to reveal the superhero's secret identity. Lastly, when a costume is directly responsible for a superhero's powers, any damage may render him powerless (see, for example, *Iron Man*, Jon Favreau, 2008).

4 Wearing the flag: Patriotism and globalization

1 Since the national identity belongs to the people of that nation, the mantle may be passed to others, as it is when Bucky Barnes adopts Steve Rogers' heroic identity in *Captain America Vol. 5*, #34 (March 2008).

2 Miles Morales' race is foregrounded in *Ultimate Comics: Spider-Man,* in notable contrast to *Spider-Man India*. *Spider-Man India* does not appear to present ethnicity as a significant defining characteristic in the same way that it does for the African American Spider-Man. Miles Morales' first issue (September 2011) presented Morales as Spider-Man on the cover, with his mask removed and black face revealed, foregrounding his race. In notable contrast, issues of *Spider-Man India* never reveal the character's ethnicity on the cover. On the inner pages, the two identities of ethnic Pavitr Prabhakar and Indian Spider-Man are kept distinctly separate until Pavitr removes his mask for Meera in the series' climax (#4, April 2005).

3 The *Batman Incorporated* venture is funded by Bruce Wayne, who publicly admits to being the long-time financial source of the Batman.

4 El Gaucho first appeared in *Detective Comics* #215 (January 1955), Batwing appeared in *Batman* #250 (July 1973), Man-of-Bats and Little Raven appeared in *Batman* #86 (September 1954).

5 Dressing up, dressing down: A spectacle of otherness, and the ordinariness of the civilian alter-ego

1 Except, of course, for Iron Man, whose powers are within the costume.

2 Superman adheres to few expectations, other than those of the superhero genre itself, which have developed since Superman's first appearance. These expectations inevitably increase as the number of superheroes increases.

6 Channeling the beast

1 For Archangel, the connotations of feathered wings are angelic rather than animalistic. This vision of an angelic hero is perhaps more in-line with the hero's mission of salvation.

2 This is not true of the Hulk, who has little control over his actions, making anyone a potential target.

3 The case of Wildcat's son, Tom Bronson, is particularly interesting in this regard. While Wildcat is human (albeit enhanced with the nine lives of a cat), his son, Bronson, is a werecat, or in DC's terms, a "metahuman." Bronson transforms involuntarily into a panther, particularly when threatened (see *JSA: The Next Age*). When Wildcat proposes that the superhero identity will be inherited, questions arise about whether the costume transforms man to animal or vice versa. For Wildcat, costume allows him to appear more cat-like. For Bronson, that same costume would allow him to appear more human. Bronson's inheritance of the costume would place him in the curious position of a cat-pretending-to-be-a-man-pretending-to-be-a-cat.

7 Superheroes and the fashion of being unfashionable

1 It is worth noting that entirely utilitarian clothing is rarely, if ever, worn. As Michael Carter (2012, pp. 350–351) observes, modernism's pursuit of an entirely utilitarian garment was short-lived because of "small destructions of utility" that "diverted to the ornamental order." No superheroes can claim to have entirely utilitarian costumes, as there is "stylistic surplus"; that "lies beyond the utilitarian dimension" of the wardrobe. Nonetheless, most male superheroes make token gestures of utilitarianism in their costume design. When Batman's chest insignia changed for Frank Miller's *The Dark Knight Returns* (1989), it needed to be justified by a statement that suggested the previous version had been impractical—that it had made Batman vulnerable as a target. Without this justification, the redesign would have been entirely aesthetic, perhaps making Batman susceptible to accusations of vanity.

2 Given Edith Head's profession, it is ironic that the most significant changes to a superhero costume are seen in film, where the audience is less sympathetic to comic-book traditions. Cinema is associated with, if not defined by, realism, and drastic alterations have been made to ensure the plausibility of the superhero to cinema audiences (see Chapters 5 and 12).

3 Incidentally, the same is true of Bruce Wayne. His fondness for designer suits, and the vanity and superficiality that it implies, are only permissible as it is a part of his artificially constructed civilian alter-ego. Batman could never be depicted as so concerned for his appearance.

4 Supreme originally appeared in Rob Liefeld's *Youngblood* (1992–1996), and was later resurrected by Alan Moore for Image Comics.

5 Superman's much publicized death, in *Superman Vol. 2* #75 (January 1993), turned out to be a kind of hibernation brought on by the shock of battle.

8 Superhero cosplay

1 Yet ironically, devotion also alienates non-cosplayers. While there is a drive to encourage spectatorship, cosplay is "a form of fandom that delights in outsiders' incomprehension of their culture and values" (Bainbridge and Norris, 2009). In order to maintain exclusivity, cosplayers must necessarily assert their difference. Their play is a "resistance" to the mainstream, and even to the real world, as fans assume "unreal" identities (Bainbridge and Norris, 2013). The cosplayer's costume positions the wearer as "other" in the same way as it does for the fictional superhero.

9 Real-life superheroes

1 There are exceptions to anti-mask laws in France and New York. In France there are exceptions for sportswear and motorcycle helmets; in New York, masks are permitted if worn for entertainment, as in a masquerade.

12 The X-Men

1 Uniforms are at home in educational institutions, such as the school for "gifted youngsters" established by Charles Xavier (aka "Professor X"). Uniforms are notably absent from Xavier's school, as depicted in Bryan Singer's *X-Men* (2000) and *X2* (2003) movies, where only those who have achieved the exalted status of X-Man can wear the costume. This inverts the convention that pupils are uniformed while staff mark their authority through civilian clothing. In this context, pupils must earn their right to wear a uniform.

BIBLIOGRAPHY

Agnew, V. (2004), "Introduction: What is reenactment?" *Criticism* 46(3), pp. 327–339.

Alsford, M. (2006), *Heroes & Villains*, Waco, TX: Baylor University Press.

Álvarez-Errecalde, Ana (2014), "Superhero Costumes—'SIMBIOSIS' 2013" [email correspondence] to Barbara Brownie, April 27.

Andrae, T., and Gordon, M. (2010), *Funnyman: The first Jewish superhero*, Port Townsend, WA: Ferla House.

Antonucci, T. C., and Mikus, K. (1988), "The Power of Parenthood: Personality and attitudinal changes during the transition to parenthood," in G. Y. Michaels and W. A. Goldberg (eds), *The Transition to Parenthood: Current theory and research*, Cambridge: Cambridge University Press, pp. 62–84.

Bahun-Radunović, S. (2011), "The Ethics of Animal-Human Existence: Marie Darrieussecq's truisms," in S. Bahun-Radunović and V. G. J. Rajan (eds), *Myth and Violence in the Contemporary Female Text: New Cassandras,* Farnham: Ashgate, pp. 55–74.

Bainbridge, J., and Norris, C. (2009), "Selling Otaku? Mapping the relationship between industry and fandom in the Australian cosplay scene," *Intersections: Gender and Sexuality in Asia and the Pacific* 20.

Bainbridge, J., and Norris, C. (2013), "Posthuman Drag: Understanding cosplay as social networking in a material culture," *Intersections: Gender and Sexuality in Asia and the Pacific* 32, http://intersections.anu.edu.au/issue32/bainbridge_norris.htm [accessed October 30, 2014].

Barberena, L. (2009), "Lucha Libra: Mexican wrestlers and the portrayal of politics in the arena," in B. Brummett (ed.), *Sporting Rhetoric: Performance, games, and politics*, New York: Peter Lang, pp. 157–172.

Barnard, M. (1996), *Fashion as Communication*, London: Routledge.

Barnes, H. (2008), "The Value of Superhero Play," *Putting Children First* 27, pp. 18–21, http://ncac.acecqa.gov.au/educator-resources/pcf-articles/The_value_of_superhero_play_Sep08.pdf [accessed October 12, 2014].

Barthes, R. ([1967] 2007), "Fashion Photography," in Malcolm Barnard (ed.), *Fashion Theory: A reader*, London: Routledge, pp. 517–519.

Barthes, R. (1983), *The Fashion System*, M. Ward and R. Howard (trans.), London: University of California Press.

Basile, E. (2009), "Second Skins: Spandex and the new American woman," paper presented at *Fashion: Exploring Critical Issues*, Mansfield College, Oxford, September 25–27, http://www.inter-disciplinary.net/wp-content/uploads/2009/08/basilepaper.pdf [accessed August 16, 2014].

BBC (2013), "French Veil Law: Muslim woman's challenge in Strasbourg," *BBC News* [online], November 27, http://www.bbc.co.uk/news/world-europe-25118160 [accessed August 1, 2014].

Bedeian, R. (2008), *Ritual, Symbolism and Imagery in African Masks*, http://www. chatham.edu/pti/curriculum/units/2008/Bedian.pdf [accessed August 19, 2012].

Beige, M., and Kearns, J. (2002), "Costumes with Semi-rigid Fabric Components and Method of Manufacture of Same," US Patent USRE37533 E1, http://www.google. com/patents/USRE37533E1 [accessed May 23, 2014].

Biacchi, S. (2006), *Costume* [online]. Available at http://www.ctrteatro.com/uk/costume. htm [accessed July 7, 2010].

Bihalji-Merin, O. (1971), *Masks of the World*, New York: Thames and Hudson.

Bille, M., Hastrup, F., and Sorensen, T. F. (2010), *An Anthropology of Absence: Materializations of Transcendence and Loss*, London: Springer.

Blom, J. D. (2014), "When Doctors Cry Wolf: A systematic review of the literature on clinical lycanthropy," *History of Psychiatry* 25(1), pp. 87–102.

Blumer, H. (1969), "Fashion: From class differentiation to collective selection," *Sociological Quarterly* 10(3), pp. 275–291.

Blumer, M. (1982), "When is Disguise Justified? Alternatives to covert participant observation," *Qualitative Sociology* 5(4), pp. 251–264.

Borrelli, C. (2010), "Artist Alex Ross Shares his Methods," *Chicago Tribune* [online], April 15, http://articles.chicagotribune.com/2010-04-15/entertainment/ct-live-0415-alex-ross-20100415_1_chicago-comic-comic-book-artist-alex-ross [accessed August 21, 2014].

Boorstin, D. J. (1962), *The Image or What Happened to the American Dream*, New York: Atheneum.

Breivik, G. (2007), "Can Base Jumping be Morally Defended?" in M. McNamee (ed.), *Philosophy, Risk and Adventure Sports*, Oxon: Routledge, pp. 168–185.

Brook, P. (1987), "The Mask: Coming out of our shell," in *The Shifting Point: Theatre, film, opera 1946–1987*, New York: Harper and Row.

Brooker, W. (2012), *Hunting the Dark Knight*, London: I.B. Tauris.

Brown, J. A. (2012), "Ethnography: Wearing one's fandom," in Matthew J. Smith and Randy Duncan (eds), *Critical Approaches to Comics*, New York: Routledge.

Bruzzi, S. (1997), *Undressing Cinema*, New York: Routledge.

Bryson, D. (2009), "Designing Smart Clothing for the Body," in J. McCann and D. Bryson (eds), *Smart Clothes and Wearable Technology*, Boca Raton, FL: CRC Press, pp. 95–107.

Bukatman, S. (1994), "X-bodies: The torment of the mutant superhero," in S. Bukatman (2003), *Matters of Gravity: Special effects and Superman in the twentieth century*, Durham, NC: Duke University Press, pp. 48–78.

Bullock, S. (2006), Review of *Special*, SFX [online], November 22. http://www.sfx.co. uk/2006/11/22/special/ [accessed August 11, 2012].

Burton, T. (1989), "Beyond Batman" [DVD extra], *Batman,* USA: Warner Brothers.

Butler, T. (2005), "The Counterfeit Body: Fashion photography and the deceptions of femininity, sexuality, authenticity and self in the 1950s, 60s and 70s", http://news. mongabay.com/2005/0507-tina_butler.html [accessed August 21, 2014].

Butler, J., Holden, K., and Lidwell, W. (2003), *Universal Principles of Design*, Massachusetts: Rockport.

Cadena-Roa, J. (2002), "Strategic Framing, Emotions, and *Superbarrio*—Mexico City's Masked Crusader," *Mobilization: An International Quarterly* 7(2), pp. 201–216.

Cadwalladr, C., and Narizhnaya, K. (2012), "Pussy Riot on Putin, 'Punk Prayers' and Superheroes—video," *The Observer* [online], July 29, http://www.theguardian.com/ world/video/2012/jul/29/pussy-riot-russia-interview-video?INTCMP=ILCNETTXT3486 [accessed April 21, 2014].

Caillois, R. (1990), *The Necessity of Mind*, Venice, CA: Lapis Press.

Campbell, J. (1949 [2004]), *The Hero with a Thousand Faces*, Princeton University Press.

Carlson, M. (2011), "Furry Cartography: Performing species," *Theatre Journal* 63(2), pp. 191–208.

Carter, M. (2012), "Stuff and Nonsense: The limits of the linguistic model of clothing," *Fashion Theory* 16(3), pp. 343–354.

Castle, T. (1986), *Masquerade and Civilisation: The carnivalesque in eighteenth-century English culture and fiction,* London: Methuen.

Chabon, M. (2008), "Secret Skin: An essay in unitard theory," in *Superheroes: Fashion and fantasy,* New York: Yale University Press, and the Metropolitan Museum of Art.

Chadder, V. (1999), "The Higher Heel," in S. Chinball and R. Murphy (eds), *British Crime Cinema*, New York: Routledge, pp. 66–80.

Chambliss, J. C., and Svitavsky, W. L. (2008), "From Pulp Hero to Superhero: Culture, race, and identity in American popular culture, 1900–1940," *Studies in American Culture* 30(1), http://scholarship.rollins.edu/cgi/viewcontent.cgi?article= 1002&context=as_facpub [accessed October 30, 2014].

Channel 4 (2012), "Meet the Superhumans," *Vimeo*, https://vimeo.com/46732057 [accessed August 16, 2014].

Chilman, C. S. (1980), "Parent Satisfactions, Concerns and Goals for their Children," *Family Relations* 29(3), pp. 339–345.

Chrisafis, A. (2012), "Pussy Riot Protesters Arrested in Marseille," *BBC News* [online], August 19, http://www.theguardian.com/world/2012/aug/19/pussy-riot-protesters-arrested-marseille [accessed August 1, 2014].

Cohn, B. (2001), "Cloth, Clothes and Colonialism: India in the nineteenth century," in Daniel Miller (ed.), *Consumption: The history and regional development of consumption*, London: Routledge, pp. 405–440.

Cole, T., and Smith, G. (1995), "Ghettoization and the Holocaust: Budapest 1944," *Journal of Historical Geography* 22(1), pp. 300–316.

Collins, L. (2011), "Fashion as Confession: Revelation and concealment in personal identity," paper presented at *Fashion: Exploring Critical Issues*, Mansfield College, Oxford, September 22–25.

Comiskey, S. (2012), "Pussy Riot Superheroes Freeze Flashmob," Eyes on Rights, *Flickr*, https://www.flickr.com/photos/eorphotography/7773728882/ [accessed August 1, 2014].

Conklin, B. A. (1997) "Body Paint, Feathers and VCRS: Aesthetics and authenticity in Amazonian activism," *American Ethnologist* 24(4), pp. 711–737.

Coogan, P. (2006), *Superhero: The secret origin of a genre*, Austin, TX: Monkeybrain.

Coogan, P. (2009), "The Definition of the Superhero," in H. Jeet and K. Worcester (eds), *A Comics Studies Reader*, Jackson: University Press of Mississippi, pp. 77–93.

Cooper, M. (1999), "An Empirical and Theoretical Investigation into the Psychological Effects of Wearing a Mask," PhD thesis, University of Sussex, http://strathprints. strath.ac.uk/43402/1/1999_PhD_thesis_public.pdf [accessed August 2, 2014].

Crane, D. (2000), *Fashion and Its Social Agendas*, Chicago: University of Chicago Press.

Croci, D. (2014), "Subverting Big Brother, Reinscribing the Self: Appropriation and subjectivity in A. Moore and D. Lloyd's *V for Vendetta*," paper presented at *3rd International Conference: The Graphic Novel*, Mansfield College, Oxford, September 3–5.

Cronin, B. (2009), "Comic Book Legends Revealed 207," *Comic Book Resources* [online], May 14, http://goodcomics.comicbookresources.com/2009/05/14/ comic-book-legends-revealed-207/ [accessed October 30, 2014].

Cubbison, L. (2012), "Russel T Davies, 'Nine Hysterical Women,' and the Death of Ianto Jones," in B. Williams and A. A. Zenger (eds), *New Media Literacies and Participatory Popular Cultures Across Borders*, Oxon: Routledge, pp. 135–150.

Daniels, L. (1998), *Superman: The complete history*, London: Titan Books.

Daniels, L. (1999), *Batman: The complete history*, New Haven: Chronicle Books.

Davé, S. (2013), "Spider-Man India: Comic books and the translating/transcreating of American cultural narratives," in S. Denson, C. Meyer and D. Stein (eds), *Transnational Perspectives on Graphic Narratives: Comics at the crossroads*, London: Bloomsbury, pp. 127–140.

Davies, P., Surridge, J., Hole, L., and Muro-Davies, L. (2007), "Superhero-related injuries in paediatrics: a case series," *Archives of Diseases in Childhood* 92(3), pp. 242–243.

Davis, A. J., and Sohn, C. J. (1935), "Glider," US Patent US2067423 A, http://www.google.com/patents/US2067423 [accessed October 9, 2014].

Dawson, A. B. (1978), *Indirections: Shakespeare and the Art of Illusion*, Toronto: University of Toronto Press.

De Haven, T. (2010), *Our Hero: Superman on Earth*, London: Yale University Press.

De Zwart, M. (2013), "Cosplay, Creativity and Immaterial Labours of Love," in D. Hunter (ed.), *Amateur Media: Social, cultural and legal perspectives*, London: Routledge, pp. 170–177.

Dini, P. (2010) *The World's Greatest Superheroes*, New York: DC.

Donovan, J. (2012), "Parody and Propaganda: Fighting American and the battle against crime and communism in the 1950s," in M. Pustz (ed.), *Comic Books and American Cultural History: An anthology*, London: Continuum.

Eagan, P. L. (1987), "A Flag With A Human Face," in D. Dooley and G. Engle (eds), *Superman at Fifty: The persistence of a legend*, New York: Collier, pp. 88–95.

Edmiston, B. (2008), *Forming Ethical Identities in Childhood Play*, New York: Routledge.

Erenberg, L. A. (1998), *Swingin' the Dream: Big band jazz and the rebirth of American culture*, Chicago: University of Chicago Press.

Fehrle, J. (2011), "Unnatural Worlds and Unnatural Narration in Comics: A critical examination," in J. Alber and R. Heinze (eds), *Unnatural Narratives—Unnatural Narratology*, Berlin/Boston: Walter de Gruyter.

Feiffer, J. (2003), *The Great Comic Book Heroes*, Seattle: Fantagraphics.

Feldman, J. (2008), "Untying Memory: Shoes as holocaust memorial experience," in E. Nahshon (ed.), *Jews and Shoes,* Oxford: Berg, pp. 119–130.

Feyersinger, E. (2011), "Metaleptic TV Crossover," in K. Kukkonen and S. Klimek (eds), *Metalepsis in Popular Culture,* New York: Walter de Gruyter, pp. 127–157.

Fhlainn, S. N. (2009), "Our Monstrous (S)kin: Blurring the boundaries between monsters and humanity," in S. N. Fhlainn (ed.), *Our Monstrous (S)kin,* Oxford: Interdisciplinary Press.

Fingeroth, D. (2004), *Superman on the Couch*, New York: The Continuum International Publishing Group.

Fiske, J. (1992), "The Cultural Economy of Fandom," in L. Lewis (ed.), *The Adoring Audience,* London: Routledge, pp. 30–49.

Fitzgerald, P. (1870), *Principles of Comedy*, London: Tinsley Brothers.

Flemming, K. L. (2007), *Participatory Fandom in American Culture: A qualitative case study of DragonCon Attendees,* MA diss., University of South Florida.

Fletcher, D. (2012), "Recalibrating the 'Human'," *NEO: Journal for Higher Degree Research in the Social Sciences and Humanities* 5, http://www.arts.mq.edu.au/documents/hdr_journal_neo/neo_2012/Article_3_FLETCHER.pdf [accessed August 13, 2014].

Foster, R. J. (1991), "Making National Cultures in the Global Ecumene," *Annual Review of Anthropology* 20, pp. 235–260.

Freeman, H. (2013), "You Want to Dress Up in a Cute Animal Hat? Oh, please, just grow up!" *The Guardian* [online], February 4, http://www.guardian.co.uk/fashion/2013/feb/04/cute-animal-hat-grow-up [accessed April 13, 2013].

Fron, J., Fullerton, T., Ford Morie, J., and Pearce, C. (2004), "Playing Dress-Up: Costumes, roleplay and imagination," paper presented at *Philosophy of Computer Games,* University of Modena and Reggio Emilia, January 24–27.

Gapps, S. (2009), "Mobile Monuments: A view of historical reenactment and authenticity from inside the costume cupboard of history," *Rethinking History* 13(3), pp. 395–409.

Gavaler, C. (2012), "The Ku Klux Klan and the Birth of the Superhero," *Journal of Graphic Novels and Comics* 4(2), pp. 191–208.

Gessen, M. (2014), "Pussy Riot: Behind the balaclavas," *The Guardian* [online], January 24, http://www.theguardian.com/books/2014/jan/24/pussy-riot-behind-balaclava [accessed April 21, 2014].

Giambarrase, N. (2010) "Intellectual Property Comment: The look for less: A survey of intellectual property protections in the fashion industry," *Touro Law Review* 26, pp. 243–285.

Gibbons, D. (2008), *Watching the Watchmen*, London: Titan.

Goffman, E. (1959), *The Presentation of Self in Everyday Life*, New York: Doubleday.

Gooch, B. (2008), "The Communication of Fan Culture: The impact of new media on science fiction and fantasy fandom," Undergraduate thesis, Georgia Institute of Technology.

Gordon, S. A. (2009), *"Make it Yourself": Home sewing, gender, and culture, 1890–1930*, New York: Colombia University Press.

Greenbaum, A. (2001), "Shoes and Hair," in J. Crafield and M. V. Hasen (eds), *Chicken Soup for the Jewish Soul*, Deerfield Beach, FL: Heath Communications, pp. 272–278.

Greene, D. M., and Peacock, J. R. (2011), "Judaism, Jewishness, and the Universal Symbols of Identity: Re-sacralizing the Star of David and the color yellow," *Studies in American Jewish Literature* 30, pp. 80–89.

Gussin Paley, V. (2014), *Boys and Girls: Superheroes in the doll corner*, Chicago: University of Chicago Press.

Hagen, C. (2014), "The Bat Men Before Batman," *The Atlantic* [online], June 4, http://www.theatlantic.com/entertainment/archive/2014/06/the-original-bat-man/372100/ [accessed October 9, 2014].

Harvey, J. (2008), *Clothes*, Stocksfield, UK: Acumen.

Harris, J. (1995), "Costume History and Fashion Theory: Never the twain shall meet?," *Bulletin of the John Rylands Library* 77(1), pp. 73–79.

Hasler, R. M., Hutter, H. E, Keel, J. B., Durrer, B., Zimmermann, H., Exadaktylos, A. K., and Benneker, L. M. (2012), "Spinal and Pelvic Injuries in Airborne Sports: A retrospective analysis from a major Swiss trauma centre," *Injury* 43(4), pp. 440–445.

Hayles, K. N. (1999), *How We Became Posthuman: Virtual bodies in cybernetics, literature and informatics*, London: University of Chicago Press.

Healy, M. J., and Beverland, M. B. (2013), "Unleashing the Animal Within: Exploring consumers' zoomorphic identity motives," *Journal of Marketing Management* 29(1–2), pp. 225–248.

Ho, A. (2006), "Changing Expressions," *Trek Earth*, http://www.trekearth.com/gallery/Asia/China/photo527345.htm [accessed August 2, 2014].

Hochschild, B. (2014), "The Vietnam War—Not a Space for Superheroes," paper presented at *3rd International Conference: The Graphic Novel*, Mansfield College, Oxford, September 3–5, http://www.inter-disciplinary.net/at-the-interface/wp-content/uploads/2014/08/hochschildgnpaper.pdf [accessed September 11, 2014].

Hogan, J. (2003), "Staging the Nation: Gendered and ethnicized discourses of national identity in Olympic opening ceremonies," *Journal of Sport and Science Issues* 27(2), pp. 100–123.

Hyland, P. (2002), "The Performance of Disguise," *Early Theatre* 5(1), pp. 77–82.

Jeffrey, S. (2012), "Producing and Consuming the Posthuman Body in Superhero Narratives," https://nthmind.wordpress.com/posthumanism-and-superheroes-notes-from-phd-land/producing-and-consuming-the-posthuman-body-in-superhero-narratives/ [accessed March 6, 2015].

Jeffries, D. H. (2013), "From the Top of the Cowl to the Tip of the Cape: The cinematic superhero costume as impossible garment," *Cinephile* 9(2), pp. 30–37.

Jenkins, H. (1992), *Textual Poachers: Television fans and participatory culture*, New York: Routledge.

Johnson, S. (2012), "Is Superman's Power Now in His Suit?" *Comic-Book.com*, May 3, http://comicbook.com/blog/2012/03/08/is-supermans-power-now-in-his-suit/ [accessed August 21, 2014].

Joseph, N. (1986), *Uniforms and Nonuniforms: Communicating through clothing*, New York: Greenwood.

Julian, S. (2012), "Superheroes: Archetypes for the modern myth," *Critical Survey of Graphic Novels: History, Theme, and Technique*, New York: Salem Press, pp. 213–217.

Kaiser, S. B., Nagasawa, R. H., and Hutton, S. S. (1991), "Fashion, Postmodernity and Personal Appearance: A symbolic interactionist formulation," *Symbolic Interaction* 14(2), pp. 165–185.

Karageorghis, V. (1971), "Notes on Some Cypriote Priests Wearing Bull-Masks," *The Harvard Theological Review* 64(2/3), pp. 261–270.

Karaminas, V. (2009), "Ubermen: Masculinity, costume and meaning in comic book superheroes," in P. McNeil and V. Karaminas (eds), *The Men's Fashion Reader*, New York: Berg, pp. 179–186.

Kasson, J. F. (2001), *Houdini, Tarzan, and The Perfect Man: The white male body and the challenge of modernity in America,* New York: Hill and Wang.

Kemmelmeier, M., and Winter, D. G. (2008), "Sowing Patriotism, but Reaping Nationalism? Consequences of exposure to the American flag," *Political Psychology* 29(6), pp. 859–879.

Kerns, J. (2012), "Crime Fighter Phoenix Jones Wants Your Help to Pay for New Suit," *My Northwest*, July 16, http://mynorthwest.com/75/707275/Crime-fighter-Phoenix-Jones-wants-your-help-to-pay-for-new-suit [accessed August 2, 2014].

Keyes, R. (2004), *The Post-Truth Era: Dishonesty and deception in contemporary life*, New York: St. Martin's Press.

Khoo, O. (2007), *The Chinese Exotic: Modern Diasporic Femininity*, Hong Kong: Hong Kong University Press.

Klock, G. (2008), *How to Read Superhero Comics and Why*, New York: Continuum.

Klutz (2006), The *Superhero Starter Kit*, Palo Alto, CA: Chicken Socks.

Knowles, C. (2007), *Our Gods Wear Spandex: The secret history of comic book heroes*, San Francisco: Red Wheel/Weiser.

Koch, C. M. (2014) audience comment in response to Croci, D. (2014), "Subverting Big Brother, Reinscribing the Self: Appropriation and subjectivity in A. Moore and

D. Lloyd's *V for Vendetta*," paper presented at *3rd International Conference: The Graphic Novel*, Mansfield College, Oxford, September 3–5.

Koda, H. (2001), *Extreme Beauty: The body transformed*, New York: The Metropolitan Museum of Art.

Kövecses, Z., and Koller, B. (2006), *Language, Mind, and Culture: A practical introduction*, Oxford: Oxford University Press.

Krulos, T. (2013), *Heroes in the Night: Inside the real superhero movement*, Chicago: Chicago Review Press.

Lamerichs, N. (2011), "Stranger than Fiction: Fan identity in cosplay," *Transformative Works and Cultures* 7, http://journal.transformativeworks.com/index.php/twc/article/view/246/230 [accessed April 6, 2013].

Langley, T. (2012), *Batman and Psychology: A dark and stormy knight*, New Jersey: John Wiley and Sons.

Laver, J. (1938), *Taste and Fashion*, London: Dodd, Mead and Co.

Leigh, M., and Lepine, M. (1990), *How to be a Superhero*, London: Penguin.

Levi, H. (2005), "The Mask of the Luchador: Politics and identity in Mexico," in N. Sammond (ed.), *Steel Chair to the Head: The pleasure and pain of professional wrestling*, Durham, NC: Duke University Press, pp. 96–131.

Levi, H. (2008), *The World of Lucha Libre: Secrets, revelations, and Mexican national identity*, Durham, NC: Duke University Press.

Levy, G. (2012), "5 Places to Get Your Own Pussy Riot Balaclava," *UPI.com* [online], August 17, http://www.upi.com/blog/2012/08/17/5-places-to-get-your-own-Pussy-Riot-balaclava/7041345220031/ [accessed April 21, 2014].

Lewis, A. D. (2013), "The Muslim Superhero in Contemporary American Popular Culture," paper presented at *American Academy of Religion annual conference*, Baltimore, MD, November 23, https://www.academia.edu/5280870/The_Muslim_Superhero_in_Contemporary_American_Popular_Culture [accessed July 31, 2014].

London, J. (1903), *People of the Abyss*, New York: Macmillan. Available online at http://london.sonoma.edu/Writings/PeopleOfTheAbyss/ [accessed August 7, 2014].

Maas, D. (2001), 'Convertible Costume Construction', US Patent 6308334 B1. http://www.google.co.uk/patents/US6308334 [accessed January 1, 2015].

Madrid, M. (2009), *The Supergirls: Fashion, feminism, fantasy, and the history of comic book heroines*, Minneapolis: Exterminating Angels Press, 2009.

Male, A. (2007), *Illustration: A theoretical and contextual perspective,* Switzerland: AVA.

Manzenreiter, W. (2006), "Sport Spectacles, Uniformities and the Search for Identity in Late Modern Japan," *The Sociological Review* 54(s2), pp. 144–159.

Mass, M. (1997), "The Determinants of Parenthood: Power and responsibility," *Human Relations* 50(3), pp. 241–260.

McCloud, S. (1993), *Understanding Comics*, Northampton, MA: Kitchen Sink Press.

McCudden, M. (2011), "Degrees of Fandom: Authenticity and hierarchy in the age of media convergence," PhD thesis, University of Kansas.

McLachlan, S. (2009), *American Civil War Guerrilla Tactics*, New York: Osprey.

Medley, S. (2010), "Discerning Pictures: How we look at and understand images in comics," *Studies in Comics* 1(1), pp. 53–70.

Metropolitan Museum of Art (2008), *Superheroes: Fashion and fantasy*, New York: Yale University Press, and the Metropolitan Museum of Art.

Ménil, R. (1996), "Concerning Colonial Exoticism," in M. Richardson (ed.), K. Fijalkowski (trans.), *Refusal of the Shadow: Surrealism and the Caribbean*, London/New York: Verso, pp. 176–181.

Miller, C. M., McIntyre, S. H., and Mantrala, M. K. (1993), "Toward Formalizing Fashion Theory," *Journal of Marketing Research* 3(2), pp. 142–157.

Miller, J. (2014), "Watch Emma Stone Call Out Andrew Garfield's Spider-Man 2 Sexism in Front of a Full Audience," *Vanity Fair* [online], April 22, http://www.vanityfair.com/hollywood/2014/04/emma-stone-andrew-garfield-spider-man-2-sexism [accessed May 30, 2014].

Miller, K., Jasper, C. R, and Hill, D. R. (1991), "Costume and the Perception of Identity and Role," *Perceptual and Motor Skills* 72(3), pp. 807–813.

Monks, A. (2010), *The Actor in Costume*, New York: Palgrave Macmillan.

Morel d'Arleux, L. J. M. (1806), "Le Brun's System on Physiognomy," *Les Maitres des Arts Graphiques*, http://www.maitres-des-arts-graphiques.com/-EXB.html [accessed August 20, 2012].

Morris, T. (2005), "The Secret of Secret Identities," in T. Morris and M. Morris (eds), *Superheroes and Philosophy,* Illinois: Carus, pp. 250–266.

Morrison, G. (2011), *Supergods: Our world in the age of the superhero*, London: Jonathan Cape.

Moser, J. E. (2009), "Madmen, Morons, and Monocles: The portrayal of the Nazis in Captain America," in R. G. Weiner (ed.), *Captain America and the Struggle of the Superhero: Critical essays*, Jefferson, North Carolina: McFarland.

Moynihan, C. (2012), "3 Fight Anti-Mask Law that Prompted their Arrests," *The New York Times* [online], November 21, http://cityroom.blogs.nytimes.com/2012/11/21/3-fight-anti-mask-law-that-prompted-their-arrests/?_php=true&_type=blogs&_r=0 [accessed August 1, 2014].

Muecke, F. (1986), "Plautus and the Theatre of Disguise," *Classical Antiquity* 5(2), pp. 216–229.

Mullen, B., Migdal, M. J., and Rozell, D. (2003), "Self-Awareness, Deindividuation, and Social Identity: Unraveling theoretical paradoxes by filling empirical lacunae," *Personal and Social Psychology Bulletin* 29(2), pp. 1071–1081.

Mullen, J. (2014), "European Rights Court Rules in Favor of French Burqa Ban," *CNN* [online], July 1, http://edition.cnn.com/2014/07/01/world/europe/france-burqa-ban/ [accessed August 1, 2014].

Myerly, S. H. (1996), *British Military Spectacle: From the Napoleonic Wars through the Crimea*, Cambridge, MA: Harvard University Press.

Nakamura, L. (2002), *Cybertypes: Race, ethnicity, and identity on the Internet*, London: Routledge.

Nama, A. (2011), *Super Black: American pop culture and black superheroes*, Austin, TX: University of Texas Press.

Napier, A. D. (1986), *Masks, Transformation, and Paradox*, Berkley: University of California Press.

Nayar, P. (2011), "Haunted Knights in Spandex: Self and othering in the superhero mythos," *Mediterranean Journal of Humanities* 1.2, pp. 171–183.

Nayar, P. K. (2014), *Posthumanism*, Cambridge: Polity Press.

Newby, B. (2012), "Watchful Guardian or Dark Knight? The vigilante as a social actor," *International Foundation for Protection Officers Article Archives*, http://www.ifpo.org/wp-content/uploads/2013/08/Newby_Vigilante.pdf [accessed August 1, 2014].

Olofsson, M., Vallin, A., Jakobsson, S., and Wiklund, C. (2010) "Marginal Eyespots on Butterfly Wings Deflect Bird Attacks Under Low Light Intensities with UV Wavelengths," *PLOS One* 5(1).

O'Rourke, D., and Rodrigues, P. A. (2007), "The 'Transcreation' of a Mediated Myth: Spider-Man in India," in T. R. Wandtke (ed.), *The Amazing Transforming Superhero! Essays on the revision of characters in comic books, film and television*, Jefferson, NC: McFarland, pp. 112–128.

Osbourne, H. (1985), *The Oxford Companion to the Decorative Arts,* Oxford: Oxford University Press.

Parkins, W. (2004), "Celebrity Knitting and the Temporality of Postmodernity," *Fashion Theory* 8(4), pp. 425–441.

Parrish, J. J. (2007), "Inventing a Universe: Reading and writing internet fan fiction," PhD thesis, University of Pittsburgh.

Patten, F. (2004), *Watching Anime, Reading Manga: 25 years of essays and reviews*, Berkeley, CA: Stone Bridge Press.

Pavitt, J. (2000), *Brand New,* London: V&A Publications.

Pearson, R. E., and Uricchio, W. (eds) (1991), *The Many Lives of the Batman: Critical approaches to a superhero and his media*, New York: Routledge, 1991.

Pemberton, R. (2013), "Wingsuit History," *All Things Aero*, http://allthingsaero.com/alternative-flight/skydiving/video-wingsuit-history [accessed October 9, 2014].

Pickert, K. (2014) "Tank Man at 25: Behind the iconic Tiananmen Square photo," *Time* [online], June 4, http://lightbox.time.com/2014/06/04/tank-man-iconic-tiananmen-photo/ [accessed October 12, 2014].

Pine, K. J. (2014), *Mind What You Wear: The psychology of fashion*, Kindle Singles [ebook].

Potts, A. (2007), "The Mark of the Beast: Inscribing 'animality' through extreme body modification," in L. Simmons and P. Armstrong (eds), *Knowing Animals*, Leiden, The Netherlands: Brill, pp. 131–154.

Poynor, R. (2001), *Obey the Giant: Life in the image world*, London: August Media Ltd.

Pyle, C. L. (1994), "The Superhero Meets the Culture Critic," *Postmodern Cultures* 5(1), http://pmc.iath.virginia.edu/text-only/issue.994/review-6.994 [accessed May 19, 2014].

Rahman, O., Wing-sun, L., and Cheung, H. (2012), "Cosplay: Imaginative self and performing identity," *Fashion Theory* 16(3), pp. 317–342.

Rauch, E., and Bolton, C. (2010), "A Cosplay Photography Sampler," *Mechademia* 5, pp. 176–190.

Rauser, A. F. (2008), *Caricature Unmasked: Irony, authenticity, and individualism in eighteenth century English prints*, Cranbury, NJ: Rosemont.

Reynolds, R. (1992), *Superheroes*, London: Batsford.

Reynolds, W. H. (1968), "Cars and Clothing: Understanding fashion trends," *Journal of Marketing* 32, pp. 44–49.

Ricca, B. (2013), *Super Boys: The amazing adventures of Jerry Siegel and Joe Schuster, the creators of Superman*, New York: St Martin's Press.

Richards, J. D. (2005), *Vikings: A Very Short Introduction*, Oxford: Oxford University Press.

Riviere, J. (1929), "Womanliness as Masquerade," *The International Journal of Psychoanalysis* 10, pp. 303–313.

Robertson, V. L. D. (2013a), "Where Skin Meets Fin: The mermaid as myth, monster and other-than-human identity," *Journal for the Academic Study of Religion* 26(3), pp. 303–323.

Robertson, V. L. D. (2013b), "The Beast Within: Anthrozoomorphic identity and alternative spirituality in the online therianthropy movement," *Nova Religio: The Journal of Alternative and Emergent Religions* 16(3), pp. 7–30.

Roche, D., and Birrel, J. (1994), *The Culture of Clothing*, Cambridge: Cambridge University Press.

Rosenberg, R. S. (2009), "The Liberation of Anonymity," *Psychablog,* October 12, http://psychablog.blogspot.co.uk/2009/10/liberation-of-anonymity-part-i.html [accessed May 23, 2014].

Rosenberg, R. S. (2011), "Being a Superhero: It's about the costume?" *Psychology Today*, April 5, http://www.psychologytoday.com/blog/the-superheroes/201104/being-superhero-its-about-the-costume [accessed May 23, 2014].

Rouse, E. (1989), *Understanding Fashion*, Oxford: BSP Professional Books.

Sadowski, G. (ed.) (2009), *Supermen: The first wave of comic book heroes 1936–1941*, Seattle: Fantagraphics.

Sapir, E. (1985), "Fashion," in D. G. Mandelbaum (ed.), *Edward Sapir: Selected writings in language, culture and personality*, 1st paperback edition, Berkeley, CA: University of California Press, pp. 373–381.

Sawyer, R. K. (2003), *Improvised Dialogues: Emergence and creativity in conversation*, Westpost, CT: Greenwood.

Schatz, Robert T., and Lavine, H. (2007), "Waving the Flag: National symbolism, social identity, and political engagement," *Political Psychology* 28(3), pp. 329–355.

Schocket, E. (1998), "Explorations of the 'Other Half,' or the Writer as Class Transvestite," *Representations* 64, pp. 109–133.

Schöpflin, G. (2010), *The Dilemmas of Identity*, Tallin: TLU Press.

Scott, J., (2008) "A Dialogue Between Sichuan and Beijing Opera (review)," *Asian Theatre Journal* 25(2), pp. 370–373.

Sheets, D. (2009), "Watchmen, Superhero Comics, and the Loss of Consciousness," *Literary Gulag*, https://www.ideals.illinois.edu/bitstream/handle/2142/11884/May2009.htm?sequence=9 [accessed August 7, 2014].

Shields, N. (2011), "Empty Shoes Fill with Memories at Ocean Grove 9/11 Memorial," *Asbury Park Press* [online], September 9, http://archive.app.com/article/20110909/NJNEWS/309090048/Empty-shoes-fill-memories-Ocean-Grove-9-11-memorial [accessed August 6, 2014].

Shone, T. (2012), "The Amazing Spider-Man and the Iron Law for Superheroes: Less is more," *The Guardian* [online], July 4, http://www.guardian.co.uk/film/filmblog/2012/jul/04/the-amazing-spider-man-superhero [accessed August 11, 2012].

Siddiqi, A. H. (1965), *Heroes of Islam, Part I*, Karachi: Jamiya-ul-Falah.

Simmel, G. (1904), "Fashion," *International Quarterly* 10, pp. 130–155, www.modetheorie.de/fileadmin/Texte/s/Simmel-Fashion_1904.pdf [accessed August 7, 2012].

Singer, M. (2012), *Grant Morrison: Combining the worlds of contemporary comics*, Mississippi: University Press of Mississippi.

Smith, G. M. (2009), "The Superhero as Labor: The corporate secret identity," in A. Ndalianis (ed.), *The Contemporary Comic Book Superhero*, New York: Routledge, pp. 126–143.

Smith, M. (2014), "Tank Man: What happened to the man who stood in front of tanks in Tiananmen Square?," *The Mirror* [online], June 4, http://www.mirror.co.uk/news/world-news/tank-man-what-happened-man-3644636 [accessed October 12, 2014].

Smith-Spark, L. (2012), "Russian Court Imprisons Pussy Riot Band Members on Hooliganism Charges," *CNN* [online], August 18, http://edition.cnn.com/2012/08/17/world/europe/russia-pussy-riot-trial/ [accessed July 31, 2014].

Sobchack, V. (ed.) (2000), *Meta-Morphing: Visual transformation and the culture of quick change*, Minneapolis: University of Minnesota Press.

Solomon, M. (2000) "Twenty-Five Heads under One Hat: Quick change in the 1890s," in V. Sobchack (ed.), *Meta-Morphing: Visual transformation and the culture of quick change*, Minneapolis: University of Minnesota Press.

South, J. B. (2005), "Barbara Gordon and Moral Perfectionism," in T. Morris and M. Morris (eds), *Superheroes and Philosophy,* Illinois: Carus, pp. 89–101.

Staszak, J. F. (2009), "Other/otherness," in R. Kitchin and N. Thrift (eds), *International Encyclopedia of Human Geography*, Elsevier Science [reproduced online], http://www.unige.ch/ses/geo/collaborateurs/publicationsJFS/OtherOtherness.pdf [accessed June 2, 2014].

Steranko, J. (2013), "Foreword," in *Superman: The golden age omnibus* 1, New York: DC, pp. 8–11.

Stenger, J. (2006), "The Clothes Make the Fan: Fashion and online fandom when Buffy the Vampire Slayer goes to eBay," *Cinema Journal* 45(4), pp. 26–44.

Stone, G. P. (1981), "Appearance and the Self: A slightly revised version," *Social Psychology through Symbolic Interaction*, Macmillan, pp. 187–202, in D. Brisset and C. Edgeley (2009), *Life as Theatre: A dramaturgical sourcebook*, 2nd edition, New Bruswick, NJ: Transaction, pp. 141–162.

Strashnaya, R. (2012), "Constructing the Visual Self: Dressing for occasions," in *Fashion: Exploring critical issues*, Oxford: Interdisciplinary Press.

Taylor, J. (2014), "Concentration Camp Uniform as a Tool of Subjugation and a Symbol of the Holocaust," in P. I. Cornish and N. J Saunders (eds), *Bodies in Conflict: Corporeality, materiality, and transformation*, Oxon: Routledge, pp. 144–168.

Thomas, A. (2006), "Fan Fiction Online: Engagement, critical response and affective play through writing," *Australian Journal of Language and Literacy* 29(3), pp. 226–239.

Thomas, N. (1994), *Colonialism's Culture: Anthropology, travel and government*, Melbourne: Melbourne University Press.

Thompson, I. (2005), "Deconstructing the Hero," in J. McLaughlin (ed.), *Comics as Philosophy*, Jackson, MS: University Press of Mississippi, pp. 100–129.

Tognazzini, B. (1993), "Principles, Techniques, and Ethics of Stage Magic and Their Application to Human Interface Design," *Proceedings of InterCHI'93*, Amsterdam.

Tolokonikovoy, N. (2012), "Art and the Human Manifesto of Nadia Tolokonikovoy," in Stephen Morgan (ed.), *Pussy Riot v. Putin: Revolutionary Russia*, pp. 285–292.

Tolson, A. (2001), "Being Yourself: The pursuit of authentic celebrity," *Discourse Studies* 3(4), pp. 443–457.

Toynbee, P. (2003), *Hard Work: Life in Low-pay Britain*, London: Bloomsbury.

Tseëlon, E. (2001), "Reflections of Mask and Carnival," in *Masquerade and Identities: Essays on gender, sexuality and marginality*, London: Routledge.

Turk, T. (2011), "Metalepsis in Fan Vids and Fan Fiction," in K. Kukkonen and S. Klimek (eds), *Metalepsis in Popular Culture*, New York: Walter de Gruyter, pp. 83–103.

Turner, J. H. (2013), *Contemporary Sociological Theory*, New York: Sage.

Turner, R. H. (1978), "The Role and the Person," *American Journal of Sociology* 84(1), pp. 1–23.

Turner, T. (2008), "Cosmology, Objectification and Animism in Indigenous Amazonia," paper presented at *Nordic Network for Amerindian Studies*, Copenhagen, Denmark, November 9, http://www.newstudiesonshamanism.com/wp-content/uploads/2011/01/COSMOLOGY-1.doc [accessed June 15, 2013].

Tye, L. (2012), *Superman: The high-flying history of America's most enduring hero*, New York: Random House.

Wagner, T. (2014), "'My Suits . . . They're Part of Me': Considering disability in the *Iron Man* trilogy," *Cinephile* 9(2), pp. 4–11.

Waites, R. (2011), "V for Vendetta Masks: Who's behind them?" *BBC News Magazine* [online], http://www.bbc.co.uk/news/magazine-15359735 [accessed August 1, 2014].

Walter, H. (2011), "Putting Himself Off With His Clothes: Dress and body of the actor," paper presented at *Fashion: Exploring Critical Issues*, Mansfield College, Oxford, September 22–25.

Wanzo, R. (2009), "Wearing Hero-Face: Black citizens and melancholic patriotism in *Truth: Red, White and Black*," *The Journal of Popular Culture* 42(2), pp. 339–362.

Wark, M. (1999), *Celebrities, Culture and Cyberspace: The light on the hill in a postmodern world*, Annandale, NSW: Pluto Press.

Warner Bros. (2014), "A Super Hero for Every Generation—Warner Bros. Entertainment and DC Entertainment Celebrate Batman's 75th Anniversary," [press release], March 27, http://www.warnerbros.com/studio/news/super-hero-every-generation-%E2%80%93-warner-bros-entertainment-and-dc-entertainmentcelebrate [accessed February 8, 2015].

Webster, J. (2011), "Zoomorphism and Anthropomorphism: Fruitful fallacies?" *Animal Welfare* 20(1), pp. 29–36.

Weldon, G. (2013), *Superman: The unauthorized autobiography*, New Jersey: Wiley.

Weltzien, F. (2005), "Masque-ulinities: Changing dress as a display of masculinity in the superhero genre," *Fashion Theory: The Journal of Dress, Body & Culture* 9(2), pp. 229–250.

Wenger, C. (2007), "Superheroes in Play Therapy With an Attachment Disordered Child," in L. C. Rubin (ed.), *Using Superheroes in Counselling and Play Therapy*, New York: Springer.

Widener, J. (2014), interviewed in "Behind the Picture," *Time* [online], June 4, http://ti.me/1krBIv8 [accessed October 12, 2014].

Williams, M. P. (2011), "Superhero Narratives and Social Values: The role of globalisation and the avant–garde in Grant Morrison's *Batman*," *Werewolf.co.nz* [online], May 25, http://werewolf.co.nz/2011/05/superhero-narratives-and-social-values/ [accessed March 10, 2015].

Wilsher, T. (2007), *The Mask Handbook*, Oxon: Routledge.

Winge, T. (2006), "Costuming the Imagination: Origins of anime and manga cosplay," *Mechademia* 1, pp. 65–76.

Wolf-Meyer, M. (2006), "Batman and Robin In the Nude, or Class and Its Exceptions," *Extrapolation* 47(2), pp. 187–206.

Woodward, W. (2009), "The Nonhuman Animal and Levinasian Otherness: Contemporary narratives and criticism," *Current Writing: Text and Reception in Southern Africa* 21(1–2), pp. 342–362.

Yeats, W. B. (1972), *Memoirs*, London: Macmillan.

Yockey, M. (2009), "Secret Identities: The superhero simulacrum and the nation," *Cine Action* 77, http://www.cineaction.ca/wp-content/uploads/2014/04/issue77sample1.pdf [accessed July 31, 2014].

Young, A. B. (2007), "Fashion has its Laws," in M. Barnard (ed.), *Fashion Theory: A reader*, London: Routledge, pp. 46–57.

Yu, Shiao-Ling (1996) *Chinese Drama after the Cultural Revolution: 1979–1989*, New York: Edwin Mellen Press.

INDEX